Unpacking
the Collection

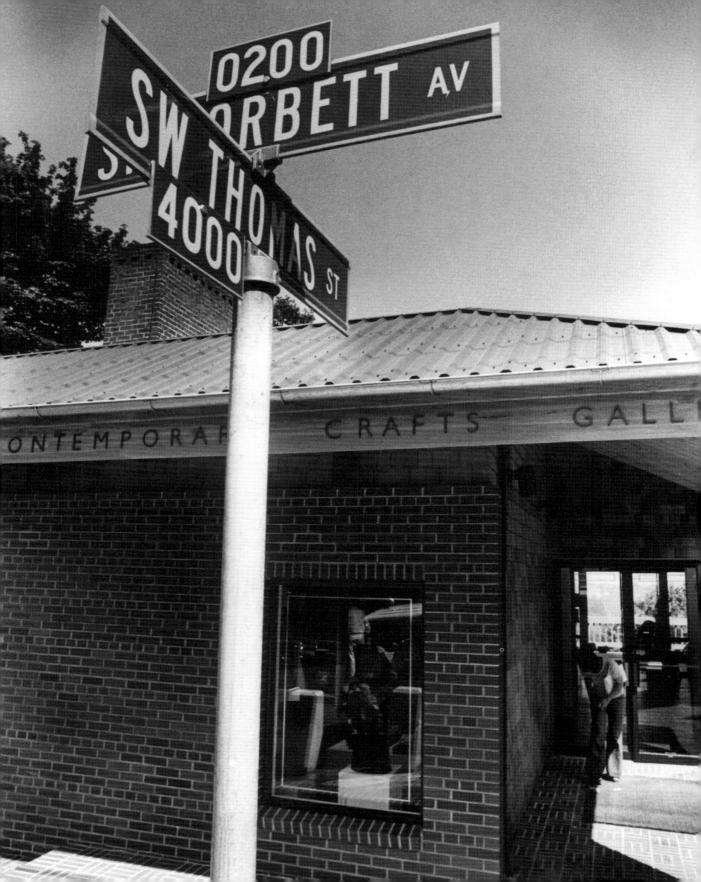

Unpacking the Collection

SELECTIONS FROM THE MUSEUM OF CONTEMPORARY CRAFT

Museum of Contemporary Craft, Portland, Oregon

This publication was made possible through
an anonymous gift.

Project Coordinator: Kat Perez
Editor: Anjali Gupta
Copy Editor: John Ewing
Design: Katherine Bovee

Photography: Dan Kvitka (unless otherwise noted)
Museum of Contemporary Craft Archives

Printing: Dynagraphics, Portland, Oregon

This book is typset in PTL Skopex and PTL Skopex Gothic

ISBN: 0-9728981-3-1

Published by Museum of Contemporary Craft
724 NW Davis Street
Portland OR 97209
www.museumofcontemporarycraft.org

Printed in Portland, Oregon

IMAGE CREDITS

PAGE 2: Exterior, Contemporary Crafts Gallery, c. 1970

PAGE 6, TOP LEFT: Betty Feves was one of the artists who demonstrated at the *Fire, Clay & Grog Fête*, 1961.

PAGE 6, BOTTOM LEFT: Paul Smith and Ken Shores at the Member Preview for *Generations: Ken Shores*, April 2008. Photo: Brian Foulkes.

PAGE 6, RIGHT (L TO R): Ruth Halvorsen and Rachael Griffin with *Sixth Annual Exhibition of Northwest Ceramics* jurors Dr. Francis J. Newton, Hilda Morris and Maija Grotell, 1955.

Table
of Contents

David Cohen
Introduction

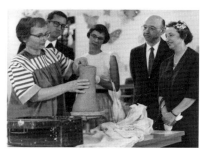

The works included in this catalogue are but a portion of the Museum of Contemporary Craft's collection, which currently exceeds one thousand objects and continues to grow. It follows a trajectory of personal and cultural influences, from early to mid twentieth-century pioneers, through the radical ideas of West Coast rebels, the idealism of the sixties and, finally, the technical artistry explored in the past few decades. When presented as a book, collections risk the loss of a certain dimension—the comprehensive understanding of the richness inherent in an individual object. Our hope is to reverse this tendency. With this publication and through this institution, we hope to illuminate the life behind the object: the stories of artists, some of whom never made it into the history books but whose impact certainly shaped the aesthetic sensibilities of a region and, arguably, a nation.

In many ways, our collection mirrors the seventy-year journey of the Museum of Contemporary Craft itself, which for decades served as an oasis for some of the leading artists this side of the Mississippi. The collection records the artifacts of a journey—telltale signs of creation whose connectedness and richness we devotedly seek to uncover and amplify. Like anthropologists, we are in the business of recreating the story behind the object. Luckily there are still people among us who remember the details. In some cases, we have been able to retain tangible evidence as well: letters, documents, photographs, audio recordings and press clippings that help fill in informational gaps, retracing connections that further enhance the understanding of the context of each work.

But objects are more than mere facts and figures, and much more than the sum of their visual attributes. Can we look at a piece of wood and hear Leroy Setziol's booming guffaw or smell the fresh wood chips that lay in piles on his studio floor? Can we sense the boisterous celebration that occurred the first time our Peter Voulkos vase was exhibited or imagine Dr. Francis Newton gathering friends for a grand feast, serving up sweet-smelling soup from a Wally Schwab tureen? These were, I am sure, moments full of warmth, full of humanness, full of life. Craft is an art form that is both personal and direct. It is about touch—about the primacy of the senses. It resides in a place where the everyday and art cohabitate.

Clearly, the objects in our collection have had journeys of their own, perhaps starting as clay deep in the earth, a thriving tree or the wool on a sheep's back. These raw materials, transformed by the minds and hands of individuals of vision, became what you will see in the pages that follow. Sometimes fire was involved or brute strength. Clanging tools and roaring machines may have served the will of the maker. Other times, the most delicate of gestures, obsessively repeated, cause us to ponder the limits of patience and endurance. These objects did not just take form. They traveled. From the quarry to the flatbed truck, from the studio to the gallery—then, perhaps, to someone's home before making their way back to the Museum. Many people handled them, admired them, touched and were touched by them. Objects may seem silent, but their stories are endless.

The Pacific Northwest is a true home to the craft-based arts—a unique place where there was never a break in legacy—where artists expanded upon traditions that have never been forgotten. Such work is still being created here. We recently built a new home to celebrate these objects and their stories—their past, present and future—and have now produced a document that speaks of their individual journeys. This book is a tribute to the makers who have enriched our lives. May they continue to inspire us with their vision, their technical mastery and the beauty they bring to the world.

David Cohen is Executive Director at the Museum of Contemporary Craft.

Janet Koplos
A Glimpse of the Past

We Americans are not very good at history, and Americans in the craft world are probably worse than average, in part because only the medium of ceramics has thus far benefited from historical surveys. We might suppose that important developments in the crafts movement occurred in only a few locales, but that's far from the truth. A vast number of communities were active from the turn of the nineteenth century onward, when craft-as-trade became craft-as-aesthetic and artistic medium. In Portland, Julia Hoffman founded the Arts and Crafts Society in 1907, which continues today as the Oregon College of Art and Craft, and in 1937 Lydia Herrick Hodge and others founded the Oregon Ceramic Studio that evolved into the Museum of Contemporary Craft, the institution and collection this book celebrates.

Hodge's pots, with their simple forms and experimental glazes, are the oldest works in the museum collection. Also among the threads of history we can trace through the collection are the knowledge, skills and technology that came with immigrants from Europe. Early examples are the works of Gertrud and Otto Natzler and Marguerite Wildenhain, all of whom fled the Nazis at the end of the thirties. Most West Coast pottery was cast, coiled or press-molded at that time, and available wheels were operated with sewing-machine treadles. Gertrud Natzler, a skillful thrower, brought her wheel with her and amazed the Southern California pottery community. Wildenhain brought to the Bay Area the discipline of her Bauhaus training and an equivalent degree of skill, although her bowls were thick and robust compared to the thin elegance of Natzler's work. Otto Natzler, self-taught in glazing, kept exacting

records, developing a scientific repository of information he was willing to share. European training influenced work in all the crafts mediums throughout the twentieth century. A more recent example represented in the collection is a piece by Lino Tagliapietra, the Italian glass master whose visits to the States introduced his superlative technique—drawn from Murano glass traditions—as a model for American glass artists in the eighties and nineties.

While textiles in the collection are few, Jack Lenor Larsen's *Remoulade* recalls the postwar era of "designer-craftsmen," when practicality and production were prime motivations for working in the crafts mediums. Larsen was a professional on a scale that stretches outside the crafts world, but he is known in this context for his use of natural materials and retaining the appearance of hand weaving. Larsen frequently drew on exotic, third-world sources, and this fabric alludes to such spicy mixtures—a French sauce—which also comes in a variety of colors.

In ceramics, which dominates the collection, it's almost amusing to see examples of fifties vessels by Peter Voulkos. They are the tightly thrown, resist-decorated vases, which got him into national shows and won awards beginning when Voulkos was still a student. While they display admirable skill, they are quite unlike the work that made him famous, which is represented by a large, stacked, carved and glaze-splashed vase from the sixties, also in the collection. Big changes in the crafts began with Voulkos' use of scale and rough, expressionist surfaces. Another innovation was the irreverent humor in works created in the sixties, represented here by Fred Bauer's *Green Giant's Lunch*—a plate

of piled peas—and Erik Gronborg's *American Anatomy Chart*, which displays the garishness and eroticism that were part of the era's aesthetic.

The collection also includes a major name in handmade furniture, Sam Maloof, and a leader in wood turning, Bob Stocksdale. Maloof, essentially self-taught in both woodworking and design, is represented in the collection by a functional and beautiful print rack—not one of his most famous forms but revealing of his interests and skills. Stocksdale developed his skills in a camp for conscientious objectors during World War II. He became a connoisseur of exotic woods, employing simple but not rigidly symmetrical forms that exploit the beauty of wood grain. Later turners were more enamored by complexity of form, distortion, color and other effects, making Stocksdale's approach seem austere in comparison.

The narrative became a favored mode of expression in the late twentieth century, usually implying a story that the viewer must puzzle out. Ronna Neuenschwander's ceramic sculpture *Queen Semiramis' War Elephant* is a provocative and amusing example of such work, while Lou Cabeen's *Ambition*, by the use of found domestic textiles, evokes the past with a particular link to the domestic realm and femininity.

In jewelry, use of non-precious materials was a major trend late in the twentieth century. A leader in the use of unconventional found materials was Ramona Solberg, represented in the collection by a necklace that incorporates pieces of bone that obviously had a previous life. Her selection and framing of found elements—mounting them as jewels—makes precious what was once casual or mundane. Donna D'Aquino uses steel rather than silver wire for her *Wire Bracelet #13*, and its form is also surprising: it's a linear scribble that does not offer an obvious path for the hand. This work contrasts with Ron Ho's earlier *Silver Necklace*, which uses more traditional materials and form, although the pendant is a good example of the graphic drama and relatively large scale popular in the seventies, favored over delicacy or complexity.

An almost baroque level of elaboration is another trend in all mediums beginning in the sixties and seventies, changing specifics like medium and scale but not disappearing even in the new century, as shown by Kyoko Tokumaru's *Germination (Festive)*, with its dense compaction of upward-striving lines. Leaving the porcelain uncolored unifies the piece and makes it elegant but in no way minimizes the surface activity.

From these examples—and other works in the collection discussed later in this book—we can see many of the formal interests, ideas and attitudes embedded in the craft arts of the last seventy years, as one particular studio matured into a museum and its random acquisitions became an increasingly coherent collection. Crafts, in their own time, offer pleasures of immediacy, tactility, symbolism and beauty; crafts in a collection like this offer a window into changing social movements and cultural values. The admirable debut of the Museum of Contemporary Craft promises greater opportunities to study these aesthetic and philosophical premises, which is important not just for Portland, for Oregon or just the Pacific Northwest, but for the history of American visual arts.

Janet Koplos is Senior Editor at Art in America.

Glenn Adamson
Look Here

We all know—or think we know—where to look for the defining objects of art history: the Uffizi, the Louvre, the Museum of Modern Art. Such great collections have dictated discourse on the subject for centuries and will doubtlessly continue to do so in the future, even as contemporary art becomes increasingly unruly and more and more difficult to pin to a gallery wall. Craft history is harder to locate. Even the most important decorative art collections tell only a partial story, usually one that is skewed up the social ladder to the "finest" examples of workmanship made in any given period. Indeed, the possessions of the lower and middling classes—that is, almost everyone—do not tend to survive because they were not seen as worthy of preservation. And when the typical material culture of the past manages to persist, it is distributed across encyclopedic institutions devoted to many subjects—science, history, folk life, transportation—and craft objects can be found in all of them.

In the case of modern craft—that is, work made since the inception of the industrial revolution—it is even harder to point to museums that adequately represent the field in all its diversity. The flagship American craft museums, such as the Museum of Arts & Design in New York and the Renwick Gallery in Washington, DC, have tiny acquisition budgets, and their collections, while important, are far from comprehensive. The rationale of craft acquisitions at these institutions and at even larger civic museums, such as the Metropolitan Museum of Art, the Boston Museum of Fine Arts and the Philadelphia Museum of Art, is often hard to reconstruct. Objects were often acquired because of personal friendships (such as that between the eminent Boston-based curator Jonathan Fairbanks and renowned California furniture maker Sam Maloof) or thanks to the generosity of public-minded collectors.

Patrons are particularly important within the crafts, often shaping collections to a much greater extent than curators or even directors. In some cases, such as the Everson Museum of Art in Syracuse, NY, or Minnesota Museum of American Art in St. Paul, museums enjoyed longstanding relations with local craft guilds and other organizations, collecting objects in response to these groups' events rather than through long-term curatorial planning. Such collections have real historical depth but tend to be particular to medium or geography, and are far from comprehensive in scope.

The surprise is that all of this is just fine. While one often hears complaints from the cognoscenti that museums are all beginning to look the same—like a high-culture version of malls all featuring the same chain stores—no such problem exists for craft. Unlike modern art, which was unquestionably centered in Paris before World War II and New York after, modern craft has never had a headquarters. Its geography is varied, mapped according to the presence of charismatic individuals, shifts in educational leadership and even the specificity of personal relationships. Interested in the designer-craftsman movements of the forties and fifties? Then you go to where the action was: New Hampshire, the upper Midwest and Southern California. Want to see the groundbreaking metalwork of Margaret De Patta or Margaret Craver? You will have to go to Oakland and Boston, respectively. University museums, like those at

the Rhode Island School of Design and Cranbrook, often have the best holdings of work by their own staff and former students.

Craft's dispersed nature reflects the fact that, unlike fine art, it is not now—and never has been—driven by the logic of the "masterpiece." Despite many attempts by artists to dismantle the explicitly hierarchical framework imposed by museums, it is still in place and, given the current state of affairs in the art market, more powerful than ever. In the history of craft, though, that logic never stuck. With a few notable exceptions, artists operating in the terrain of craft have made objects serially, with only incremental shifts from one pot or weaving to the next. There is even a vital tradition of "production work," bread-and-butter items that sustained many a craftsperson's career in good times and bad. This category has been disregarded, even by many craft historians and commentators, but unjustly: the weed pots, salad servers and table runners of bygone days not only yield valuable insights into the careers of individual craftspeople but can also, in their quiet way, be as aesthetically pleasing as any nonfunctional craft "sculpture."

What all this adds up to is the collection of the Museum of Contemporary Craft: a regional collection, to be sure, and one that includes masterpieces and modest pieces alike. It is anchored by a body of material associated with Lydia Herrick Hodge, the potter and artist who founded the Oregon Ceramic Studio in 1937 with a group of likeminded colleagues. Like Frances Louisa Goodrich, founder of the Southern Highlands Handicrafts Guild in Appalachia, Herrick Hodge started a collection that was also an autobiography. She captured the network of West Coast potters in which she herself lived and worked, including the famous (Peter Voulkos), the moderately well known (Glen Lukens and Laura Andreson) and the unfairly overlooked (Frances Senska and Hal Riegger)—all of whom knew and, in some cases, taught one another. The chance to compare their works side by side is tantamount to recovering a lost moment in the history of American ceramics.

It is for all of these reasons that this newly re-imagined museum will now take its place as one of the defining (rather than the definitive) institutions in the field of craft study and display. It is a place to engage with the realities of craft in its full range and in all the vibrant particularity that only a local story can provide. If you are looking for a true picture of modern craft—or at least a part of its infinitely varied fabric—you need look no further.

Glenn Adamson is Head of Graduate Studies and Deputy Head of Research at the Victoria and Albert Museum, London.

Namita Gupta Wiggers
Unpacking

Searching for inspiration for a title for this publication, I began pulling books off my shelves. Picking them up one at a time without really looking at what was in my hand, I found myself immersed in Walter Benjamin's essay "Unpacking My Library."[1] Here, Benjamin writes eloquently about his personal book collection, touching on the emotional qualities of anticipation while waiting to unpack—of the struggle between disorder and order and the role of the catalogue as the "counterpoint to the confusion of the library."[2]

Unpacking the Collection owes much to this essay. Quite literally, the title is a play on Benjamin's essay and refers to the physical packing—and unpacking—of the collection that was recently moved between the Museum's original home of seventy years at 3934 SW Corbett Avenue to its present location at 724 NW Davis Street in 2007. Under the direction of Collections Manager Nicole Nathan, a team of interns, volunteers and staff inspected, packed and physically moved nearly 1,000 objects from site to site. Anyone who has ever moved from point A to B understands that moving offers an opportunity for assessment—a chance to delve into rarely opened boxes and to categorize one's possessions in new ways. Thanks to the generosity of an anonymous donor, a critical study was made possible through this publication, the first ever focused on the collection of the Museum of Contemporary Craft.

Unpacking is also a term used in critical thought today to describe the process of revealing the many facets and parts of a given subject. The process of unpacking the Museum's collection and presenting it in some kind of order was a challenge. Any curator essentially inherits a collection, and part of curatorial practice in collecting institutions is the process of sorting through such objects to understand what is present—and, more importantly, why. The acquisition pattern at the Museum at first appeared largely unguided, unfocused and lacking what Benjamin calls "tactical instinct."[3] Closer inspection and research, however, exposed a connection between objects in the collection and the exhibitions organized at the Museum during its seventy-year history. The Museum's archives—scrapbooks (created by volunteers that meticulously recorded photographs and articles about the organization's history from its inception through the sixties), personal correspondence, slides and images of exhibitions and individual artists' works, invitations for openings and even Viewmaster discs—provided another layer in understanding how the collection and the institutional history connects to regional interests, broader cultural changes and to the history of craft in the twentieth and twenty-first centuries.

What also became clear are the unique qualities that distinguish this collection from those at other museums. This is not, by any means, a comprehensive collection; it does not reflect every artist or shift in craft over the past several decades regionally, nationally or internationally. It does, however, reveal a critical shift in the practice of craft as it moved out of the home and into academia. It reveals transitional moments in the careers of young artists who went on to produce mature work that altered people's understanding of craft in visual practice. The objects in the collection at this moment are typically domestic in scale—a reflection of the interests of artists creating work in the Pacific Northwest as well as

the limitations caused by costly shipping expenses. The collection illuminates regional specificity and interests despite the mask of globalism that prevails today.

Both Janet Koplos and Glenn Adamson contributed essays to frame the collection and the institution in broader cultural terms. Each chapter is organized by decade and includes an introduction, object entries and photographs of selected works from the collection. Rather than group the entries by media or by artists' names, sections are devised to connect individual pieces to overarching questions explored by craft artists across the country in any given decade. Abbreviated artist biographies are included to further communicate the many overlapping communities and connections that create one perspective on an arena known today as craft. Last but not least, an abbreviated chronology with selected images from the archive links the institution's exhibition history to that of the American Craft Movement and broader visual culture. To quote Robert Storr, this publication presents "a definite but not a definitive point of view."[4]

Benjamin's essay concludes with him lingering over the unpacking of his library, each object connecting him to the place it was purchased, his experiences with each book linked to the broader history of his life. "Ownership is the most intimate relationship that one can have to objects," he writes.[5] With this publication, the Museum of Contemporary Craft is able to provide the public with an opportunity to spend time with selections from the collection and to consider how each work and each artist connects to a history beyond. A book is an intimate object, but an object in a museum collection is not. As a civic and educational institution, the Museum's collection is a public collection. This publication allows the Museum to bring you into the unpacking process and make the Museum's collection your own.

Namita Gupta Wiggers is Curator at the Museum of Contemporary Craft.

1. Benjamin, Walter. *Illuminations* (New York: Harcourt, Brace & World, 1968), p59–67.
2. Benjamin, 60.
3. Benjamin, 63.
4. Storr, Robert. "Show and Tell." *What Makes a Great Exhibition?* Ed. Paula Marincola (Philadelphia: Philadelphia Exhibitions Initiative, Philadelphia Center for Arts and Heritage; London: Reaktion Books; Chicago: University of Chicago Press, 2006), p14.
5. Benjamin, 67.

1930s

A Place for
a New Kind
of Craft

In 1937, Lydia Herrick Hodge and a group of dedicated volunteers founded the Oregon Ceramic Studio (OCS), the first new arts organization to open in Portland in twenty-five years. Though linked to the Arts & Crafts Movement's emphasis on the value of the hand-crafted object, romantic ideals were not guiding principles of the OCS. Instead, the institution focused on critical shifts in the way ceramics were being used in the Modernist idiom. The OCS' inaugural exhibition, the *California Second Annual Ceramic Exhibition* (1939), included works by Laura Andreson, Glen Lukens and recent émigrés Gertrud and Otto Natzler.

While working with clay might seem common today, few West Coast artists in the thirties and forties used a potter's wheel or had easy access to glazes, kilns or molds. Materials and instruction on creating work in clay outside of industrial use was hard to find, and academic programs were nascent at best. Through the combination of education and an artist-centric ethos, the OCS established the foundation and legacy of the studio movement in the Pacific Northwest.

Modeled after European studios and ateliers that Hodge observed during her travels in the 1920s, the OCS served many purposes: it was a place for artists to purchase then difficult-to-locate clays, glazes and tools; it housed a kiln to fire completed work; it served as an exhibition space focused on exemplary work from the region and beyond and a venue through which to sell completed work; and finally, the OCS instituted an education program that connected artists with the community through hands-on experiences with clay. The OCS also encouraged many artists and craftspeople that had flocked to Oregon to work on the construction of Timberline Lodge to remain in the area. Located on Mount Hood, Timberline Lodge was part of Franklin D. Roosevelt's Works Project Administration (WPA) effort, and is recognized today as a National Historic Landmark.

The OCS leased and later purchased a four-lot hillside plot overlooking the Willamette River, in a residential neighborhood just outside of downtown, from the Portland Public School District in 1937. The price of the land—ten dollars—was agreed upon in exchange for a long-term commitment from the OCS to fire ceramic works by public school students. Grants from the WPA provided funds to support the labor and materials needed to create an Art Deco building designed by Ellis Lawrence, Dean of the University of Oregon School of Architecture and Allied Arts. Hodge led the organization from 1937 until her death in 1960. The organization remained at this original location—3934 SW Corbett Avenue—until moving to Portland's Pearl District in July 2007.

FACING PAGE: Founding Ladies of the Oregon Ceramic Studio, c. late 1930s (not pictured: Edna Barnes, Lydia Herrick Hodge and Mary Ireland)
Front row: Anne Chalmers, Mabel Simpson, Winifred Newberry; Middle row: Elaine Pirofsky, Barbara Weber, Margaret Gordon, Ella Meisner, Maurine Roberts, Irma Sears, Minne Johnston; Back row: Phebe Hayslip, Bernice Church

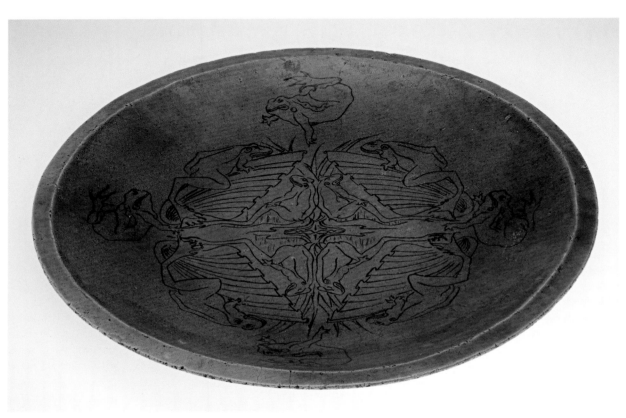

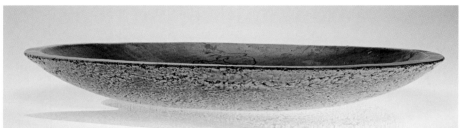

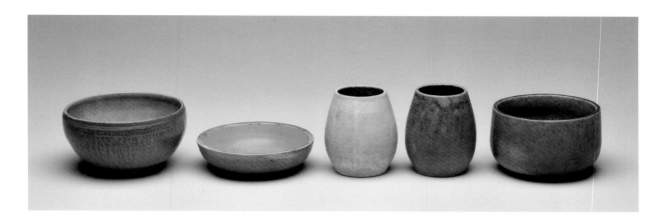

Lydia Herrick Hodge
ONSET OF MODERN CERAMICS

Lydia Herrick Hodge's ceramics reveal important transitions in the use of clay and aesthetic preferences in the Pacific Northwest during the thirties and forties. In opposition to the muted palette and stylized nature forms of the Arts & Crafts Movement, Art Nouveau and the Victorian aesthetic, this emerging approach to ceramics employed luxuriant and abundant color, heightened attention to structural elements and streamlined and simple vessel forms.

Heavily textured underneath but smooth on top, *Frog Platter* was created with a simple mold in a way that exposes rather than masks the materials used in its creation. While the drawing is reminiscent of both Art Nouveau and a Victorian aesthetic, the exploration of the impact of a single color on a simple form signals a transition into modern ceramics.

Hodge's palette on these small vessels typifies the limited glaze options available to artists at the time. Pieces such as these were created at the OCS during the thirties and forties as substitutes for expensive and difficult-to-obtain European tableware. Bue Kee,

Hal Riegger and others worked with Hodge and OCS volunteers to create, fire and glaze tableware for local audiences. They reveal a developing style of "American" tableware that would eventually capture the interest of Russel Wright, creator of Fiesta Dinnerware, for inclusion in his "American Way" project.[1]

1. Interview with Ken Shores and Lamar Harrington; Harrington, LaMar, *Ceramics in the Pacific Northwest: A History* (University of Washington Press, Seattle, 1979).

FACING PAGE: Lydia Herrick Hodge, *Frog Platter*, 1939; ceramic; 2.25 × 19.25 inches diameter; Gift of the artist; 1998.00.27

ABOVE (L TO R): Lydia Herrick Hodge, *Untitled grouping of vessels*

small orange bowl (yellow interior with flower), c. 1938–45; ceramic; 2.25 × 4.25 inches diameter; Gift of Margaret Murray Gordon Estate; 1998.00.29

small dish with yellow exterior, orange crackle interior, c. 1938–45; ceramic; 1 × 4 inches diameter; Gift of Margaret Murray Gordon Estate; 2004.10.29

yellow bud vases, c. 1938–45; ceramic; 3 × 2.25 inches diameter; Gift of Margaret Murray Gordon Estate; 2004.10.32–33

small brown bowl, c. 1938–45; ceramic; 2.25 × 3.75 inches diameter; Gift of Margaret Murray Gordon Estate; 2004.10.17

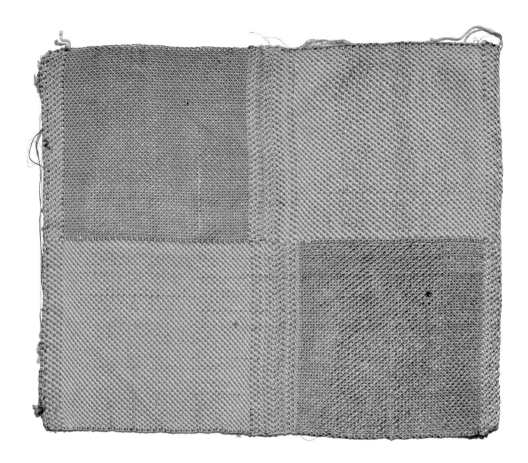

The Crocker Sisters
DEFINING A REGIONAL AESTHETIC

During the 1930s, Anna Belle and Florence Crocker, known as the Crocker Sisters, wove textiles for numerous projects, including the widely acclaimed John Yeon-designed home for Aubrey Watzek, featured in *Built in USA*, 1932–1944 at the Museum of Modern Art (MoMA), New York. That exhibition brought international attention to an emerging Northwest architectural style. Integrated into rather than placed within the environment, the Crocker Sisters' upholstery and draperies for the Watzek House furthered a growing regional aesthetic that embraced both local and innovative new materials with skillful craftsmanship.

Anna Belle Crocker served as the first director of the Portland Art Association (1909–1936), now the Portland Art Museum (PAM). An innovative curator, Crocker brought Marcel Duchamp's *Nude Descending a Staircase* (1912) to Portland in 1913 amidst international furor over the Cubist work. With Harry Wentz, she co-founded the Museum Art School, which separated from the PAM and became the independently run Pacific Northwest College of Art in 1994. Crocker also worked to bolster national recognition for the region through the promotion of the work of architects Pietro Belluschi and John Yeon, curator and artist Rachael Griffin and artists Jack McLarty and William Givler—among others.

ABOVE: Anna Belle and Florence Crocker, *Untitled placemat*, c. 1930s; silk, wool; 16 × 19 inches; Gift of Mary and Nelson Hazeltine; 1998.42.01

Glen Lukens
WEST COAST PIONEER

A simple molded form luxuriously coated with vivid color and a crackle glaze, this bowl is characteristic of Glen Lukens' work in the thirties and forties. Believed to have been purchased by Hodge from the OCS' inaugural exhibition, *California Second Annual Ceramic Exhibition*, this piece is considered the first contribution to the collection. Lukens played a vital advisory role from the inception of the OCS, connected to the organization through Victoria Avakian Ross, one of his former students. Ross taught at the University of Oregon and helped Hodge develop a palette of glazes for OCS.

Lukens is well known for his adaptation of the sewing machine into a potter's wheel, used as a rehabilitation device for recovering veterans during World Wars I and II. In workshops throughout the country, Lukens and his student F. Carleton Ball also taught many artists how to incorporate his modified potter's wheel in their studio practice.

Leaving his teaching post at the University of Southern California in the hands of Vivika Heino, Lukens lived in Haiti from 1952 to 1953, while working for UNESCO. He returned to a vastly changed cultural landscape. During his absence, Shoji Hamada and Bernard Leach's Mingei movement had swept the nation, prompting a dramatic shift in the way artists worked with clay. West Coast stoneware had been replaced with new clay forms, molds with the potter's wheel and colorful glazes created from local sources trumped by muted earth tones and wax-resist designs. Widely recognized for his unique glazes and simple, streamlined forms in such exhibitions as the prestigious *Ceramic National Exhibitions* in Syracuse, New York, throughout the thirties and forties, Lukens continued to work with clay and experiment with kiln-formed glass until his death in 1967.

BELOW: Glen Lukens, *Untitled yellow crackle bowl*, c. 1939; ceramic; 3.5 × 7 inches diameter; Gift of Lydia Herrick Hodge; 1998.50.01

1940s

Working Around the War

The cultural climate in the United States shifted dramatically during the 1940s. As countless émigrés fled the war in Europe and settled across the country, new ways of working with materials, aesthetics and ideas entered the collective consciousness. On the West Coast, Gertrud and Otto Natzler and Marguerite Wildenhain settled in California, bringing with them wheel-throwing and glazing skills, as well as a clearly defined Modern aesthetic for functional forms that ultimately changed the ceramic landscape.

Despite the difficulties in obtaining the most basic of supplies including clay and glazes, as well as the loss of labor needed to run large kilns as young men were called into service during World War II, the activities of the OCS persevered. In terms of education and outreach, ceramics remained of central interest. The OCS hosted what is believed to be Marguerite and Franz Wildenhain's first traveling exhibition in the United States in 1940, and *Western Craftsmen* (1945), which included Laura Andreson, Victoria Avakian Ross, Glen Lukens, Gertrud and Otto Natzler, Marguerite Wildenhain, as well as art jeweler Margaret De Patta and weaver Dorothy Liebes. As the Museum's archive also reveals, a growing emphasis on weaving and textiles ensued during this period. This focus reflects both the interests of and materials available to the community at hand during the War Years—a community comprised primarily of women.

Working in collaboration with the Portland Art Museum, University of Oregon and the Portland Public School System, the OCS obtained a $6,000 grant from the Carnegie Foundation in 1941. OCS volunteers worked hard to stretch these funds and developed a workshop and exhibition program that successfully connected local artists with nationally recognized leaders in both ceramics and design. While workshops educated the Portland community about emerging techniques, design concepts, materials and processes, exhibitions provided examples of finished works for both viewing and purchase. Workshops taught by such notable artists and designers as John Ryder, Arthur E. Baggs, Dorothy Liebes, Marian Hartwell and Margaret De Patta were highlights of this program.

During this same period, Aileen Osborn Webb spearheaded the development of the American Craftsmen's Council in New York City, known today as the American Craft Council (ACC). Founded in 1939, the project involved two primary elements in the early forties: America House, a retail venue through which rural craftsmen could sell their work in a metropolitan market, and *Craft Horizons*—renamed *American Craft* in 1979—originally a quarterly publication that became the primary resource for artists and craftspeople to learn what was happening throughout the country in this growing field.

From its inception, Lydia Herrick Hodge and the OCS played a vital role in facilitating a national connection between the ACC and the Pacific Northwest. Rachael Griffin, curator at the Portland Art Museum, was a frequent contributor to *Craft Horizons*; her articles connected the OCS to the national scene. In 1944, the OCS was asked to jury submissions by artists and craftspeople from the Northwest interested in selling their work at America House, an accolade that recognized the OCS as an important regional center and further solidified Portland as a hub for crafts-based activity.

In order to maintain a high standard for exhibitions and programs, OCS volunteers had to devise creative solutions to circumvent the hardships caused by the war, including scarcity of materials, labor and shipping costs. For instance, when the tenacious Lydia Herrick Hodge discovered that *Modern Textiles*, an exhibition organized by the Museum of Modern Art (MoMA), was traveling between San Francisco and Seattle, she worked tirelessly to convince MoMA to allow the OCS to host the exhibition in Portland in 1946. A significant coup, *Modern Textiles* included work by such notables as Anni Albers, Louise Bourgeois, Robert D. Sailors and Marianne Strengell among others. Another traveling exhibition, *International Textiles* (1947), offered further connections to a growing and innovative textile community.

Throughout the decade, local guilds from Eugene, Oregon, and Seattle, Washington, exhibited weaving at the OCS that used such locally grown resources as Mount Angel flax. Nationally recognized weavers Merlin Dow and Dorothy Liebes exhibited at the OCS as well, introducing innovative approaches to weaving with bamboo and metallic yarns and applications for textiles that fit an emerging Modernist aesthetic for domestic interiors.

In addition, many artists represented in the Museum's collection served during World War II, including Rudy Autio, Ray Grimm, Tom Hardy, Otto Heino, Frances Senska, Ramona Solberg, Paul Soldner and Peter Voulkos. Others, such as Hal Riegger and Bob Stocksdale, spent the war in camps as conscientious objectors. Following the war, many of these artists were able to attend colleges and universities—academic avenues that would have been nearly impossible for some of them to pursue if not for the financial support of the G.I. Bill. The entrance of people from a range of economic backgrounds into the academy, coupled with an increasingly global community and aesthetic, dramatically altered both the academy and art programs in the United States and contributed immeasurably to the development of what is now called the American Craft Movement.

PREVIOUS PAGE: Hal Riegger, Demonstration, unknown location, 1947
FACING PAGE: Exterior of Oregon Ceramic Studio, exhibition by Weavers Guild of the Arts & Crafts Society, 1948

Hal Riegger
CARNEGIE PROGRAMS

In 1946, the OCS collaborated with the Portland Art
Museum, University of Oregon and the Portland Pub-
lic Schools to execute a series of ceramic and textile
design workshops funded by a grant from the Carnegie
Foundation. Hal Riegger, the new OCS studio technician,
enrolled in a workshop taught by San Francisco designer
Marian Hartwell. This plate, believed to have been cre-
ated during one of those workshops, was used to serve
refreshments at the OCS for many decades and was
featured in an article in *Craft Horizons* (now *American
Craft*), which showcased both Hartwell's work and that
of her students.[1] Stretching the Carnegie grant over a
period of several years, the OCS also helped bring in
the team of Alfred E. Baggs and Mary Giles, as well as
Dorothy Liebes and Margaret De Patta, to teach work-
shops in Portland.

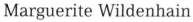

1. Griffin, Rachael. "Delvings in Design Presents," *Craft Horizons* (November, 1946),
p32–33, 38.

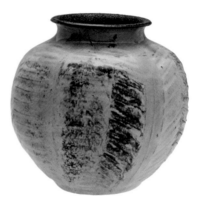

Marguerite Wildenhain
POND FARM

Marguerite Wildenhain arrived in the United States
in 1940, one of many European émigrés who fled the
advance of the National Socialist Party before World
War II. Bauhaus-trained, Wildenhain exemplified both a
philosophical and rigorous, process-oriented approach to
object making. Wildenhain self-identified as a potter and
was trained in an apprenticeship model that focused on
the repetitive creation of functional vessels as a means
of achieving ideal form. This particular piece embodies
several characteristic elements of her work. While
the form overtly references classical European vessels,
its surface also bears the marks of its maker—carefully
applied glazes and carvings that emphasize the physical-
ity of its creation.

During the early forties, Wildenhain taught at Black
Mountain College and California College of the Arts. In
the late forties, she established the summer workshop
program known as Pond Farm, a combination studio/
teaching environment in Guerneville, California. Wilden-
hain believed that the search for strong form was the

means to creating works that would stand the test of
time—an ideal she expected her students to adhere to
as well. For instance, her students might throw vessels
for eight hours each day. But at the end of the day, they
often found themselves with only one piece—if any—that
she deemed worthy of firing and being glazed, usually by
Wildenhain herself. This rigorous emphasis on process
and editing, searching for an individual form of expres-
sion, matched Wildenhain's philosophical and aesthetic
ideals. This modified application of Bauhaus training to
the very different teaching environment in the United
States impacted the practice and teaching styles of many
of Wildenhain's students, including Charles Counts,
James Lovera, Victoria Avakian Ross, Frances Senska
and Ken Shores.

ABOVE, TOP: Hal Riegger, *Untitled cake plate*, 1946; earthenware; 10.75 × 9.25 × .75
inches; Gift of Dr. Steven Kormanyos; 2000.09.01

ABOVE, BOTTOM: Marguerite Wildenhain, *Pond Farm Vase*, c. 1942; ceramic; 6 × 6 inches
diameter; Gift of Winifred Newberry; 1998.69.12

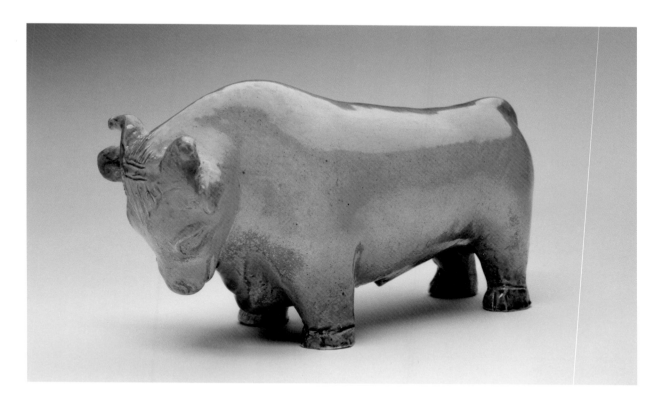

Lydia Herrick Hodge
PAUL BUNYAN IN CLAY

Early in 1940, Lydia Herrick Hodge, Margaret Gordon and Katharine McNab became involved in Russel Wright's "American Way" program, a craft-retailing scheme piloted in 1940. Wright gathered together 65 artists and craftspeople from across the country. His goal was to revolutionize the American home with products suited for a modern lifestyle—objects that also defined a uniquely "American" aesthetic. Work by OCS artists featured prominently in Wright's publicity materials, including ads in *Life* magazine.[1] Between production and distribution issues that plagued the project from the beginning and the onset of World War II, the endeavor became increasingly difficult to sustain, and Wright's ambitious project folded just over a year after its inception.

However, this project prompted Hodge and OCS volunteers to explore the idea of establishing an aesthetic identity. Taking its theme from a children's book—the tall tale lumberjack hero and his companion Babe the blue ox—*Paul Bunyan in Clay* opened in 1941.[2] The exhibition featured work by twenty regional artists working in a range of media, all based on the palette and landscape of the Pacific Northwest.

Each participating artist responded differently, resulting in a mixed media exhibition that included ceramics, textiles, furniture and more. Hodge continually sought ways to educate the community about OCS offerings. Connecting Babe to a herd of bulls Hodge saw in Hillsboro, Oregon, a small herd of "testers" was created to fit the theme of the exhibition. Each bull was glazed differently to showcase materials available for use at the OCS and reveal technical intricacies, such as how each glaze reacted to being fired at different temperatures.

1. Museum of Contemporary Craft Archives, "American-Way." *Magazine of Art* (November, 1940).
2. The theme was based on a series of books about Paul Bunyan produced by local publishers Binfords and Mort.

ABOVE: Lydia Herrick Hodge, *Bull*, c. 1940; ceramic; 3 × 5.5 × 2 inches; Gift of Ken Shores; 2006.01.01

Victoria Avakian Ross
SCULPTURAL GLAZES

Much like her teacher Glen Lukens, Victoria Avakian Ross preferred simple, molded forms as the foundation for thick and sculptural glazed surfaces. In *White on White Bowl*, Avakian Ross explores the sculptural effect of layers of dense viscous glaze—a technically difficult piece to create in the forties, when artists did not have the benefit of thickening agents or other additives available today. Known for her experimental spirit and boundless energy, Avakian Ross encouraged students to find their own working methods and use unexpected tools just as she did, exemplified by the unique extruded glazed surface of *Uranium Glazed Plate*.

Avakian Ross served as the Head of Ceramics at the University of Oregon School of Architecture and Allied Arts from 1920 to 1964. Her technical knowledge of clay, kilns and glaze recipes was also essential to the development of the OCS. She brought many artists to the region, connecting both her students and the OCS with such visitors as Peter Voulkos and Marguerite Wildenhain. While little of Avakian Ross' work remains in public collections today, a sample of her meticulous test-tile records in the Museum's archives is evidence of her dedication to providing new and exciting materials to area artists and her students. Her impact on the generation of artists who shifted their practice from the use of clay primarily for creating functional forms to a medium of sculptural expression is evident in the work of Tom Hardy, Eric Norstad, Ken Shores and many others.

FACING PAGE: Victoria Avakian Ross, *White on White Bowl*, c. 1948; ceramic; 4.75 × 5.75 inches diameter; Gift of the Victoria Avakian Ross Estate; 1998.76.04

ABOVE: *Uranium Glazed Plate*, 1948; Clay with uranium glaze; 2 × 13.5 inches diameter; Gift of the Victoria Avakian Ross Estate; 1998.76.03

1950s
The Decade
of the
Northwest
Ceramic
Annuals

In 1950, the OCS launched its *Annual Exhibitions of Northwest Ceramics*, modeled after the prestigious *Ceramic National Exhibitions* in Syracuse, New York, established in 1932.[1] Open to artists from Oregon, Washington, Idaho and Montana, the Annuals provided a vital regional venue for artists working in clay, as well as an opportunity to build a collector base for ceramics in the Pacific Northwest. The objects included in these exhibitions tended to be domestic in scale—a reflection of both the costs involved in shipping ceramics and an indication of the interests of both OCS volunteers and the larger community. Unencumbered by centuries-old European-based craft traditions as found in other parts of the country, artists were free to experiment, mixing Asian and Scandinavian influences with local materials and new techniques. In this regard, geographic isolation fueled an exploratory energy that pushed engagement with clay into new arenas.

The first seven Annuals were juried by panels composed of artists, including Victoria Avakian Ross, Betty Feves, Maija Grotell, Tom Hardy, Edith Heath, Lydia Herrick Hodge, Glen Lukens, Hilda Morris, Frances Senska and Peter Voulkos, as well as museum professionals Dr. Francis J. Newton of the Portland Art Museum and Edgar Kaufmann, Jr. of the Museum of Modern Art. For the OCS' *Eighth Biennial Exhibition of Northwest Ceramics*, the jurors widened the pool, inviting artists from across the country; the resulting exhibition included a broad range of work, from functional vessels to large, ethereal sculptures. An examination of exhibition photographs in the Museum's archives reveals dramatic shifts from small-scaled sculptures and vessels to monumental pieces that pushed the very boundaries of ceramics practice.

The 1950s were a time of discovery. OCS volunteer and exhibition director Maurine Roberts actively sought out young talent, like Finnish-born woodworker William Stromberg. During an impromptu visit to the University of Washington, Roberts and friends also came across the work of Jack Lenor Larsen, an unexpected encounter that led to Larsen's first solo exhibition held at the OCS in 1950. Rudy Autio and Peter Voulkos—students of Frances Senska—as well as artists Betty Feves, Ray Grimm, John Mason and Ken Shores were all drawn into the OCS community by Roberts and Lydia Herrick Hodge. The reputation of the small but active organization caught the attention of British ceramist Bernard Leach, who visited and exhibited at the OCS in 1951, drawing record crowds. Other exhibitions of note include Mariska Karasz, who presented her abstract needlework in 1953, and a group exhibition of the artists-in-residence from the Archie Bray Foundation for the Ceramic Arts, Montana, in 1954. These exhibitions indicate the strength of the OCS' continued relationships with international artists and important regional centers throughout the decade.

In 1952, Shoji Hamada, Bernard Leach and Soetsu Yanagi introduced the Mingei Movement to the United States through a series of lectures and workshops held from Los Angeles, California, to Black Mountain College, North Carolina. The Mingei Movement inspired the nation, prompting a shift in the way artists worked with clay: West Coast stoneware was replaced with new clay bodies, molds with potter's wheels and colorful glazes created from local sources replaced with muted earth tones, wax-resist designs and painterly applications of glazes. The introduction coincided with a counter-culture fascination with Zen Buddhism and East Asian ideas, including such explorations as Alan Watt's version of American Zen on his Berkeley, California, radio program and the writings of Beat Generation icons Allen Ginsberg and Gary Snyder. As curators Gail Gelburd and Geri DePaoli noted, "the encounter with Asian ideas resulted in new ways of seeing, new ways of being, new conceptions, and new experiences of space, time, form, void, subject and the object."[2]

During this period, groups of artists banded together to support each other in various capacities. In Seattle, Russell Day, Henry Lin, Irene McGowen, Coralynn Pence, Ruth Penington, Lisel Salzer, Hella Skowronski, Evert Sodergren and Robert Sperry created Northwest Designer Craftsmen in 1954, a guild-oriented collective created to foster high standards for craft and design. At the same time in Los Angeles, the Otis Group formed around Peter Voulkos. He and John Mason, Ken Price, Paul Soldner and Henry Takemoto produced expressionistic works that challenged the scale, functionality and traditional forms of ceramic vessels.

In 1957, the American Craftsmen's Council (now the American Craft Council) organized its first annual conference at Asilomar, California. Gathered together for the first time were attendees from forty-eight states, Afghanistan, Canada, Denmark, Finland, Japan, Mexico and Sweden: artists who had rarely—if ever—had the opportunity to meet until then. Over the course of three days, attendees discussed the socioeconomic outlook facing craftspeople, the relationship between design and technique and issues facing a range of makers, from the studio craftsman to the academic. Ken Shores and Jere and Ray Grimm attended the conference and established relationships with colleagues that continued to connect Portland with a growing international community. Today, the conference at Asilomar is considered a landmark moment in which a developing community coalesced, with the conference and its proceedings serving as the foundation for the newly defined American Craft Movement.

1. The *Annual Exhibitions of Northwest Ceramics* continued from 1950 to 1956, turning into *Biennial Exhibitions of Northwest Ceramics* from 1958 to 1964.
2. Gelburd, Gail and Geri DePaoli, *The Transparent Thread: Asian Philosophy in Recent American Art* (University of Pennsylvania Press: Philadelphia, 1990), p11.

PREVIOUS PAGE: *Seventh Annual Exhibition of Northwest Ceramics,* jurors Lydia Herrick Hodge and Richard Petterson, 1956
FACING PAGE: Jack Lenor Larsen, Jack Wright and Hal Riegger, Oregon Ceramic Studio, c. 1950. Ceramics by Riegger.

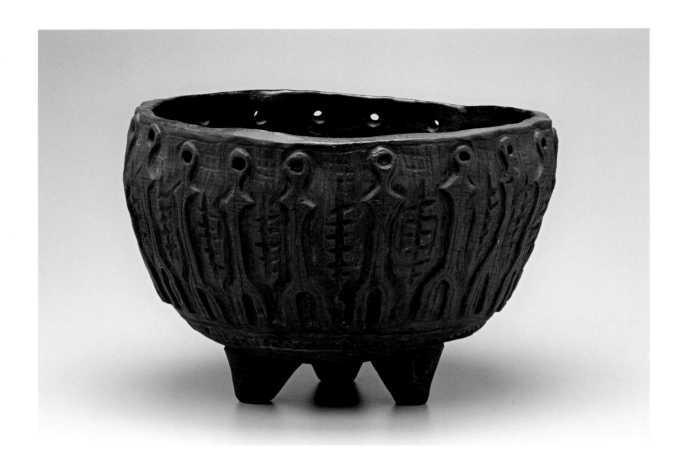

Peter Voulkos
EARLY WORK

This early piece from Peter Voulkos' student days is visibly different from his production ware of the early fifties, and from the later sculptural forms for which he is best known. The piece reveals an important shift in ceramics, both in this individual artist's practice and in the medium as a whole. Reminiscent of a "primitive" wooden vessel, *Carved Pot* shows one way in which artists began to break away from both strictly utilitarian and functional forms, and from primarily Euro-centric sources. (Voulkos' ceramics teacher, Frances Senska, was raised in Cameroon and may have introduced her students to vessels like this one.) The piece is roughly hewn and has a few structural issues that match its experimental nature. The way in which Voulkos mimics the effect of a carved wooden surface signals an active and

physical engagement with the materiality of clay, which continued to develop through the decade.

Voulkos worked as a molder apprentice at Western Foundry Company in Portland from 1942 to 1943, just prior to being drafted into the army. Following the war, Voulkos studied art on the G.I. Bill at Montana State University. There, under Senska, Voulkos switched from painting to ceramics during his senior year. His undergraduate work gained immediate attention at the *15th National Ceramic Exhibition* at the Syracuse Museum of Fine Arts (1950) and the *Second Annual Exhibition of Northwest Ceramics* at the OCS (1951).

ABOVE: Peter Voulkos, *Carved Pot*, 1951; stoneware; 10.75 × 14.5 inches diameter; Oregon Ceramic Studio Purchase, Crossroads, Inc. 1952; 1998.51.01; [*Second Annual Exhibition of Northwest Ceramics*, 1951]

Shoji Hamada/Bernard Leach
MINGEI MOVEMENT

Although Shoji Hamada's work was not exhibited at the OCS, his impact on ceramics in the Northwest—and North America—continues today. Together with Bernard Leach and Soetsu Yanagi, Hamada cofounded the Mingei Movement, a philosophical approach to pottery rooted in Zen Buddhism. Espousing a direct approach to working with materials and tools available to village potters worldwide, the focus of the movement was not to emulate folk artisans but to imbue modern ceramics with a comparable simplicity and immediacy.

The OCS exhibited Bernard Leach's *St. Ives Pottery* in 1951, one of the most challenging exhibitions presented to date at the space because of its size and importance. Organized by Contemporary Arts, Washington, DC, the exhibition required opening OCS on Sundays for the first time in order to accommodate record attendance. Several important pieces sold, including two works purchased by the Portland Art Museum.

In a historic tour during 1952 and 1953, Shoji Hamada and Bernard Leach lectured to crowds from Los Angeles, California, to Black Mountain College, North Carolina, introducing the Mingei Movement to American audiences. Emphatic that any significant work begins with strong form, Hamada demonstrated a range of glaze applications, from deft calligraphic marks to the artfully manipulated dripping of glaze from a ladle. This plate, produced during one of these influential workshops, uses Hamada's trademark *tenmoku* iron glaze as the

background for gestural and painterly brushstrokes—a quickly executed treatment that suited the rapidity of a workshop environment. *Water Vessel*, by contrast, takes its shape from vessels traditionally used in Japanese tea ceremonies, modeled by Hamada after the forms and glazes used by anonymous craftsmen of centuries past.

BELOW, TOP: Shoji Hamada, *Untitled water vessel*, date unknown; ceramic; 7.25 × 7 inches diameter; Promised gift from Carol and Seymour Haber

BELOW, BOTTOM: Shoji Hamada, *Untitled plate from workshop*, c. 1952; ceramic; 2 × 11 inches diameter; Promised gift from Carol and Seymour Haber

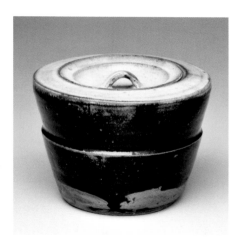

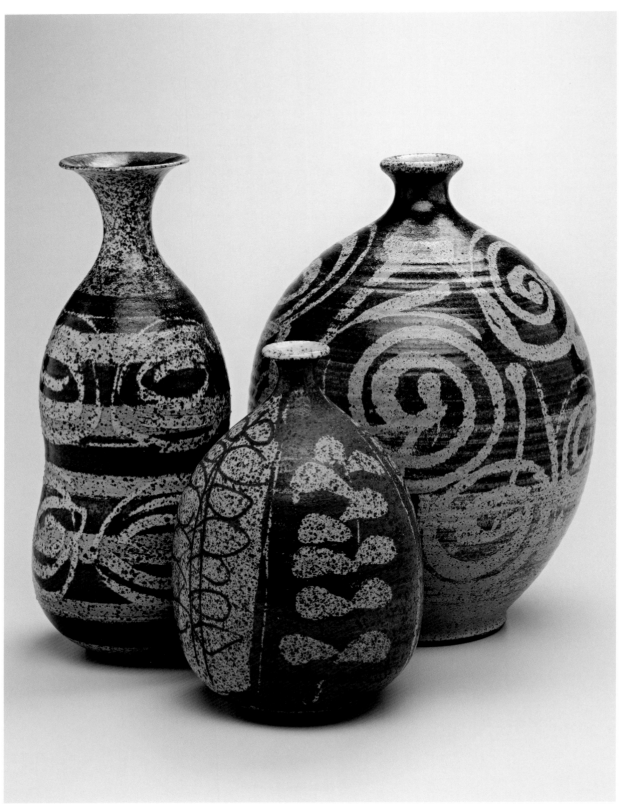

Peter Voulkos
PAINTERLY GESTURES

Voulkos completed his master's degree at the California College of Arts and Crafts in Oakland (now California College of the Arts), where he studied with Antonio Prieto. Known for tightly formed vessels that combined elegant, rounded silhouettes with a mixture of layered surface treatments, Prieto's influence can be seen in both the shapes and the layered glaze patterns on these vessel forms; the palette, however, is more reminiscent of Frances Senska's natural tones. Voulkos used a wax resist method with earthy glazes, applied in painterly swirls that radiate energy in sharp contrast to the tightly thrown vessels popular at the time. Here, the expressionistic application of the strokes feels barely contained on the surfaces of the forms—a precursor to the physically expressive approach to clay Voulkos developed in the mid-fifties.

FACING PAGE (L TO R): Peter Voulkos, *Gourd Shaped Vase*, 1952; clay; 15.75 × 21 inches diameter; Gift of Dr. Francis J. Newton; 1998.93.47 [*Third Annual Exhibition of Northwest Ceramics*, May 1952]

Vase with Leaf, 1952; stoneware; 11 × 6 × 4 inches; Gift of Rose Fenzl; 2001.10.01

Green Swirls Vase, 1952; stoneware; 15 × 10 inches diameter; Osmon B. Stubbs Memorial Award Recipient; 1998.52.03 [*Third Annual Exhibition of Northwest Ceramics*, May 1952]

Frances Senska
FUNCTIONAL TABLEWARE

Stationed in San Francisco during World War II, Frances Senska rediscovered her love of clay while taking evening classes from Edith Heath, founder of Heath Ceramics. Senska later studied ceramics under Maija Grotell, Lazlo Moholy-Nagy, Hal Riegger and Marguerite Wildenhain, each of whom had a distinctive aesthetic and philosophical approach to functional forms for daily living. Senska, in turn, taught Rudy Autio and Peter Voulkos, two artists who changed the way ceramics were used—and ultimately viewed—in twentieth-century art.

Senska still creates tableware for daily use, focused on simple shapes in an earth-tone palette. Her clay of choice is stoneware—not porcelain—as the raw material for her serving dishes, vases, pitchers, cups and other vessels. These merge form and function with an aesthetic derived from functional pottery recalled from her childhood in Cameroon, West Africa, and from the natural surroundings of her adult home in Montana.

ABOVE (L TO R): Frances Senska, *Untitled black bottle*, 1952; stoneware; 12 × 4.25 inches; Oregon Ceramic Studio Purchase; 1998.52.02 [*Third Annual Exhibition of Northwest Ceramics*, May 1952]

Ray Bowl, 1954; ceramic; 2.25 × 10.5 inches diameter; Unknown Gift; 1998.54.01

Peter Voulkos
BUILDING THE BRAY

In 1951, Archie Bray, Peter Meloy and Branson Stevenson established the Archie Bray Foundation for the Ceramic Arts in Helena, Montana, located on the site of the former Western Clay Manufacturing Company. Rudy Autio and Peter Voulkos, along with Frances Senska and Kelly Wong, helped construct the facility's kilns and buildings and established an artist-in-residence program that continues to serve as an active center for artists working in clay.

Voulkos began his professional career producing dinnerware and functional forms and won numerous awards in annuals and biennials on both coasts. This piece was created during a period in which Voulkos' ideas about ceramics and art were in flux. After teaching a summer workshop at Black Mountain College, North Carolina, in 1953, Voulkos began to consider how to use ceramics as an artistic medium that stretched the strict functionality for which it was best known. In 1954, he accepted a teaching position to establish a ceramics program at the Los Angeles County Art Institute (known today as Otis College of Art and Design). Here, Voulkos' work moved away from this type of refined form into abstract and expressionistic explorations that *Craft Horizons* editor-in-chief Rose Slivka would later define as "The New Ceramic Presence."[1]

1. Slivka, Rose, "The New Ceramic Presence," *Craft Horizons* (July–August, 1961), p30–37.

FACING PAGE: Peter Voulkos, *Striped Vase*, c. 1953, earthenware; 13.75 × 11 inches diameter; Gift of Ruth Halvorsen; 1998.93.46 [*Fourth Annual Exhibition of Northwest Ceramics*, May 1953]

RIGHT: Betty Feves, *Three Figures No. 4*, 1955; stoneware; 18 × 12 × 6 inches; Oregon Ceramic Studio Purchase, Osmon B. Stubbs Memorial Award, 1955; 1998.55.02 [*Sixth Annual Exhibition of Northwest Ceramics*, May 1955]

Betty Feves
EARLY MODERN INFLUENCES

Following several years of art school in New York City, Washington-born Betty Feves settled in Pendleton, Oregon, in 1945. Influenced by Cubism and early Modernist approaches to form and abstraction, Feves' exploration of positive and negative space and the relationships between the form of the body and the natural landscape are reminiscent of Henry Moore; however, Feves deliberately focused on clay. Using hand-building and slab techniques, her direct working method resulted in a textured, "primitive" quality that incorporated her personal response to the natural terrain and the palette of the central Oregon landscape. Her later work involved the stacking of hand-built clay forms—Modernist "totems" along the lines of Barbara Hepworth. An active exhibitor in the 1950s, including exhibitions at MoMA and in Europe, Feves played an important role in shifting the recognition of ceramics from a strictly functional enterprise to an artistic and expressive medium, moving on to architectural installations in later decades.

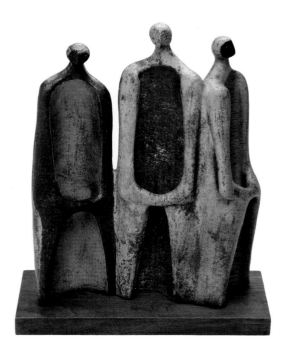

The Weed Pot

All of these vases are domestic in scale, but none are truly functional as containers for most types of flowers. Since the fifties, this vessel form has taken on the nickname "weed pot," indicating that only a small dried weed could be displayed in it. While these forms seem commonplace today, it is important to consider that artists and art students were exploring this type of wheel-thrown vessel form for the first time in U.S. academies in the 1950s. These three examples by Peter Voulkos, Antonio Prieto and Eric Norstad reveal some of the ways artists were creating individual approaches to this vessel form, connecting it to Modern art, aesthetics and architecture.

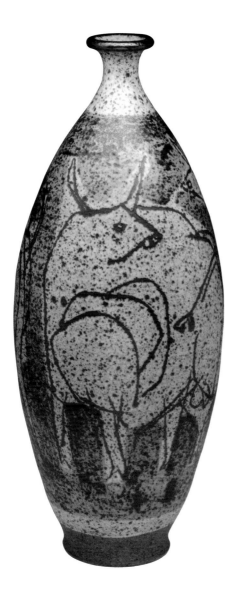

PETER VOULKOS

Employing the palette and wax-resist glaze techniques for which resident artists at the Archie Bray Foundation were known at the time, Voulkos merged a stylized drawing derived from the Caves of Lascaux with the story of Babe the blue ox, tall-tale hero and Paul Bunyan's companion. This vessel shows Voulkos' skill at moving clay to create soaring, slender forms.

LEFT: Peter Voulkos, *Babe the Blue Ox*, 1954, ceramic; 30 × 7 inches diameter; Oregon Ceramic Studio Purchase Award, Archie Bray Foundation, 1954; 1998.54.02 [*Fifth Annual Exhibition of Northwest Ceramics*, May 1954]

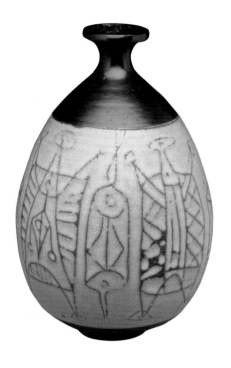

ANTONIO PRIETO

Trained at New York State College of Ceramics at Alfred University, Prieto's work linked early Modernist interests in primitivism with an artisanal approach to functional vessel forms. Prieto's strong blocks of color and drawing scratched into the glazed surface (*sgraffito*) are reminiscent of Paul Klee and early twentieth-century Surrealist drawings. Personal friends with Rafael Canogar, Shoji Hamada, Bernard Leach, Pablo Picasso and Antoni Tapies, Prieto's charismatic energy and teaching style connected his students with an international art community. The San Francisco Bay Area functioned as an incubator during this period—with teachers like Prieto in Oakland and later Voulkos in Berkeley—catalyzing critical changes in the way ceramics were both taught and made.

LEFT: Antonio Prieto, *Untitled vase*, c. 1956; ceramic with sgraffito; 12 × 7 inches diameter; Gift of the Margaret Murray Gordon Estate; 2004.10.08

ERIC NORSTAD

A graduate of the University of Oregon School of Architecture and Allied Arts, Eric Norstad studied ceramics under Victoria Avakian Ross. Norstad also worked as an architect in both Washington and California. As the place for the artisan shifted from religious and church architecture to the Modern, mid-century home, Norstad was one of several West Coast artists who specifically created handmade, functional and accessibly-priced work to fit this new domestic environment. While handcrafted vessels are typically discussed in separate terms from the industrial designs that dominated the aesthetic of the Atomic Age, Norstad's gently rounded, carved patterns reveal a synthesis of these disparate but concurrent cultural motifs.

RIGHT: Eric Norstad, *Untitled carved bottle*, 1956; stoneware; 13 × 9 inches diameter; Osmon B. Stubbs Memorial Award Recipient; 1998.56.02 [*Seventh Annual Exhibition of Northwest Ceramics*, May 1956]

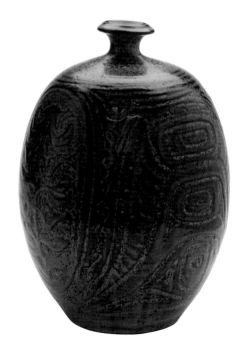

William Stromberg
GOOD DESIGN

William Stromberg left Finland by sea in 1914, jumped ship in San Francisco in 1916 and made his way to Coos Bay, Oregon, where he became a high rigger in the logging industry. Nicknamed "High Lead Bill," a shipyard accident in 1942 left Stromberg with a broken back, paralyzed legs and damaged elbows. After a year of hospitalization, Stromberg turned to a former lumber-camp hobby of whittling to make a living. Using wood scraps provided by friends, he created Finnish-style utensils—serving spoons and forks reminiscent of forms he recalled from his youth. Elegant, simple and unusual at the time, they caught the attention of Maurine Roberts, volunteer and exhibition director at the OCS. Stromberg's salad sets, similar to these in the Museum's collection, became popular additions to the OCS sales gallery.

Roberts introduced Stromberg's work to a national audience, leading to its inclusion in *Good Design*, organized in 1952 by the Museum of Modern Art for the Merchandizing Mart in Chicago. The first shipment of Stromberg's work was stolen from the exhibition. The second set, rushed to Chicago after the receipt of an urgent telegram, was stolen as well. Nevertheless, orders poured in from Georg Jensen, Billy Baldwin of Baldwin-Machado Interior Design, *Better Living Magazine*, Associated Merchandizing Corporation, and the department stores Frederick & Nelson, Bleazby's and Bloomingdales, among others. Overwhelmed by this response and the loss of two full orders, Stromberg became physically ill, and decided to focus his limited energy on filling orders exclusively in the Pacific Northwest. However, Stromberg's work did appear in the *Good Design: 5th Anniversary* (1955) in Chicago along with Herbert Bayer, Harry Bertoia, Hugo Dreyfuss, Charles Eames, Arne Jacobsen, Finn Juhl, Jack Lenor Larsen, Raymond Loewy, George Nelson, Lucie Rie, Eero Saarinen, Peter Voulkos, Hans Wegner and Russel Wright.[1]

1. From the Museum of Contemporary Craft Archives. Edgar Kaufmann, Jr., then director of the Department of Industrial Design, MoMA, initiated the national *Good Design* program, in operation from 1950 to 1955.

BELOW: William Stromberg, *Untitled salad utensils*, 1952; wood; 10 × 2 × 1.25 inches; Gift of Maurine Roberts; 1998.74.05 A,B

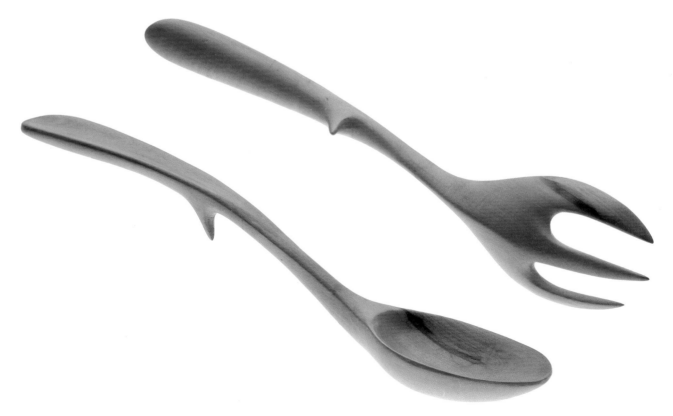

Jack Lenor Larsen
DESIGNER CRAFTSMAN

Originally woven by hand, this length of fabric combines a wide range of yarn types, each with individual widths, tensile strength and elasticity. Weaving such a piece by hand, particularly in a randomly repeated pattern that enhances the tactility of the finished work, is quite complex. When production exceeded Larsen's ability to weave such fabric by hand in order to meet market demands, he employed a textile engineer to translate the work into an industrially manufactured product, a process he repeated throughout his career. This process established him as a postwar pioneer in the field of interior textiles. Over the years, Larsen incorporated techniques from around the world into his product line, merging Western and non-Western approaches to textiles created specifically for modern architectural environments, filling a niche for craftsmanship in what was then an emerging market.

Larsen studied architecture and furniture design at the University of Washington. After discovering his work in a student exhibition, Maurine Roberts immediately invited Larsen to exhibit at the OCS in 1950, the first solo exhibition of his career. A student of Ed Rossbach and later Marianne Strengell, Larsen used materials popular at the time for weaving wall hangings and window treatments in unusual and unexpected patterns, combining, for example, bamboo with a range of yarns and weaving techniques. Influenced early in his career by Seattle-based Hella Skowronski, who was creating textiles that complemented the architecture of mid-century buildings and homes in the Pacific Northwest during the fifties, Larsen defined himself as a "designer craftsman," a term used by many people of his generation to differentiate studio artists from designers, and handicrafts from the work being made by craftspeople associated with the emerging American Craft Movement.

ABOVE: Jack Lenor Larsen, *Remoulade* (details), 1954; machine-woven linen, cotton, silk; 108 × 50 inches; Gift of Hal Cary; 1998.91.34

John Mason
EMERGING TALENT

Modestly scaled in comparison to Mason's well-known, large, handbuilt clay sculptures—monumental cross-shaped and mathematically derived geometric forms—this piece reveals an early exploration of the physical and plastic properties of clay. Deeply influenced by Abstract Expressionist painting, Mason engaged in a similar gestural approach in the creation of this sculpture. Here, he slices and pulls apart pieces of stoneware, covering the object with oozing, icinglike glaze. Despite its small scale, *Blue Cube* exudes the power of an unseen natural force splintering and spreading the form apart. Associated with the legendary Ferus Gallery in Los Angeles, Mason is one of many significant artists who reshaped perceptions about clay's ability to function in an avant-garde context.

In a letter to Lydia Herrick Hodge, dated October 10, 1956, Peter Voulkos wrote that John Mason was "the best new talent I have run into in this country."[1] A studio mate of Voulkos' and a student of Susan Peterson, Mason was also an active participant in the Otis Group, a community of artists in Los Angeles who pushed each other to create new approaches to working with clay.

1. Correspondence between Peter Voulkos and Lydia Herrick Hodge, from the Museum of Contemporary Craft Archives

FACING PAGE AND BELOW: John Mason, *Blue Cube*, c. 1956; stoneware; 3.75 × 6.25 × 5 inches; Unknown Gift; 1998.57.01

Creating a Community

TOM HARDY

At Lydia Herrick Hodge's encouragement, Tom Hardy's parents supported his pursuit of art at the University of Oregon, where he studied under Victoria Avakian Ross. A frequent exhibitor and the first unofficial artist-in-residence at the OCS, Hardy's *Romney Ram* (not pictured) earned the top prize in the *First Annual Exhibition of Northwest Ceramics* (1950), and was later donated to the Portland Art Museum.

Hardy shifted his focus from ceramics to metal while pursuing his MFA at University of Oregon. By 1955, his work was exhibited in the Whitney Biennial of American Art, the San Francisco Museum of Modern Art and frequently at the OCS. In addition, he received many large public commissions throughout the Pacific Northwest. Deeply connected to his family's ranch, abstracted animal forms dominated much of Hardy's early work, from his small sculptures to large public commissions, including this small bull with its strong, proud personality.

BELOW: Tom Hardy, *Metal Bull Sculpture*, c. 1958; rusted steel; 6 × 9 × 3 inches; Gift of Hal Cary; 1998.91.24

FACING PAGE, TOP: Ken Shores, *Tall Goblet*, c. 1960; ceramic; 13 × 9 inches diameter; Gift of Ruth Halvorsen; 1998.93.40

FACING PAGE, BOTTOM: Ray Grimm, *Don Quixote*, 1956; stoneware; 1 × 6.5 inches diameter; Unknown Gift; 1998.59.01

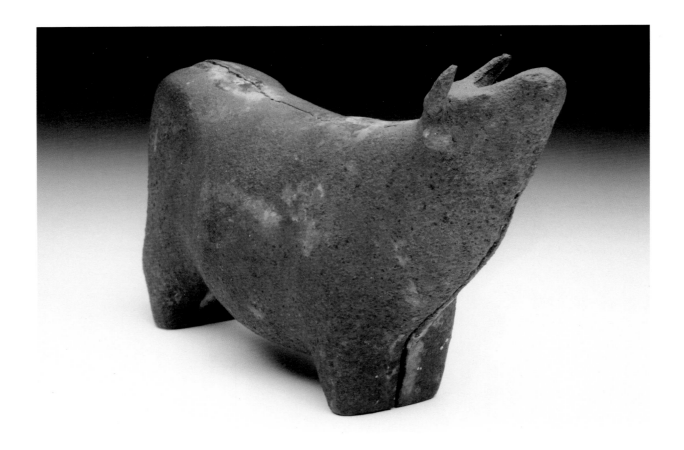

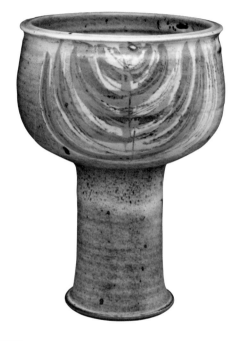

During the summers of 1955 and 1956, Shores attended workshops at Pond Farm where he learned to throw on a potter's wheel from Marguerite Wildenhain. Spending hours a day throwing cylinders under Wildenhain's guidance clearly impacted his early forms, palette and style of mark-making. The oversized proportions of this piece, however, indicate Shores' interest in the sculptural aspects of vessel forms over the desire for functionality.

Shores graduated from the University of Oregon with an MFA with Honors in Ceramics, where he studied under Victoria Avakian Ross. Skipping graduation to attend the First Annual Conference of American Craftsmen at Asilomar, California, in 1957, he immediately moved to Portland to take a position as the Studio Technician/artist-in-residence at the OCS. Shores served as acting director of the OCS from 1960 to 1964, and as the first paid director from 1965 to 1968. As director, Shores initiated a change in the name of the organization from the OCS to Contemporary Crafts Gallery (CCG), expanded the facility's exhibition space and made sure Portland remained connected to a national community through his service on the board of the American Craft Council. In 1968, Shores left CCG to take a teaching position at Lewis & Clark College in Portland, where he taught for nearly thirty years.

RAY GRIMM

Ray and his wife, sculptor and ceramist Jere Grimm, arrived in Portland in 1957 to establish the ceramics program at Portland State University, where Ray Grimm taught from 1957 to 1988. Grimm's experiments with replication of Chinese glazes—particularly Chun Dynasty blues—brought new techniques to the growing clay community in Portland. His *Don Quixote* plate reveals how Grimm merged his signature blue glaze with a Modern aesthetic. Grimm's presence in Portland also signals an important shift in an increasingly interconnected academic ceramics community. Grimm studied ceramics under F. Carleton Ball, who in turn studied under Glen Lukens at the University of Southern California, Los Angeles, connecting prewar and postwar ceramics. Grimm is also one of many ceramic artists who began working with glass after attending workshops in the early 1960s with Dominic Labino and Harvey Littleton. Grimm later created the Glass Shack, one of the first studio-glass spaces in Portland in 1972.

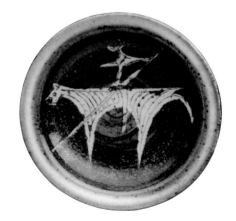

1960s
A New
Ceramic
Presence

When Lydia Herrick Hodge passed away in 1960, there was concern that the OCS was too linked to her to survive. Artist-in-residence Ken Shores unofficially led the institution from 1960 until he became its first paid director in 1964. Shores and David Pugh, Board president and a partner at Skidmore, Owings and Merrill, led two major institutional changes that same year. To more clearly communicate the breadth of work exhibited and sold, the OCS was renamed Contemporary Crafts Gallery (CCG). The kiln room was dismantled and the sale of clay and the firing of children's work discontinued as other places in the city emerged to support those needs. Architect Richard Norman and landscape architect Richard Ellis were hired to enlarge and remodel the building, converting vacant spaces into additional exhibition areas, and revitalizing the building's exterior.

Renewed energy—a byproduct of all this activity—strengthened CCG's national connections to the American Craftsmen's Council (now the American Craft Council) and the rapidly growing community of studio artists linked to the American Craft Movement. Exhibitions such as *Northwest Regional Exhibition of Craftsmen USA '66*, juried by Toshiko Takaezu for the American Craftsmen's Council, linked regional artists to the national community. Select artists from the aforementioned exhibition were also included in an exhibition at the Museum of Contemporary Crafts, New York City (renamed Museum of Arts and Design in 2002). The decade ended with *Young Americans* (1969), also organized by the ACC, a touring exhibition designed to introduce a new generation of craftspeople to the nation.

Craft Horizons (now *American Craft*) continued to serve as a primary resource for the American Craft Movement, catalyzing change and instigating dynamic conversations through such essays as Rose Slivka's "The New Ceramic Presence," (July/Aug 1961). Slivka argued that a significant change was occurring in ceramics at the time, a "new emphasis...[on] the excitement of surface qualities—texture, color, form—and to the artistic validity of spontaneous creative events during the actual working process."[1] The expressionism she describes began in the midfifties when Peter Voulkos started deconstructing the vessel—a gesture that had a ripple effect, expanding into a movement that includes the work of Ken Shores, Robert Sperry and others. As ceramics shifted from a strictly functional to both a functional and conceptual medium, this movement was the first of several to separate the ceramics community into various overlapping segments, from functional potters to studio craftsmen, studio artists to conceptual practitioners.

In the mid-sixties, West Coast Funk was identified and named by art historian Peter Selz, based on an exhibition organized at the University of California at Berkeley Art Museum. Robert Arneson, Margaret Dodd, David Gilhooly, Chris Unterseher and Peter Vandenberge were just a few of the artists first identified with this movement. Erik Gronborg, who taught ceramics

at Reed College from 1965 to 1969, organized an exhibition of Funk ceramics at the College. The controversial exhibition closed before it opened in response to the scatological content of one of Arneson's pieces. West Coast Funk, with its irreverent sarcasm and commentary on the state of ceramics, differed a bit from the Super Object ceramics of Seattle-based Fred Bauer and Patti Warashina. Whereas Arneson's work took a deliberate, in-your-face turn, Bauer and Warashina's work remained pleasing to the eye, toeing a delicate line between the history of decorative arts and conceptual practice.

While CCG continued to connect with a range of communities—local, regional and national—the focus of exhibitions fell primarily within the bounds of the American Craft Movement. Exhibitions of work by Bauer, Gronborg, Kottler and Warashina connected ceramics to contemporary art-world concerns, but most of CCG's exhibitions and audience remained connected to a worldview that primarily focused on American revisions of vernacular and folk traditions from a range of global sources, with a bit of conceptual bleed-over. Exhibitions generally presented work that pleased rather than provoked, operating outside the concurrent Pop, Op and Minimalist concerns that prevailed in the contemporary art world.

In 1968, Shores resigned as director of CCG, taking a teaching position at Lewis & Clark College, Portland, where he continued to teach for nearly thirty years. Gordon Smyth, an interior decorator with strong interests in emerging artists, became director and led the organization from 1968 to 1973.

1. Slivka, Rose, "The New Ceramic Presence," *Craft Horizons* (July–August, 1961), p33.

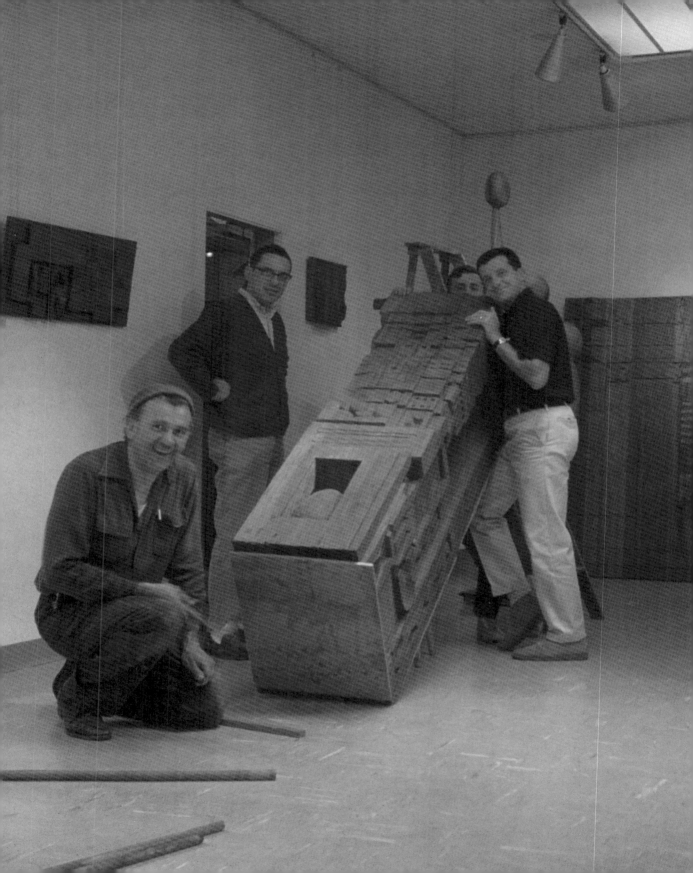

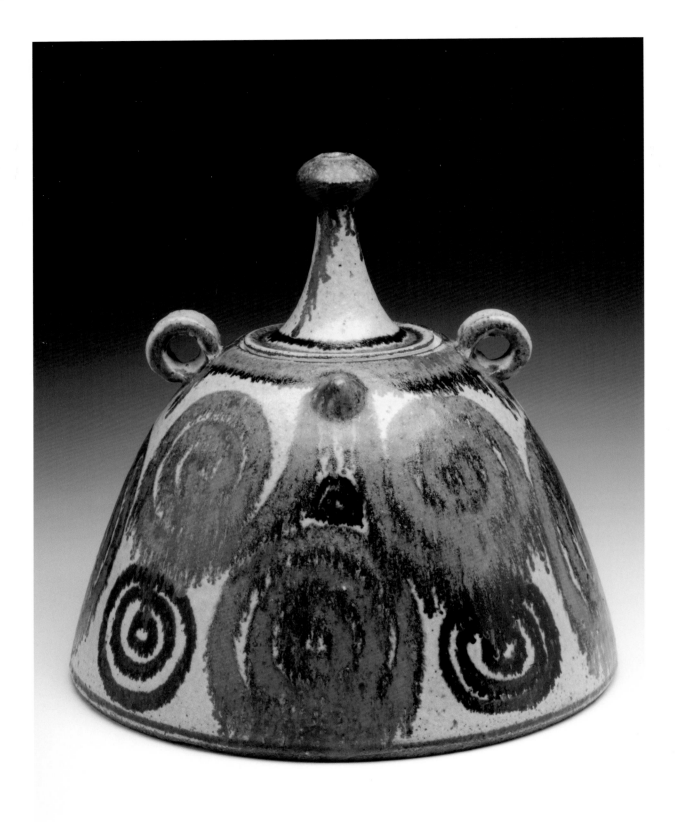

Robert Sperry
ACTIVATING SURFACES

Designed to evoke the forms of traditional Chinese vessels, the surface of Robert Sperry's *Warrior Urn #2* is activated by dripping swirls and whorls, recalling both the watery palette and style of glaze application similar to that used during the T'ang Dynasty and Abstract Expressionism, which dominated American art in the 1950s. Sperry is an example of a generation of ceramic artists twice removed from practitioners who self-identified as potters. His contemporaries, including Rudy Autio, Ken Ferguson, Peter Voulkos and others, were educated in similar environments. This group of artists occupied a liminal space in which process and production remained rooted in the studio, but to focus on form and function were deliberate and individual choices. Thus, they were, in a sense, marginalized from the broader art world, which had began turning to more conceptual concerns, as well as from object makers who operated purely in a production model.

FACING PAGE: Robert Sperry, *Warrior Urn #2*, 1960; stoneware; 19.25 × 13 inches diameter; Gift of Ed Cauduro; 1998.67.01 [John Howard Connolly Award, *Ninth Biennial Exhibition of Northwest Ceramics*, 1960]

BELOW: Rudy Autio, *Enormous Jar*, 1954; ceramic; 40 × 24 inches diameter; Oregon Ceramic Studio Purchase, George T. Gerlinger Memorial Award Fund, 1960; 1998.60.01 [*Ninth Biennial Exhibition of Northwest Ceramics*, May 1960]

Rudy Autio
PAINTING AND THE VESSEL

Enormous Jar is a glimpse at Rudy Autio's early exploration of the relationship between painting and the vessel. Here, painted lines accentuate the jar's bulging center, encouraging—even requiring—physical movement around the object as the eye follows lines painted in glaze across its surface. Autio furthers this effect in later works, merging painting and ceramics into sculptures in which a hollow, columnar base is pulled and morphed into organic planes. While many vessels from this period can be understood from a fixed frontal position despite their dimensionality and scale, Autio's work cannot. He uses form and surface to physically engage the viewer, instigating the experience of multiple perspectives as one circumnavigates a path around his sculpture. The integrity of the vessel form is not lost but extended into a different kind of investigation of space. It is believed that Autio created this piece at a University of Washington workshop and donated it to the OCS collection because it was too big to transport back to Montana. Frequently on view in earlier decades, OCS volunteers stuffed *Enormous Jar* with paper to prevent a neighborhood cat from taking up residence inside.

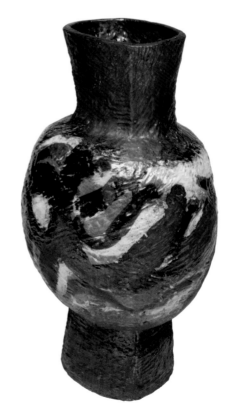

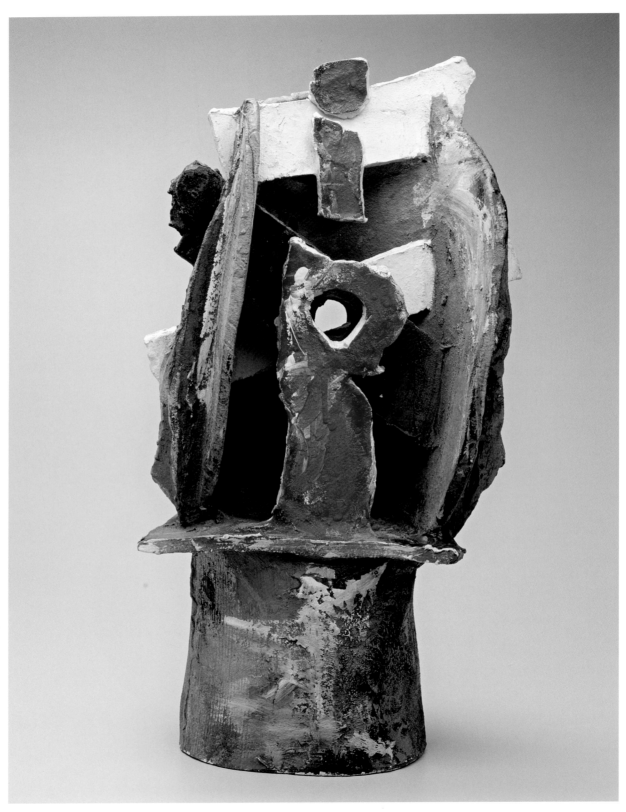

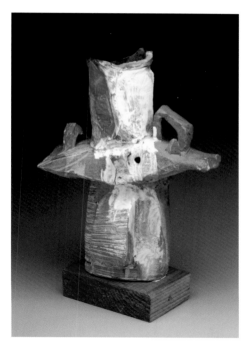

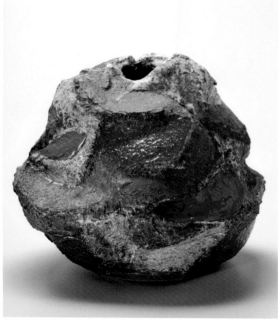

Deconstructing the Vessel
KEN SHORES, PETER VOULKOS AND ROBERT ARNESON

Grouped together, these three works demonstrate the dynamic deconstruction of the vessel form as discussed in Rose Slivka's article "The New Ceramic Presence," published in *Craft Horizons* in July/August 1961. Her controversial article called public attention to artists who were simultaneously activating both the vessel's surface and form, rather than simply making a form and painting glaze on top of it. Drawing parallels to the way Abstract Expressionism activated the surface of the canvas and explored "art for art's sake," Slivka's ideas can be extended to consider how Shores, Voulkos and Arneson explored *clay for clay's sake.*

Ken Shores fragments the vessel into an architectural grouping of slabs through which the viewer can peer to the other side. Shores breaks the boundaries of clay materials even further by using paint—an idea that stemmed from his travels in South and Central America. Using paint in ceramics was highly controversial at the time, as many believed in the purity of materials—that the color of clay objects should come solely from glazes.

Voulkos' work reveals the energy used to build the form and then deconstruct it. Everything about the piece speaks of working intuitively and quickly—even the thick brushstrokes of glaze applied to its surface. The application of handles returns the hollow cylindrical base to the role of a vessel, while simultaneously raising questions about when a vessel functions as a sculpture versus a utilitarian object.

Both Voulkos and Robert Arneson studied with Antonio Prieto, from whom they learned to make tightly formed vessels in a Chinese-derived Modernist idiom. Here, however, Arneson smacks, bangs and pushes the vessel into a shape that visibly and physically resembles the mud and clay from which it is formed. Marked in an almost tribal-like manner, red and yellow glaze prevents the object from being simply "a rock" and exaggerates the planar portions of the deliberately distorted vessel.

These works challenge the integrity of functional form itself as much as the relationship between form and surface, pushing materials to act as more than mere decoration or surface treatment, demonstrating the range of ways in which clay can be manipulated without denying the origins of the medium.

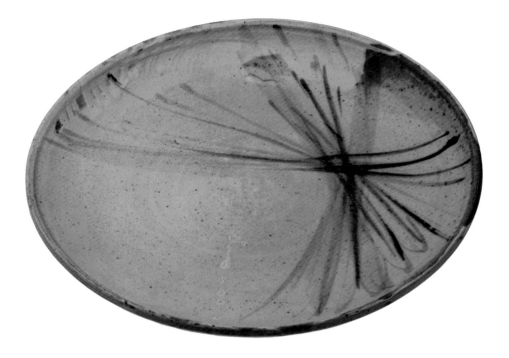

Ken Ferguson
CONNECTIONS TO THE BRAY

Ken Ferguson brought *Yellow Plate* directly from the Archie Bray Foundation for the Ceramic Arts to the OCS for the *Tenth Biennial Exhibition of Northwest Ceramics* (1962)—price sticker included! While the piece is quite different from the contemporaneous expressionistic work of Robert Arneson and Peter Voulkos, the way in which Ferguson selectively glazes only portions of the plate's surface reveals a comparable interest in material properties.

Years of functional work and contact with visiting artists while serving as the resident potter and manager of the Archie Bray Foundation provided Ferguson with vast technical knowledge. Ferguson left the Bray to head the ceramics program at the Kansas City Art Institute from 1964 to 1996. Ferguson is considered one of the most influential teachers of his generation. His students include John Balistreri, Cary Esser, Andrea Gill, Richard Notkin, Chris Staley, Akio Takemori, Kurt Weiser and many others.

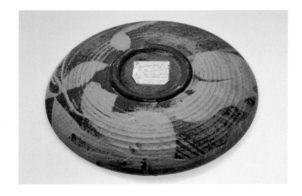

ABOVE AND LEFT: Ken Ferguson, *Yellow Plate*, 1962; wheelthrown stoneware, reduction fired, with yellow glaze and iron oxide; 2.5 × 18.5 inches diameter; Oregon Ceramic Studio Purchase, Archie Bray Foundation, 1962; 1998.62.04 [*Tenth Biennial Exhibition of Northwest Ceramics*, May 1962]

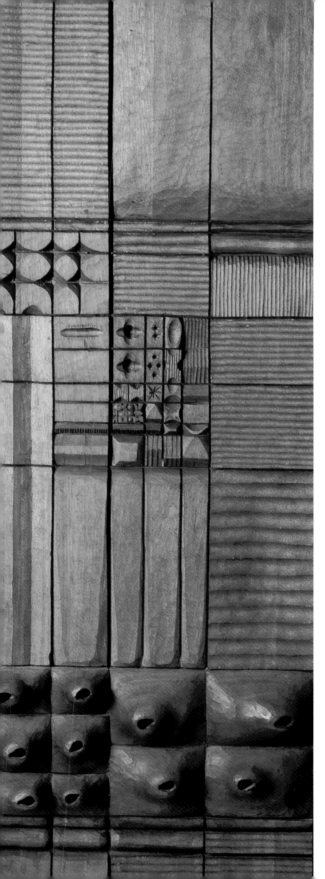

Leroy Setziol
PROJECTING A NORTHWEST AESTHETIC

Known for working in a variety of sculptural forms, self-trained woodcarver Leroy Setziol often employed a tight grid structure in which geometric patterns integrated with organic forms, revealing the wood's natural textures and grain. Merging European Modernism with diverse sources, such as carvings Setziol saw while serving as a U.S. Army Chaplain in the South Pacific, the artist experimented with a range of media, but teak remained his material of preference.

This is one of a pair of doors that once greeted visitors to the Museum's original home at 3934 SW Corbett Avenue, just down the street from Setziol's original studio. In 1964, developer John Gray commissioned Setziol to create fourteen relief panels for Salishan Lodge on the Oregon coast, a luxury resort and golf retreat that introduced countless visitors to the state and the artist's work and, for many, helped define a Northwest aesthetic. Setziol's larger public works can be found in numerous hospitals, churches and libraries across the state, and his functional wares still reside in numerous homes throughout the area.

ABOVE AND LEFT: Leroy Setziol, *Teak Door*, 1966; teak; 7 × 3 feet; Contemporary Crafts Gallery Purchase; 1998.66.01

Joe and Linda Apodaca
SCANDINAVIAN-STYLE HOLLOWWARE

Joe and Linda Apodaca studied metals at the Rochester Institute of Technology in upstate New York under noted Danish silversmith Hans Christensen, a former apprentice to Georg Jensen. Clearly influenced by Scandinavian design, these hollowware pieces from their student years skillfully blend silver and rosewood in a material approach that continues in the Apodacas' jewelry today. Starting with a single sheet of silver, these vessels and bracelet were created by heating, shaping and raising metal through a combination of stakes and forms. To achieve such a perfectly mirrored surface despite the pounding required to create these forms hints at the depth of the Apodaca's technical prowess.

The Apodacas exhibited frequently in the late sixties and early seventies. Joe's work was included in *Objects: USA* (1969) among other exhibitions. Exhibitions did not, however, lead to commissions and the financial stability needed to support the Apodaca's growing family. In fact, it became difficult for most metalsmiths to earn a living in the United States by making impeccably crafted, handmade silver tableware as entertaining grew increasingly more casual, and the investment of time and materials did not match the price the general public was willing

to pay. In 1978, the couple moved to Portland, where Joe chaired the metals program at the Oregon School of Arts & Crafts (now Oregon College of Art and Craft) from 1979 to 1985. Committed to making a living through their work, both artists continue to create jewelry and hollowware by commission.

ABOVE: Linda Apodaca, *Casserole*, 1967; sterling silver, rosewood; 6.5 × 11.5 × 5.75 inches; Promised gift from Joe and Linda Apodaca

BELOW: Linda Apodaca, *Untitled bracelet*, 1967; 10K sterling silver, 10K gold wire, cultured pearls; 2.75 × 3 × 1 inches; Gift of Joe and Linda Apodaca; 2007.07.02

FACING PAGE: Joe Apodaca, *Coffee Pot*, 1963; sterling silver, rosewood; 12 × 6 inches diameter; Promised gift from Joe and Linda Apodaca

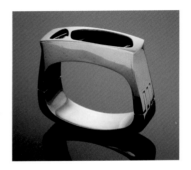

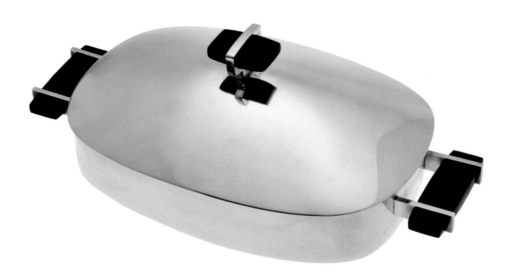

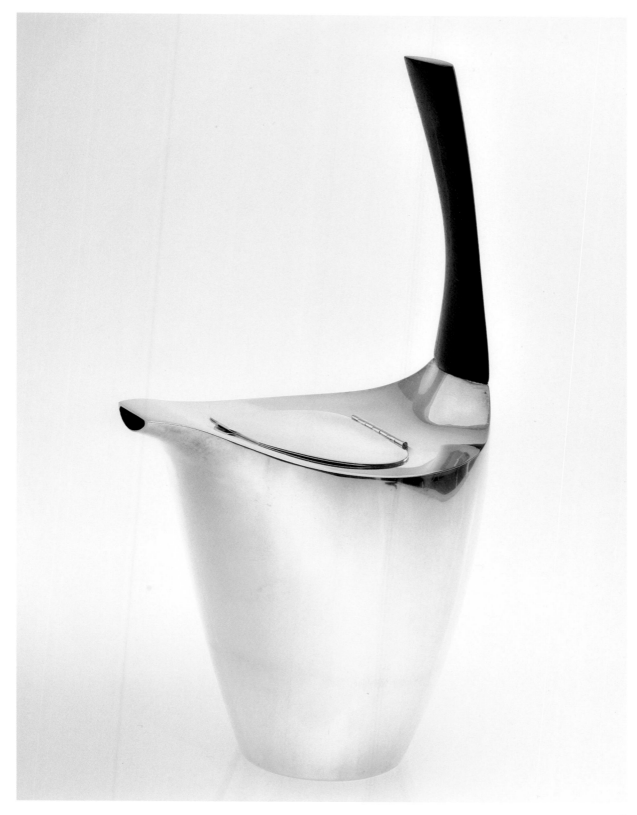

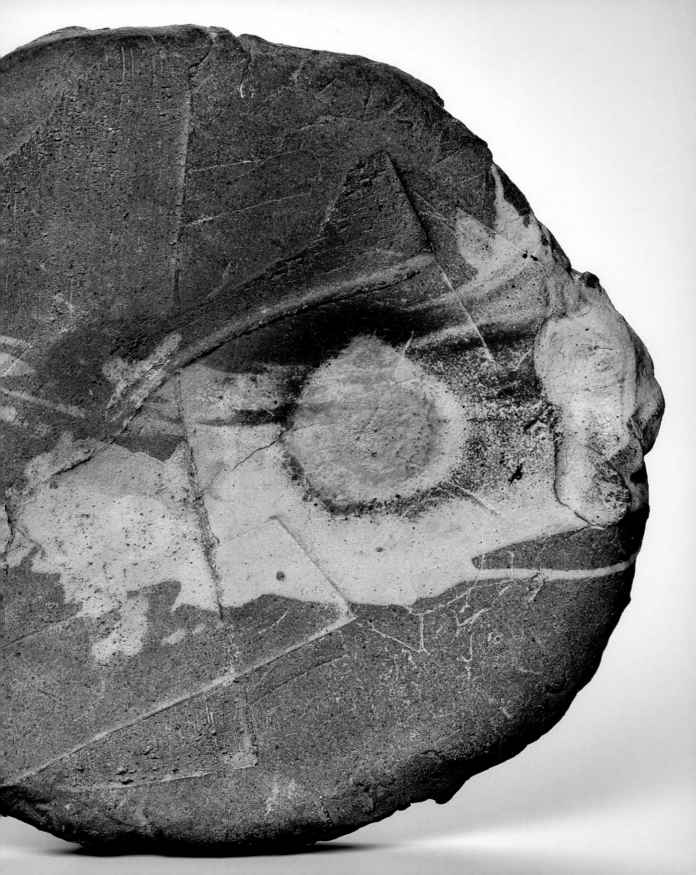

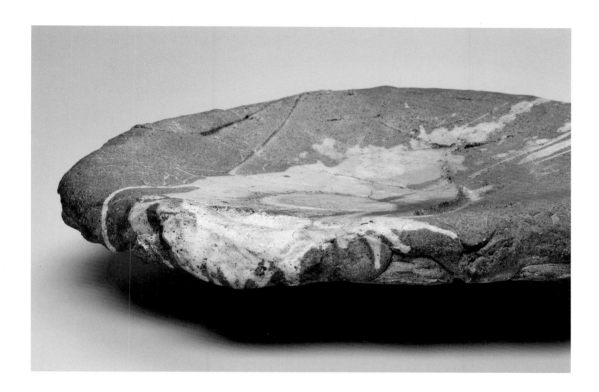

David Shaner
LAND ART

Created during David Shaner's tenure as resident director of the Archie Bray Foundation for the Ceramic Arts, *Garden Slab* is a sensual, personal and physical response to Glen Canyon, Utah: a harsh, dry landscape spotted by tranquil pools. Shaner shaped his materials to convey the mass and heaviness of this landscape, using puddles of glaze as liquid relief. *Garden Slab* provides an interesting, alternative approach to that of other contemporary artists interested in the environment during the sixties. Whereas Robert Smithson's *Spiral Jetty* (completed in 1970), for example, is a grand, sweeping and theatrical gesture, Shaner's work offers the viewer a quiet yet equally contemplative experience. Shaner intentionally created work in a realm between the potter (who peddles his wares at street fairs) and the artist (who creates work for the pedestal). Today, this

places the work in the midst of a critical conundrum. The questions it raises and engages are fairly insular, ceramics-world questions, but interestingly Shaner's work is increasingly being collected by the "pedestal" community.

FACING PAGE, ABOVE AND BELOW: David Shaner, *Garden Slab*, 1964; slab built stoneware; 4 × 18 inches diameter; Oregon Ceramic Studio Purchase, George T. Gerlinger Memorial Award Fund, 1964; 1998.64.01 [*Eleventh Biennial Exhibition of Northwest Ceramics*, May 1964]

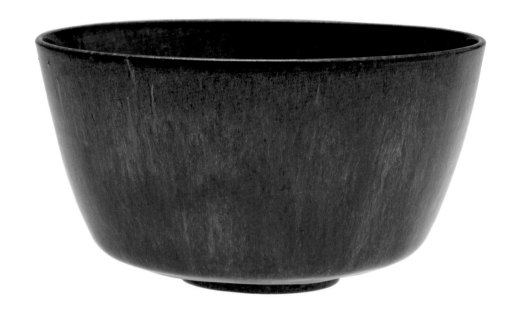

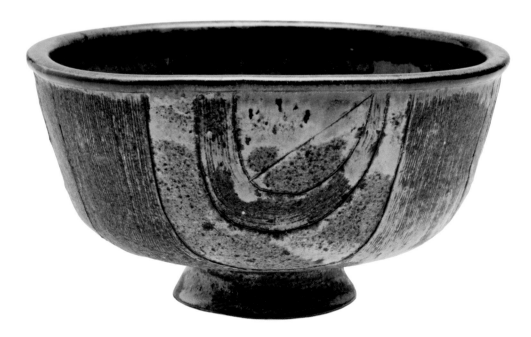

Persistence of the Vessel Form

GERTRUD AND OTTO NATZLER, MARGUERITE WILDENHAIN
AND JAMES LOVERA

The work of the studio artist—an individual who cre-
ates a piece from start to finish—did not disappear as
the exploration of ceramics as a conceptual medium
increased. Gertrud and Otto Natzler, Marguerite Wilden-
hain and James Lovera, for example, were all prolific
producers who continued to explore the vessel as a form.
Often referred to as functional, works by the Natzlers
and Lovera are far from usable. Instead, they operate as
extremely simplified vessel forms—structural vehicles in
a sense—upon and through which the material properties
of clay and glazes were explored.

Each artist engaged the bowl in a different way.
With the Natzlers, the structure and glaze were so inte-
grated—so perfectly aligned—that the clay and glaze are
inseparable, leaving one to wonder what actually holds
the vessel together. Lovera took a painterly approach,
using a black, slip-glaze base upon which he added a
range of color tonalities to fill the surface from center

to rim. Neither bowl is really useable. Both were created
as objects to be viewed and examined, never intended
to contain food. Wildenhain's bowl, on the other hand,
is deliberately functional, employing the characteristic
brown and blue palette and carved surfaces that pre-
vailed in her work. Its painterliness and surface treat-
ment, however, are not precious or created for their own
sake, making this a vessel from which eating is both a
possibility and a pleasure.

FACING PAGE, TOP: Gertrud and Otto Natzler, *Bright Blue Bowl*, 1968; ceramic;
5.25 × 3 inches diameter; Gift of Tom Hardy; 1998.68.13

FACING PAGE, BOTTOM: Marguerite Wildenhain, *Pond Farm Bowl*, 1968–69; stoneware;
4 × 7.75 inches diameter; Gift of Victoria Avakian Ross; 1998.75.11

BELOW: James Lovera, *Red Bowl*, c. 1965; ceramic; 2.75 × 7.5 inches diameter; Gift
of Carol and Seymour Haber; 1999.07.04

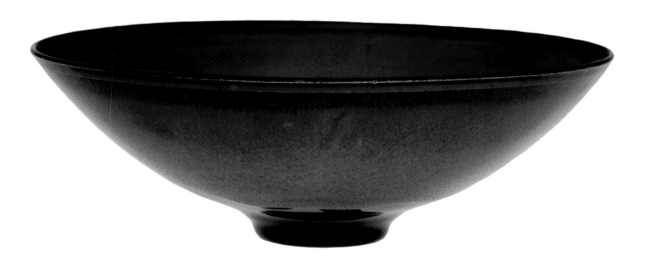

The Vessel as a Conceptual Vehicle
ERIK GRONBORG AND HOWARD KOTTLER

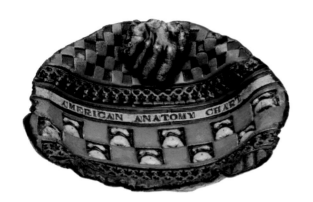

Erik Gronborg harnessed popular culture in his works, using the photographic effects of silkscreening, comics, china paint and commercial glazes, all applied in a deliberately non-precious and "crafty" way. Three important concerns guided Gronborg's work. He insisted on the vessel as a valid subject for artistic investigation. He deliberately worked within the structure of a 1,000-year-old continuum of ceramic history, using T'ang Dynasty glazes, for example, on *Pax Americana*. Lastly, Gronborg created work that reflected the contemporary cultural moment in which he lived, satirizing America's obsession with Hollywood and media personalities through absurdly scaled and vividly hued ceramic objects in forms that directly relate to the historical traditions of functional vessels.[1]

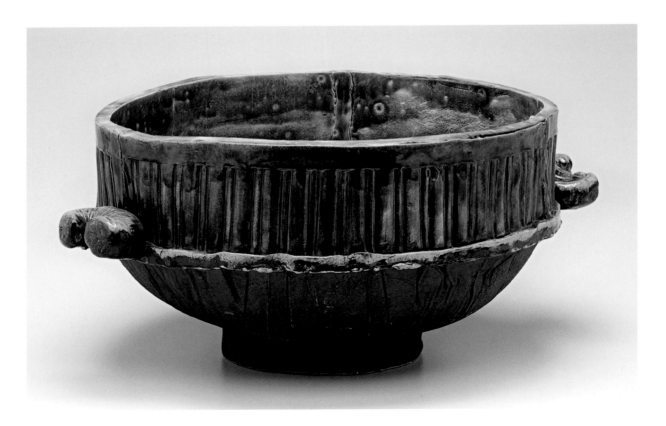

Kottler, too, worked deliberately within the history of ceramics. *The Lecher* is an early piece from his infamous "decalcomania" series. Using commercially available ceramic decals—first on hand-thrown stoneware and later on commercially available plates—Kottler eventually removed his hand entirely from the process of object-making, while continuing to centralize the plate as the locus of his playful visual puns.

Kottler is known for his notorious comment that artists either make peasant ware or royal ware. His goal was to make the latter, focusing on the creation of work that operated in the conceptual realm. While his visual puns, executed through the collaging of ceramic decals, are reminiscent of Surrealist word games, the removal of the artist's hand and focus on factory production is very Warholian. Kottler's work, however, remained focused on the cultural history of the plate and its dual role as both subject and object.

Kottler taught ceramics at the University of Washington from 1964 until his death in 1989, creating one of the premier programs in the country alongside colleagues Robert Sperry and Patti Warashina.

1. Nordess, Lee. *Objects: USA* (New York: The Viking Press, 1970), p112.

FACING PAGE, TOP: Erik Gronborg, *American Anatomy Chart*, c. 1967; stoneware with stamped relief; 3 × 13 inches diameter; Unknown Gift; 1998.00.16

FACING PAGE, BOTTOM: Erik Gronborg, *Pax Americana*, 1969; stoneware; 16.75 × 15.75 × 9.5 inches; Contemporary Crafts Gallery Purchase; 1998.69.02

ABOVE AND RIGHT: Howard Kottler, *The Lecher*, 1967; porcelain; 1.75 × 8 inches diameter; Gift of Arlene Schnitzer; 1998.91.33

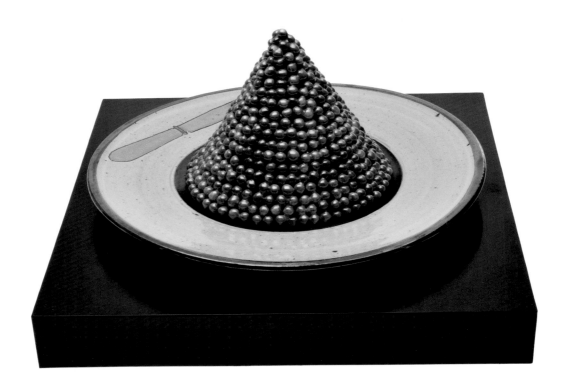

Super Object—The Northwest Way
FRED BAUER AND PATTI WARASHINA

Deeply influenced by California Funk, Surrealism and Super-Object trends in which domestic objects were replicated in unexpected materials and proportions, Fred Bauer and Patti Warashina quickly created a following amongst ceramics students. Mixing technical prowess and a range of building approaches with a vivid, psychedelic, pop-culture-inspired palette, Bauer and Warashina presented an approach that combined a fascination with everyday things and pushed the boundaries of trompe l'oeil.

An example of the Pacific Northwest approach to the Super-Object movement in the seventies, Bauer's *Green Giant's Lunch* required strong technical skills and luxurious ceramic materials and glazes, providing a satirical commentary on the growing place of advertising and marketing in everyday life. For Warashina, the series for which *Egg in Grass (Lidded Jar)* was created was a

breakthrough. It was in the construction of these vessels that she learned the handbuilding skills and techniques that allowed her to move on to the bigger sculptural forms for which she is widely known.

Bauer and Warashina taught together at the University of Michigan and later at the University of Washington. Bauer's combination of humor, irreverence and technical skill led to a cult of personality surrounding the couple (divorced in 1972). Warashina continued teaching at the University of Washington with colleagues Howard Kottler and Robert Sperry.

ABOVE: Fred Bauer, *Green Giant's Lunch*, 1969; lustered ceramic, mother of pearl, platinum; 9 × 15 inches diameter; Gift of Ed Cauduro; 1998.69.01

FACING PAGE: Patti Warashina, *Egg in Grass (Lidded Jar)*, 1969; earthenware; 14.5 × 10 × 10 inches; Gift of Hal Cary; 1998.91.70

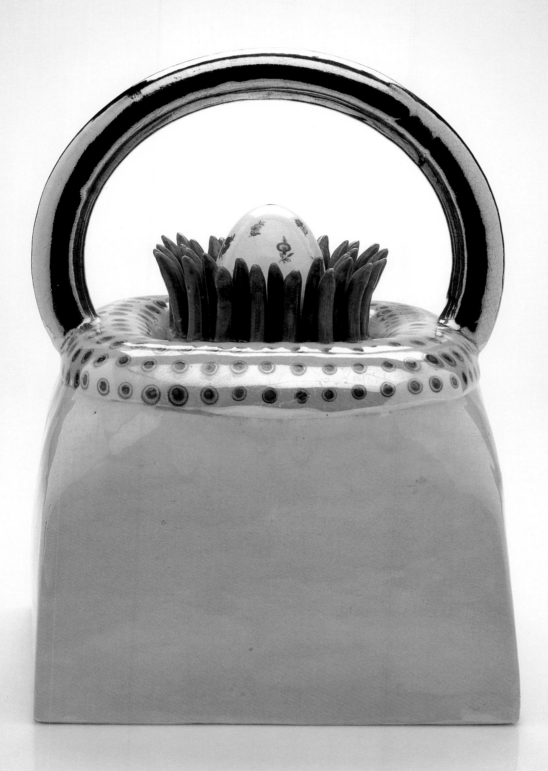

1970s
Changes

Interior designer Gordon Smyth, a risk-taker with an interest in emerging artists, followed Ken Shores as director of the Contemporary Crafts Gallery. Smyth established two important new programs during his tenure. Although the organization had hosted an informal residency program since the late 1950s, it wasn't until the construction of a potter's studio on-site at 3934 SW Corbett Avenue in 1969 that a formal residency was established. In the early seventies, Smyth worked with CCG President Dick Norman to develop the artist-in-residence program, endowed by Ruth Halvorsen. For young artists beginning their careers, the Halvorsen Residency provided an opportunity to focus and create a significant body of work, culminating in an exhibition at CCG and the donation of a piece to the collection.

Smyth also helped institute the Craftsmen-in-the-Schools program in 1972, through which local craft artists provided hands-on outreach in Portland's public schools. The program outgrew CCG's ability to manage it in later years, and administration of the renamed Artists-in-the-Schools program was transferred to the Regional Arts and Culture Council in 1996. During Smyth's tenure, the CCG hosted a range of exhibitions and continued to serve as a social hub for area artists and collectors. Solo exhibitions of work by Jack Lenor Larsen and Ken Shores, as well as exhibitions featuring macramé, wearables, body art, black light, installations, experimental films and videos filled the exhibition schedule in the first half of the decade.

Jan de Vries directed CCG from 1973 to 1978. De Vries, a woodworker and furniture builder, followed the Board's directive of bringing in exhibitions by major artists. He organized exhibitions that documented craft history, which included exhibitions of work by Gerhardt Knodel, Sam Maloof, Gertrud and Otto Natzler, Paul Soldner, Robert Sperry, Bob Stocksdale, John Takehara, Peter Voulkos and Betty Woodman, and a twenty-five-year retrospective of the work of Tom Hardy. De Vries also managed a major expansion in 1976, which added another gallery on the main floor of the building and a basement, thereby doubling CCG's exhibition space.

Joan Shipley served as pro tem director before and after the short-lived tenure of Lukman Glasgow. Glasgow, a ceramic artist and the former director of the Los Angeles County Art Center, directed CCG for six months, then was asked to resign by the Board. The democratic and primarily volunteer-run organization rejected Glasgow's leadership style, as well as his interest in bringing challenging and controversial exhibitions to the institution.

In 1978, artist and educator Marlene Gabel replaced Glasgow as director. Trained in painting and metalsmithing, Gabel also organized the restoration of tapestries at the Timberline Lodge, Mount Hood. Over the next twenty years, Gabel led the organization through many professional, structural and financial changes.

FACING PAGE: Gordon Smyth and Rachael Griffin on the deck during an event at Contemporary Crafts Gallery, c. 1970.

Ken Shores
FEATHER FETISHES

In 1968, Ken Shores resigned as director of Contemporary Crafts Gallery to take a teaching position at Lewis & Clark College, Portland. Teaching freed Shores from having to create production work to make a living. As a result, his art flourished. From the late sixties through the nineties, Shores produced a series that brought him international attention: his "Feather Fetishes."

With this body of work, Shores was able to merge his varied interests in the ritualistic aspects of world cultures and the exploration of clay as a sculptural medium. The resulting works are exotic but nonspecific in their cultural references. Through careful planning and a great deal of trial and error, Shores turned to

feathers as a way of pushing clay beyond its material limits. The most successful pieces in this series extend line and form, integrating feathers with clay into a singular object. Completely enclosed in Plexiglas boxes and sitting atop mirrored bases, Shores' luxurious and exquisitely crafted "Fetishes" evoke imagined functions and rituals. Using ethnographic forms and the history of the vessel as the vehicle, this work can be read today as a sociocultural commentary on the growing commoditization of the contemporary art world.

ABOVE AND FACING PAGE: Ken Shores, *Feather Fetish*, 1970; ceramic, feathers, Plexiglas, mirror; 12.5 × 14.5 × 4 inches; Gift of the artist; 2007.16.01

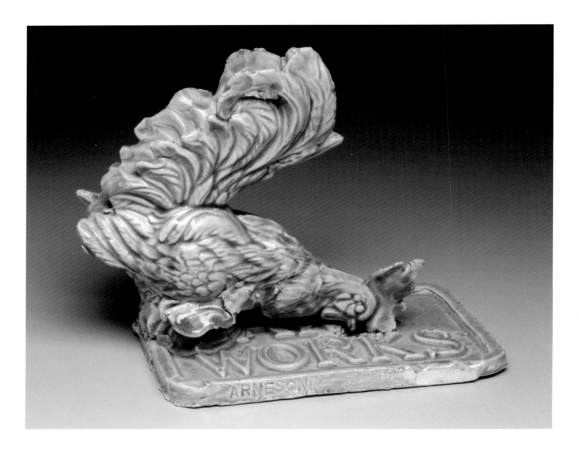

Asian Imports

ROBERT ARNESON AND RAY GRIMM

Far Eastern ceramics continued to play an important role on the West Coast. From the structural forms of utilitarian vessels to glazing techniques, elements of Chinese and Japanese ceramic traditions were explored by many artists including Robert Arneson and Ray Grimm.

Arneson's visual puns served as the foundation of California Funk, and his teaching impacted a number of twentieth-century artists, including Robert Brady, John Buck, Deborah Butterfield, David Gilhooly, Bruce Nauman, Richard Notkin, Richard Shaw and others.

In *Art Works*, Arneson's puns take on additional layers of meaning. Deliberately choosing to work within the history of ceramics and through ceramic processes, Arneson pokes fun at the age-old "art vs. craft" debate and the rift between "high" and "low" art. Around the time Arneson made this piece, his friend Stephen Kaltenbach was affixing bronze plaques to objects around town, labeling them as "artworks" in a Dadaesque game. Arneson turned the idea of Kaltenbach's plaque into the focus of his own work. Executed in porcelain and celadon glazes—both markers of highly valued and "high art" Chinese Sung Dynasty ceramics—the absurdity of both the pun and the "art vs. craft" argument in critical discourse is taken further by the futile pecking of a chicken at the sign.

To Ray Grimm, any vessel—particularly a teapot, its origins steeped in centuries-old Asian traditions—is a sculptural form. *Teapot* draws heavily on Grimm's workshop experiences with Shoji Hamada, his interest in Chinese and Japanese glazes and his ongoing investigation of the sculptural possibilities of ceramics. Mixing global influences and vessel traditions, the piece is an amalgam of cultural influences.

FACING PAGE: Robert Arneson, *Art Works*, 1970; porcelain; 8.5 × 9.5 × 4.5 inches; Gift of Myron Berggren; 1998.88.01

ABOVE: Ray Grimm, *Teapot*, 1970; stoneware; 7.5 × 7.5 inches; Gift of Jere and Ray Grimm; 1998.93.13

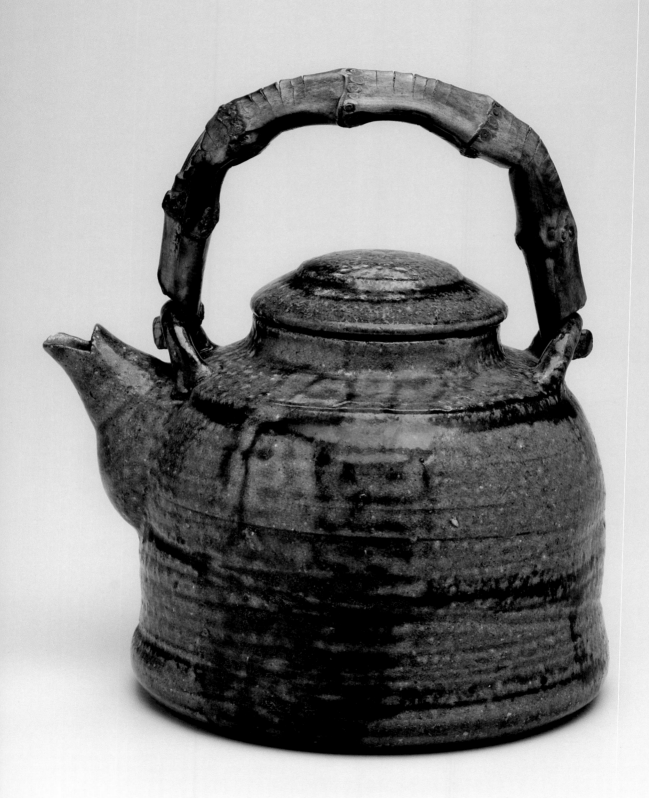

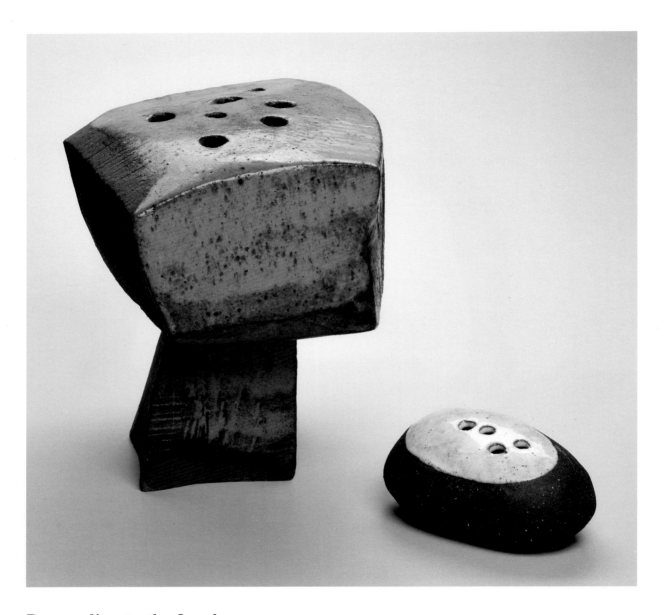

Responding to the Land
BETTY FEVES, HAL RIEGGER AND WAYNE HIGBY

In a humorous twist on the "weed pot" popular in the fifties, Hal Riegger creates an almost absurdly simple vessel to hold cut flowers. Riegger used his hands—the simplest of tools for forming clay—matching his process to the natural landscape in as direct a way as possible.

In *Weed Pot*, Betty Feves applied her characteristic approach to sculpture, in which large slabs are connected into hollow stacked "boxes," simultaneously recalling Modernist sculpture and rock formations of the Eastern Oregon landscape. Using hand-mixed clay, Feves allowed

each box to sag slightly as it dried. Rather than bisque-fire her pieces, Feves incorporated unglazed fired clay into the surface decoration of the piece, with a small amount of glaze poured onto it when dry, resulting in a stonelike appearance. The land provided material and impacted the development of Feves' forms and surfaces, but here, the landscape is also a reference point for abstraction.

For Wayne Higby, the vessel functions as a vehicle through which he translated his experiences with nature

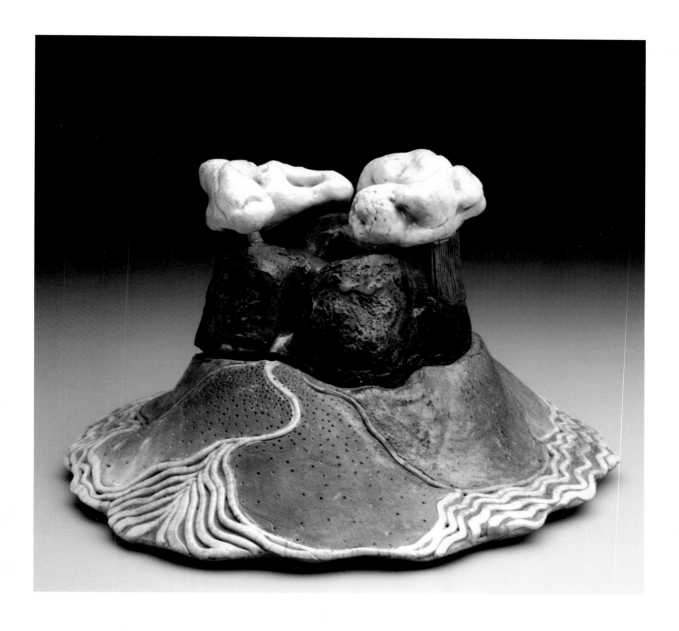

into a three-dimensional form that remains connected to the history of utilitarian objects. Influenced by classical Chinese painting in which the fewest number of lines are drawn to evoke the sensation of a landscape, Higby employed a limited palette of green, blue and brown to create lidded landscapes—boxes that convey his personal experiences through abstraction on several simultaneous levels.

FACING PAGE (L TO R): Betty Feves, *Weed Pot*, c. 1970; stoneware; 9 × 12 inches; Gift of Ruth Halvorsen; 1998.93.10

Hal Riegger, *Potato Weed Holder*, c. 1970, ceramic, 3.5 × 7 × 5 inches; Contemporary Crafts Gallery Purchase; 1998.00.56

THIS PAGE: Wayne Higby, *Island Volcano Pot*, 1971; earthenware with Egyptian paste; 10.5 × 9.5 × 6 inches; Contemporary Crafts Gallery Purchase, Sam Herrick Fund; 1998.71.02 A,B

Raku

HAL RIEGGER, PAUL SOLDNER AND JOHN TAKEHARA

One of the earliest introductions of raku to the United States came through Bernard Leach's *A Potter's Book* (1940). Raku was created in mid-1600s Japan as a direct, spontaneous and less formal means of producing tactile tea bowls, simpler than those used in traditional ceremonies. Hal Riegger and Paul Soldner are two early pioneers of raku in the United States. Riegger's experiments with raku began in the mid-1950s after reading Leach's book, which led to workshops he conducted with Betty Feves using local clays and wood for firing finished pieces in the Pendleton landscape. Riegger worked to match his materials, tools and firing techniques to the environment in which he worked; natural elements when working in nature, and studio-oriented processes and materials when in the studio.

A simple utilitarian vessel, *Planet Pot* uses a Nigerian-style *puki*—a previously made and fired clay saucer—as the base upon which the piece is formed. The form was then built up using coiling and hand-building techniques and simple tools, such as rocks and twigs for shaping and forming. The final step: a simple, Japanese-style raku firing—a technique that matched Riegger's materials, process and execution. Riegger authored two books in 1970, *Primitive Pottery* and *Raku: Art and Technique*, and taught widely, including at the College of Arts & Crafts (now California College of the Arts), Oakland, and workshops in Mill Valley, California.

It is Paul Soldner, however, who is widely recognized as the progenitor of "American raku." Soldner developed a reduction chamber that allowed a gas-fired kiln to mimic the atmospheric effects of Japanese wood-fired raku kilns. Able to engage elements of chance to experiment with surfaces and glazing effects, American studio ceramics now had the potential to move away from mere mimicry of Japanese forms and aesthetics and develop new approaches to raku.

Soldner began experimenting with the figure in the late 1960s, using images cut out of magazines as stencils on his vessels. Soldner, Peter Voulkos' first graduate student, was a central figure at Otis during a time of great change in American ceramics. For years, Soldner divided his time between teaching at Scripps College and Anderson Ranch, an artist's workshop and retreat he founded near Aspen, Colorado, in 1968. Fascinated with technology, experimentation and risk, Soldner is known for his active approach to teaching, which focused on *learning by doing*.

Korean-born to Japanese parents, John Takehara taught many students during his tenure at Boise State University from 1968 to 1998. This piece demonstrates one of the many effects possible through raku. Here, Takehara contrasts black, smoke-colored unglazed areas with a white, glazed area in which the extreme temperature changes of the raku process resulted in a decorative crackle glazing.

ABOVE AND FACING PAGE, TOP: Hal Riegger, *Planet Pot*, c. 1974; raku; 9.5 × 9.5 inches diameter; Gift of A'leen Runkle; 1998.82.03

FACING PAGE, BOTTOM LEFT: Paul Soldner, *Raku Pot*, c. 1970; raku; 16.75 × 14 inches diameter; Gift of Dr. Francis J. Newton; 2004.09.21

FACING PAGE, BOTTOM RIGHT: John Takehara, *Silver Pearl*, 1973; raku; 10 × 10 inches diameter; Gift of Contemporary Crafts Gallery Women's Activities Committee; 1998.73.05

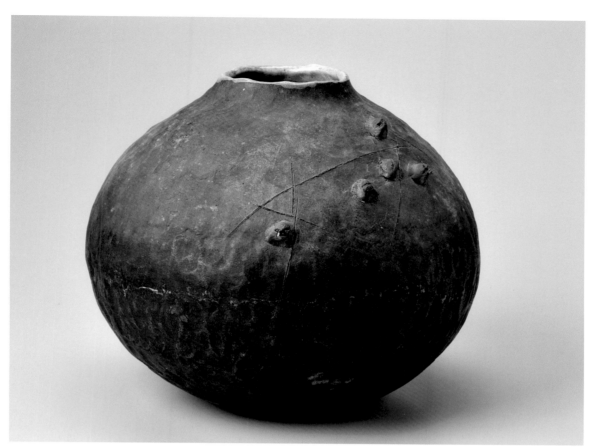

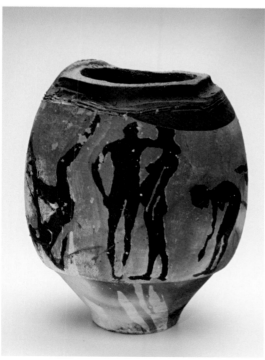

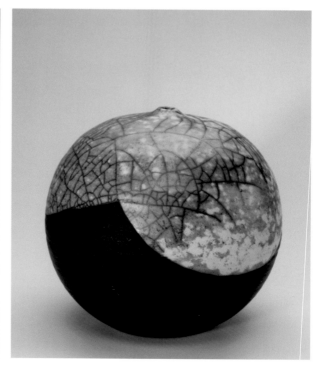

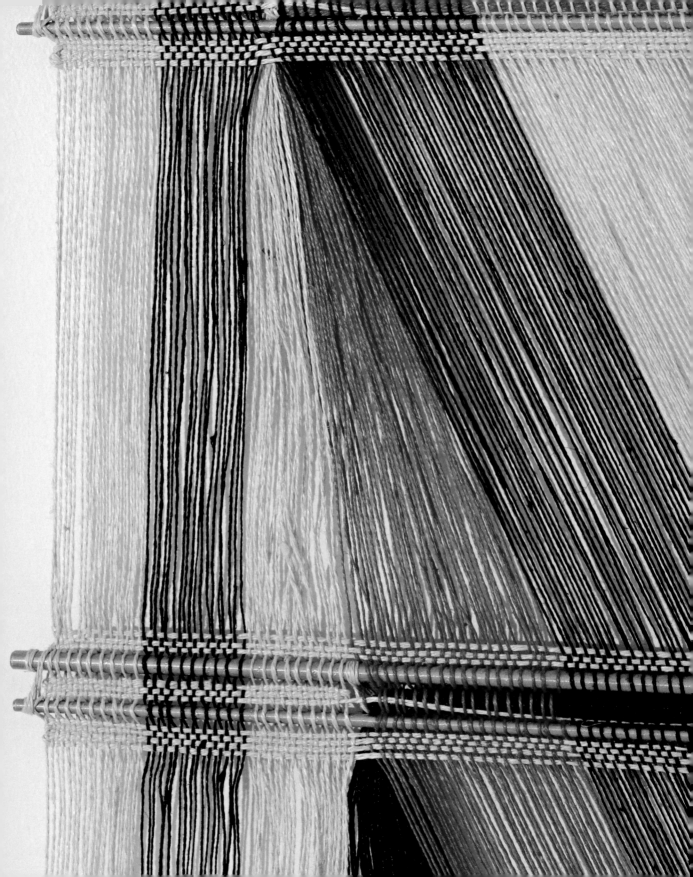

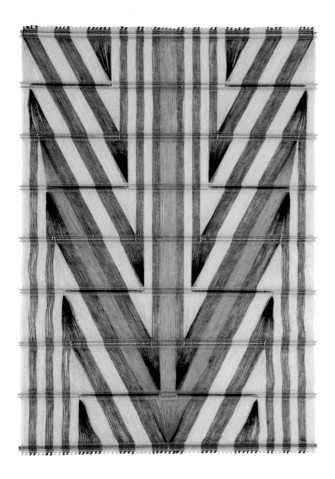

Peter Collingwood
MACROGAUZES

Most textiles are rectangular and contain vertical threads known as the warp. These threads are crossed by horizontal threads known as the weft. The finished edges of the woven piece are called the selvage, and typically run parallel to the warp. Peter Collingwood developed a method, used in *Macrogauze 119*, that allows the warp to be moved out of this parallel format, resulting in the ability to create textiles that can be closed or open, flat or three-dimensional, rectangular or shaped in other ways.

With traditional tapestry, for example, the weft threads hold the picture or pattern, serving as the place where the colored threads build up the design and image. The weft threads in Collingwood's macrogauzes, with the addition of stainless steel rods for support, are minimized to the point where they do the essential work of holding the shifted warps in new positions, rather than serve as the vehicle by which the weaver creates an image.

Collingwood shared his technique at a workshop at Oregon College of Art and Craft in 1974. Although his macrogauzes can be replicated, he made *Macrogauze 119* only once, as it was, in the artist's words, "a beast to do."[1]

1. Correspondence between Peter Collingwood and Nicole Gibbs, from the Museum of Contemporary Craft Archives.

FACING PAGE AND ABOVE: Peter Collingwood, *Macrogauze 119*, 1974; linen, metal rods; 54.25 × 37 inches; Gift of Judith Poxson Fawkes; 2001.20.01

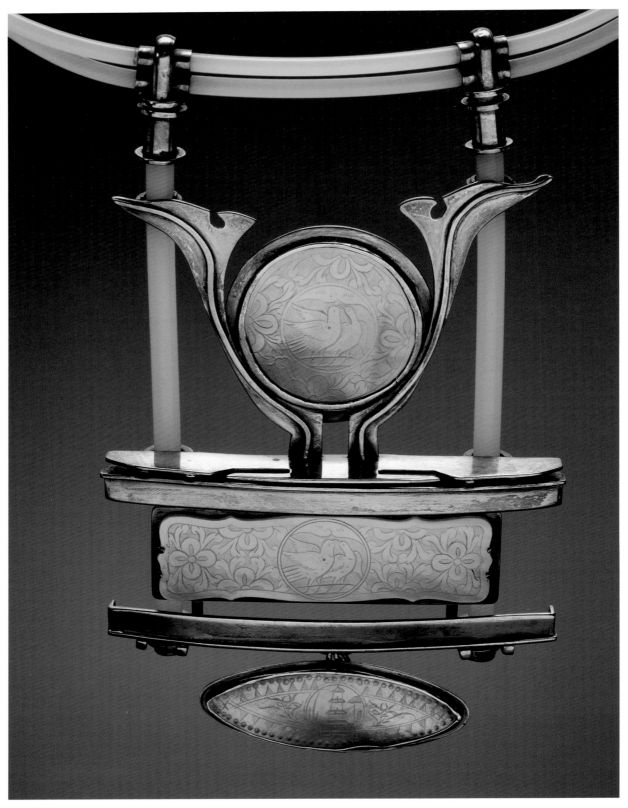

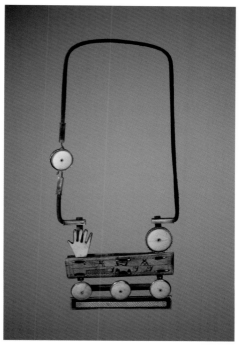 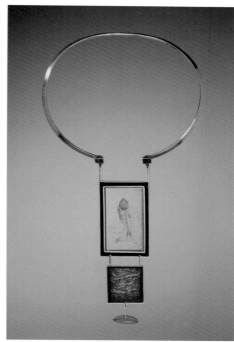

Art Jewelry
RON HO, RAMONA SOLBERG AND JO APODACA

Art jewelers in the sixties and seventies broke out of material confines, pulling non-precious and found objects into their work. As global travel and interests in non-Western cultures increased, artists created work that related differently to the body, using compositional strategies, forms and shapes. Works such as these neckpieces by Joe Apodaca, Ron Ho and Ramona Solberg, for example, reflect "ethnic jewelry" that sits on the body like a breastplate.

Solberg attended college on the G.I. Bill and studied under noted Seattle silversmith Ruth Penington at the University of Washington, where she earned her MFA. Recognized as a pioneer of "found object" jewelry, Solberg relished her role as a teacher of students of all ages—from junior high on up. Her magnetic personality drew students Laurie Hall and Ron Ho—as well as artists Kiff Slemmons and Nancy Worden—into a circle of artists with individual approaches to the incorporation of fragments into art jewelry. An avid world traveler, Solberg's frequent trips provided opportunities to collect a range of "souvenirs," objects she assembled into neckpieces that mixed ancient fragments with modern ephemera, crossed cultural and historical boundaries and were bold and strong in their composition and physical presence.

Ron Ho switched from painting to jewelry after one of Solberg's classes in which she infamously told Ho to stop drinking Coca-Cola® and start looking at his Chinese heritage as a source for his work. Her push helped Ho learn to merge his identity and his growing collections into carefully crafted sculptural assemblages. Earning his living as a public school teacher in the Seattle area for many decades, Ho's work is typically commission-based, including this piece created for Hal Cary.

Of the three pieces, Apodaca's displays the most complex metalsmithing techniques, carefully combining a small fossil with precious metals and stones into a neckpiece that clearly reveals his skills at shaping metal. Combining the lapidary materials with a range of precious metals, the underpinnings of Apodaca's experimentation with unusual textures and materials links his neckpiece to those by Solberg and Ho.

FACING PAGE: Ron Ho, *Silver Necklace*, c. 1970; silver, pearl, shell; 5.25 x 3.25 x .25 inches; Gift of Hal Cary; 1998.91.27

ABOVE, LEFT: Ramona Solberg, *Necklace*, c. 1985; silver, bone; 4.25 x 4 x .25 inches pendant, 18 inch cord; Gift of Lloyd Herman; 2007.13.01

ABOVE, RIGHT: Joe Apodaca, *Ode to the Sea*, 1974; sterling silver, turquoise, shale, 14K yellow gold, blue agate; 12.5 x 6.75 x .5 inches; Gift of Joe and Linda Apodaca; 2007.07.01

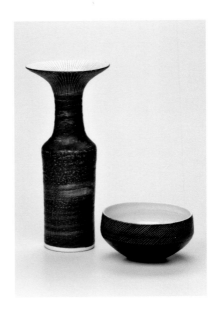
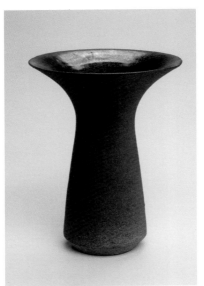
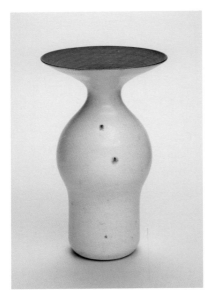

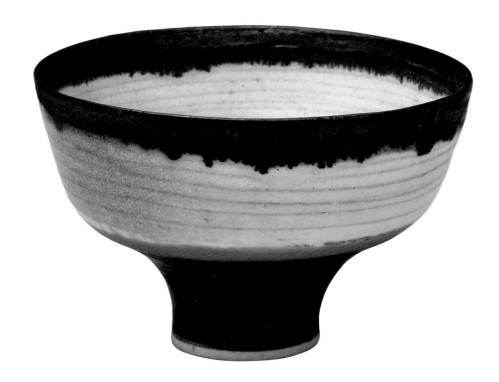

European Influences

LUCIE RIE, GEORGE CUMMINGS AND GERTRUD AND OTTO NATZLER

Lucie Rie fled Vienna during World War II, settling in Great Britain. Trained in the prestigious Kunstgewerbeschule (School of Art and Design) in Vienna in the 1920s, Rie created elegant domestic tablewares. She worked in both stoneware and porcelain, creating pieces like this thin-walled porcelain vase and bowl, glazed in her signature dark brown and marked with *sgraffito* while wet to reveal the colored surface below.

The line of Rie's vessels was of particular interest to George Cummings, leading him to spend time studying ceramics in England and Switzerland in 1964 and 1965. Cummings began his study of ceramics under Bennett Welsh at the Museum Art School (now Pacific Northwest College of Art) in 1960 to 1962, followed by a yearlong apprenticeship with Welsh at Pacific Stoneware Company. Cummings preferred to work in stoneware as opposed to porcelain, creating thin-rimmed vessels with organic yet modern silhouettes and broad, flat brims reminiscent of Rie's work, but more in keeping with the materials readily available to him in Portland. Cummings' vessels are also more weighty and solid than Rie's; heavy stoneware grounded the forms despite their simple, organic lines.

Cummings taught for many years at both the Oregon School for Arts & Crafts (now Oregon College of Art and Craft) and the Museum Art School (now Pacific Northwest College of Art). He was one of only a select few artists from the Pacific Northwest asked to teach at the prestigious Haystack Mountain School of Crafts in Maine in the seventies. However, it grew increasingly difficult for Cummings to support himself through studio practice, leading him to give up ceramics in the late eighties.

Gertrud and Otto Natzler worked collaboratively for nearly forty years until Gertrud's death in 1971. Gertrud Natzler threw the vessels, creating delicate and refined porcelain forms. Otto Natzler crafted over 2,000 glaze formulas, each individually applied by brush to Gertrud's forms and carefully documented in a book that recorded every piece the prolific couple created over the years.

Two of many émigrés forced to flee the advancing National Socialist Party before World War II, the Natzlers arrived in southern California in 1938, with little more than their potter's wheel and kiln. Supporting themselves through teaching, they introduced countless artists to modern European ceramics, sharing their approaches to the wheel and experimental glazes. Museums and

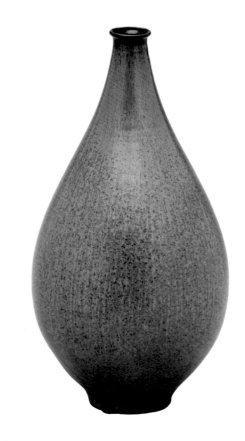

collectors nationwide quickly acknowledged their elemental and vividly hued forms. In 1975, Contemporary Crafts Gallery hosted an exhibition of the couple's work. Organized by CCG director Jan de Vries, the exhibition showcased a range of vessels, including this teardrop vase.

FACING PAGE, TOP (L TO R): Lucie Rie, *Untitled tall bottle*, c. 1950; ceramic; 8.75 × 3.75 inches diameter; Promised gift from Carol and Seymour Haber

Lucie Rie, *Untitled small brown bowl*, c. 1950; ceramic; 2 × 4 inches diameter; Promised gift from Carol and Seymour Haber

George Cummings, *Untitled tall vessel*, c. 1970; stoneware; 6.25 × 4.75 inches diameter; Gift of the Margaret Murray Gordon Estate; 2007.01.08

George Cummings, *Untitled vase*, c. 1977; porcelaneous; 8 × 4.5 inches diameter; Gift of the artist; 2007.15.01

FACING PAGE, BOTTOM: Lucie Rie, *Untitled small pink bowl*, c. 1950; ceramic; 2.5 × 3.75 inches diameter; Promised gift from Carol and Seymour Haber

ABOVE: Gertrud and Otto Natzler, *Teardrop Vase*, c. 1962; ceramic; 10 × 5 inches diameter; Promised gift from Carol and Seymour Haber

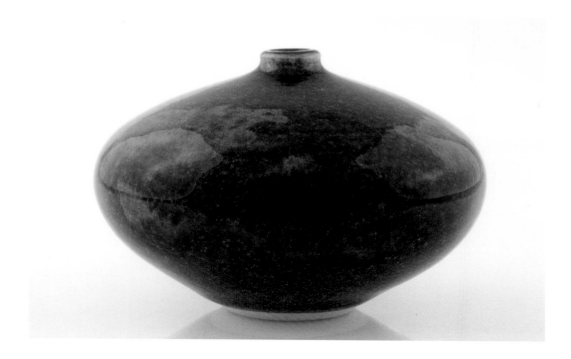

Betty Woodman
PILASTER FORMS

Woodman created this vase during a residency at Alfred University in 1975. Exhibited at CCG and purchased from the exhibition, the piece was used as an umbrella stand for a number of years. Broken roughly into columnar sections, the cylindrical form recalls classical Greek and Roman architecture. The expressionistic way in which handles are attached to the piece signals Woodman's later explorations that deconstruct the very elements of a vessel. Applied in energetic splashes, a painterly application of colored glazes simultaneously contrasts with—and heightens—this rigid form. The vase marks a transition in Woodman's work, from a focus on production ware to her pilaster series—a conversation with architectural and vessel forms from antiquity.

FACING PAGE AND RIGHT: Betty Woodman, *Pilaster Vase*, c. 1975; porcelain; 24 × 8 inches diameter; Unknown Gift; 1998.75.12

ABOVE: Vivika and Otto Heino, *Untitled small blue bottle*, c. 1980; ceramic; 3.25 × 5 inches diameter; Promised gift from Carol and Seymour Haber

Vivika And Otto Heino
LIVING THROUGH POTTERY

While working towards her MFA at Alfred University during World War II, Vivika Heino was told by her professor, Charles Herder, that it was not possible to make a living through pottery. Defying this challenge, Vivika Heino and her husband Otto were part of a generation of artists who sought to both redefine ceramics in America and create a lifestyle that allowed them the freedom to work on their own terms and in their own ways.

Maintaining a clear vision of what kind of pottery suited modern times, the Heinos are known for their experimental glazes and firing techniques, and for a forty-five-year collaboration that continued until Vivika's death in 1995. Otto continues to work today, creating functional ceramics that showcase calligraphic brush-work and sculptural form.

Vivika Heino particularly loved working with glazes, which she first focused on while working as Glen Lukens' assistant. Teaching at the University of Southern California and later Chouinard Art Institute in Los Angeles in the late fifties and early sixties placed the Heinos in the midst of a growing community that ultimately did redefine ceramics in the United States—a community that included Laura Andreson, John Mason, Gertrud and Otto Natzler, Susan Peterson, Paul Soldner, Peter Voulkos and many others.

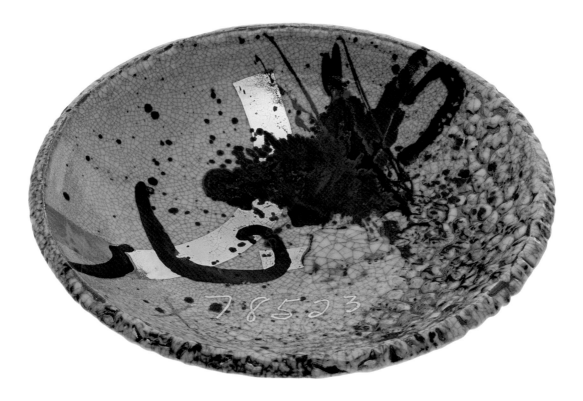

Robert Sperry

HORROR VACUI

Expressionistic and loose in some works, Robert Sperry was also known to "spend hours painstakingly decorating the surfaces of the works, building them up with literally hundreds of bits of clay or carefully gouging the surface to create a dense, overall pattern or drawing designs on every conceivable inch of space in the manner of *horror vacui* of Barbarian or Islamic Art."[1]

Sperry's interest in surface ornamentation took a painterly twist in the seventies. Building up layers of dots in white, mixed with gold luster and metallic colored glazes, Sperry's plate directly challenges perceptions about the line between taste and kitsch, beauty and excess.[2]

1. Harrington, LaMar, *Ceramics in the Pacific Northwest: A History* (Seattle: University of Washington Press, 1979), p60.
2. Kangas, Matthew, "Robert Sperry: PLANETARY CLAY," *American Craft*, 41.6 (Dec 1981/Jan 1982), p24.

FACING PAGE AND ABOVE: Robert Sperry, *Numbered Plate*, c. 1975; stoneware with crackle glaze with gold luster; 3.5 × 14.25 inches diameter; Unknown Gift; 1998.75.08

Laurie Herrick
OP ART WEAVING

Broken into differently-colored sections, Laurie Herrick's *Three Giraffes* uses a grid structure and the pattern-building capabilities of weaving to combine a contemporary pattern with a handcraft process. Herrick's work is unusual in the way it breaks the typically single plane of two-dimensional Op Art by dividing the piece into three contiguous sections. Herrick began to explore Op Art through weaving in the late 1960s—an investigation that continued through the 1970s.

Self-taught, Herrick created weavings for interior designers and members of the movie industry in Los Angeles before relocating to the Pacific Northwest. She taught weaving at the Oregon School of Arts & Crafts (now Oregon College of Art and Craft) from 1958 to 1979. Her students included Sharon Marcus, Pam Patrie, and art patrons Betty Gray and Jean Vollum.

Sam Maloof
HANDCRAFTED FURNITURE

Sam Maloof's solo exhibition at CCG in 1977 connected him with several young woodworkers in Portland, including John Economaki and Steve Foley. A self-taught furniture maker, Maloof's first pieces were created in 1948 from scrap plywood. Referring to himself as a woodworker, Maloof continues to create beautiful and functional furniture. His signature rocker is an icon of handcrafted furniture of the postwar period. For Maloof, design comes from a responsiveness to materials, resulting in tactile furniture that connects the maker's hand with the user's touch in every sinuous line and detail. In 1985, Maloof became the first craftsman to receive a MacArthur Fellowship.

RIGHT: Laurie Herrick, *Three Giraffes*, c. 1970; linen, cotton, wool; 72 × 32 inches; Gift of Ken Shores; 2006.05.01

FACING PAGE: Sam Maloof, *Double Print Rack*, 1977; wood; 24 × 15 × 40 inches; Contemporary Crafts Gallery Purchase; 1998.84.04

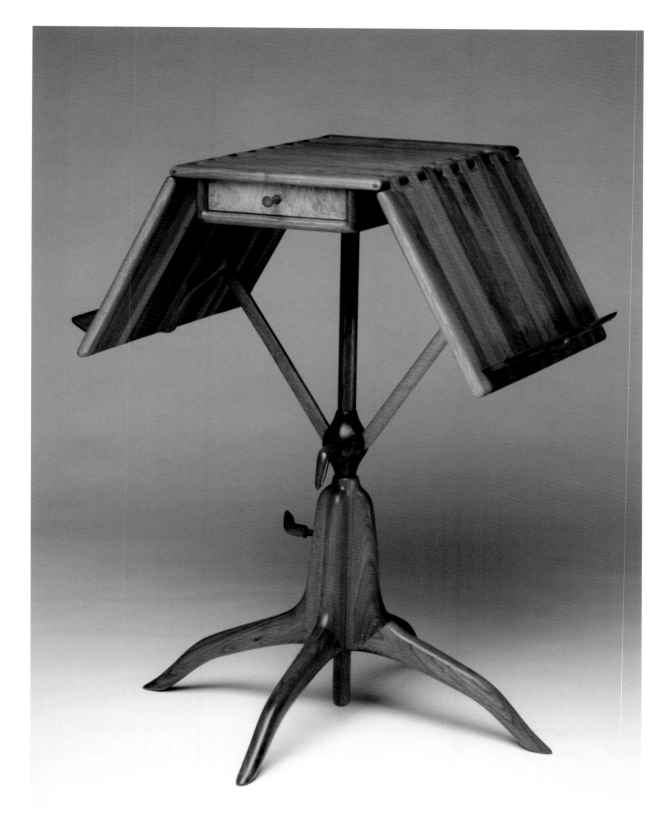

1980s Critical Mass

During the 1980s, exhibitions at CCG continued to encompass a range of craft media; the new focus, however, was on glass. In 1983, CCG director Marlene Gabel inaugurated a series of annual exhibitions, bringing the emerging American Studio Glass Movement to the attention of CCG's audience. Unlike the juried format of the ceramic annuals of the fifties, annual glass exhibitions were group shows organized by Gabel herself.

Although CCG had exhibited glass since the sixties, including the work of Marvin Lipofsky (1966) and Russell Day (1968), it wasn't until the seventies that the Pacific Northwest became a glassmaking center. In 1971, Dale Chihuly, Anne Gould Hauberg and John Hauberg founded the Pilchuck Glass School in Stanwood, Washington—a summer workshop and residency program focused on teaching artists a range of techniques. In 1972, Ray Grimm founded the Glass Shack Workshop at Portland State University, which exposed Portland artists to the techniques Grimm learned in workshops led by studio-glass pioneers Dominic Labino and Harvey Littleton. In the following years, Eric Lovell founded Uroboros Glass Studios (1973) and Ray Ahlgren and Dan Schwoerer established Bullseye Glass in 1974. Until Gabel's focus on the medium, however, glass had only been featured sporadically at CCG.

Much like the ceramic annuals of the fifties, Gabel's glass exhibitions were large surveys designed to provide a sampling of work for viewing and for purchase by local collectors. The invitational glass exhibition in 1983, *New Directions*, included work by Richard Marquis, Josh Simpson, Karen Zoot and others. *Glass Invitational* (1986) included Sonja Blomdahl, Dale Chihuly, Flora Mace and Joey Kirkpatrick, William Morris, David Schwarz and others. Gabel also continued to develop relationships with nationally recognized crafts-based artists, such as Cynthia Schira and Toshiko Takaezu, and alternated exhibiting these artists with local and regional work in response to audience attendance and to help drive sales. Group exhibitions around a theme or focus became the norm, including *Flux/Fusion/Fire*, a national enamel competition in 1980, an exhibition of regional artists organized by the Smithsonian American Art Museum's Renwick Gallery, and an exhibition of past winners of National Endowment for the Arts grants in 1983.

Perhaps the biggest project of the decade, however, was the 50th anniversary celebration in 1987, coordinated by Marilyn Fletcher. In conjunction with the publication of *3934 SW Corbett: Fifty Years at Contemporary Crafts*, written by Jane Van Cleeve, Gabel invited significant craft artists and collectors to guest-curate a series of exhibitions that were cohosted by institutions across the city. The exhibitions and curators included: *Clay* by Paul Soldner; *Collectors*, co-curated by Sue Cooley and Ken Shores; *Contemporary Fibers* by Gerhardt Knodel; *Glass* by George Saxe, *Historical Fibers: 6 Decades of American Fiber* by Jack Lenor Larsen; *Metal* by Mary Lee Hu; and *Wood* by Sam Maloof. Individually, each exhibition offered a perspective on five decades of work created in each medium. Collectively, the exhibitions provided the first historical survey of American craft to be presented by CCG.

Gabel struggled to professionalize the institution, shifting administration during her tenure away from volunteers to a small, paid staff. By the end of the decade, she and her staff found themselves exhausted from the workload of ambitious programming. CCG began to struggle to hold a clear place in a shifting cultural arena that now included numerous commercial art galleries and the innovative Portland Center for the Visual Arts.

The shifting marketplace impacted CCG as well, as the sheer number of artists creating craft began to require tremendous attention in order to remain current. Craft shows evolved too, where audiences began to attend to see and collect the latest craft, not necessarily to meet and watch the craftsperson at work. As the market grew less personal and the focus on education shifted to promotion and marketing, craft—and CCG—found itself in the midst of an identity crisis.

FACING PAGE: William Morris, David Schwarz and Dale Chihuly at Pilchuk Glass School, photographer unknown, c. 1980. Marlene Gabel was present at this event, but does not appear in this photograph.

The Bowl
LAURA ANDRESON AND DAVID SHANER

Considered a pioneer in West Coast ceramics, Laura Andreson began teaching at the University of Southern California, Los Angeles, in 1933. During the thirties and early forties, Andreson's approach and materials were limited to what was available to West Coast artists working in clay: handbuilding and mold-making techniques, earthenware clay and vividly colored glazes. But through the influence of F. Carleton Ball, Glen Lukens, Gertrud and Otto Natzler and Marguerite Wildenhain, Andreson learned how to throw on a wheel and then began teaching this technique to her students in 1944.

Blue Bowl clearly communicates why porcelain was Andreson's medium of choice and how she uses it to full effect. The smooth surface is speckled with glaze in layers and tones that evoke an eggshell. Stippled the same way on both the interior and exterior of the bowl, the eye searches for something to rest upon, landing on the crisp line of the rim. Every element of the bowl creates a sensation of lightness, openness and release. Defining herself as a functionalist, Andreson used the form of the bowl and the barest of elements to communicate her ideas and to trigger a sensation of wonder in the viewer.

The structure of Andreson's open, airy and light vessel provides an interesting contrast to David Shaner's stoneware "pillow pot" series. Shaner's *Summer Sun* is about weight and mass. Glazed black on the interior, the rounded organic form contains the air inside, within what appears to be a limitless yet contained internal void. Shaner's pot invites the viewer to step closer, to peer in, to notice the thickness of the clay, the geometry of the square opening that contrasts with the rounded form, and the blackness that heightens blue tones and other colors on the exterior and top of the vessel.

Shaner embraces the void as a contemplative space, while Andreson uses the void as a space for release. Both pieces reveal the bowl as a unique form—one that continues to defy adequate language to convey the emotional and even visceral responses evoked in the viewer.

FACING PAGE: Laura Andreson, *Blue Bowl*, 1981; porcelain with crystal glaze; 6.75 h × 11.25 inches diameter; Gift of Tempe amd Myron Berggren; 1998.96.01

ABOVE: David Shaner, *Summer Sun*, c. 1981; stoneware; 10.5 × 10.5 × 4 inches; Contemporary Crafts Gallery Purchase; 1998.82.05

Resurrecting History
PAM PATRIE AND RONNA NEUENSCHWANDER

Aubusson weaving, typically used for pictorial work, involves the creation of a tapestry in sections rather than as a single, large rectangular piece. The weaver must build colors and shapes with weft threads that run from left to right, stitching together each section to create the final tapestry. The building up of color involves the simultaneous management of multiple bobbins of threads and a consistent hand to ensure that the sections are woven with a similar tension. Otherwise, they will not fit together properly in the final construction.

A former bridge tender, Pam Patrie resurrected this classical European tapestry technique, using a portable Gobelin-style loom to document an urban view from one of Portland's bridges. Patrie learned the Aubusson technique—a difficult and highly specialized form of weaving no longer taught in universities today—at the San Francisco Tapestry Workshop and through independent studies in France. Patrie uses a historical method to document a contemporary moment, capitalizing on her need for portability to execute the work, an interesting twist given that tapestries in past centuries were, in essence, portable art.

Ronna Neuenschwander spent her yearlong Halvorsen Residency at CCG examining the role that elephants have played in history—particularly in times of war—in response to a request to create a piece for the Oregon Zoo's "Elephants in Art" collection. This piece from her residency exhibition relates one of many legends about the Assyrian Queen Semiramis (c. 800 BC), who is said to have placed stitched oxen hides stuffed with straw atop camels to create the illusion of battle elephants to scare off enemy forces. Drawing upon research in taxidermy to create her shapes and forms, Neuenschwander "stitched" her porcelain pieces together, resurrecting a semi-historical legend while simultaneously revealing—and reveling in—the humor of a clever act of subterfuge.

ABOVE: Pam Patrie, *Steel Bridge from the Broadway Bridge*, 1983; wool; 47 × 59 inches; Contemporary Crafts Gallery Purchase; 1998.86.02

FACING PAGE: Ronna Neuenschwander, *Queen Semiramis' War Elephant*, 1982; porcelain; 10.5 × 13.5 × 7.5 inches; Gift of the Contemporary Crafts Gallery Council; 1998.82.02

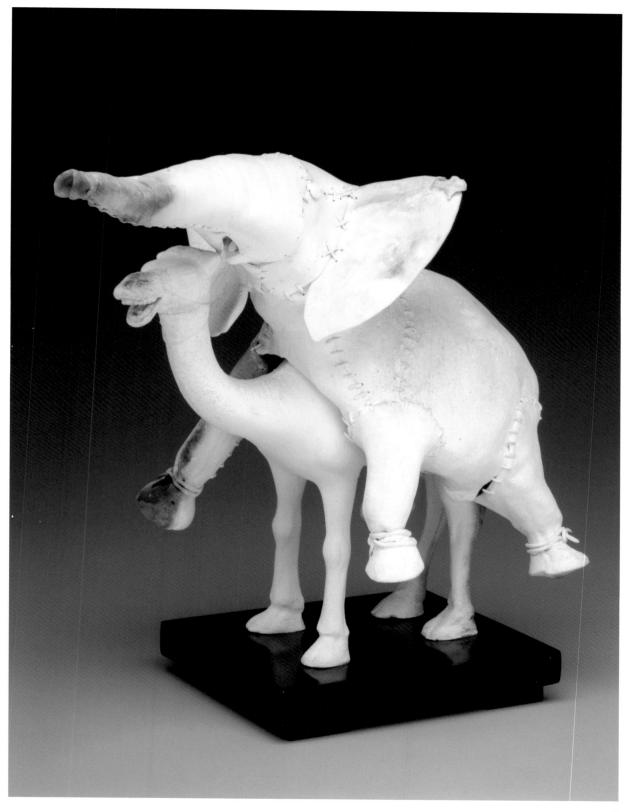

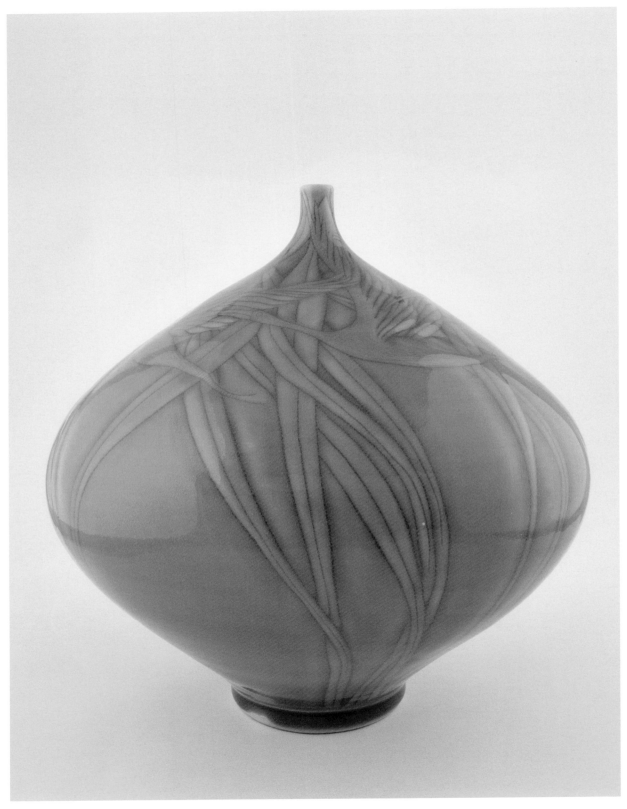

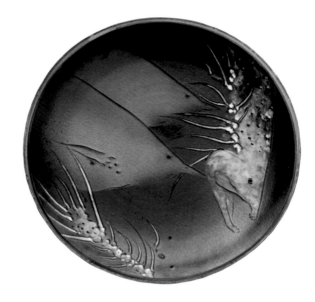

Collaborations

TOM AND ELAINE COLEMAN AND FRANK BOYDEN

Tom and Elaine Coleman have collaborated since their student days at the Museum Art School (now Pacific Northwest College of Art). Their focus on creating a life and livelihood through their work is the subject of the book *The Mud-Pie Dilemma: A Master Potter's Struggle to Make Art and Ends Meet* by John Nance, published in 1977 and updated in 2002. Frank Boyden and the Colemans have been friends and collaborators on a range of projects for decades. Here, two vessels thrown by Tom Coleman clearly show the elegant, curvilinear silhouette for which he is known. Boyden and Elaine Coleman, however, used very different approaches to line and carving to activate the vessel surfaces that Tom Coleman provided them.

Elaine Coleman's Art Nouveau-style representation of nature is tightly controlled—complex in its layering, meticulously and painstakingly carved and celadon-glazed to gently highlight her design. This results in a synchronicity in which the formality of both the form and surface are united. In contrast, Boyden, who usually drew lines into clay in a direct, immediate and intuitive response, adjusted his approach to work in tandem with—rather than against—Tom Coleman's formal, rounded and uniformly glazed vessel. This work also

reveals Boyden's characteristic approach to ceramics at the time. He merged a physical, expressionistic style with his studies of Native American and Peruvian ceramics. In his solo work, Boyden's methods revealed the roughness of stoneware; a natural palette and non-precious glazing accentuated his engagement with the unexpected changes that inevitably happen in firing processes.

The vessel on which Boyden and Coleman collaborated is one of the first pieces fired in the East Creek Anagama kiln, a replica of an eighth-century Korean Anagama kiln, and one of only two wood-fired kilns designed and built in the United States by Katsiyaki Sakazumi in 1984. Boyden continues to collaborate with artists today, particularly through residencies and workshops at the Sitka Center for Art and Ecology, which he and his wife Jane cofounded on the Oregon coast in 1970.

FACING PAGE: Elaine Coleman, *Vase with Cranes*, 1983; ceramic; 10 × 10 inches diameter; Gift of the Contemporary Crafts Gallery Council; 1998.83.01

ABOVE, LEFT: Frank Boyden and Tom Coleman, *Boyden/Coleman Vessel*, 1986; stoneware; 14 × 18 inches; Gift of Art Advocates; 1998.86.01

ABOVE, RIGHT: Frank Boyden, *Skeleton Fish Forms*, 1984; stoneware with brushed decorations; 2.5 × 25 inches diameter; Contemporary Crafts Gallery purchase in memory of David Erickson; 1998.84.02

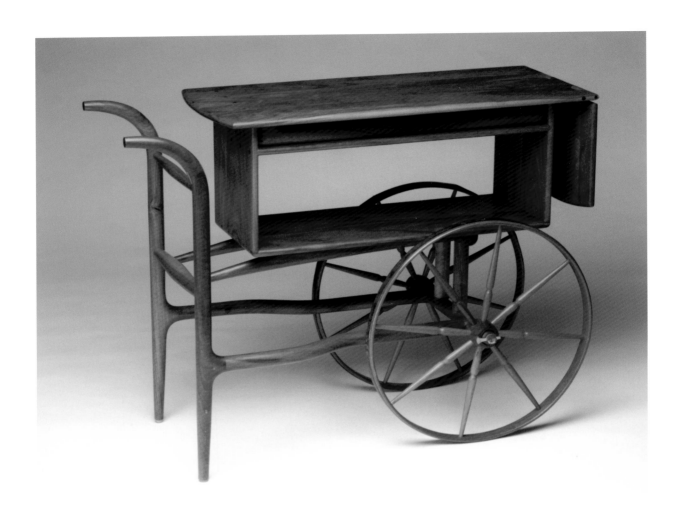

Forms from Wood
JOHN ECONOMAKI AND BOB STOCKSDALE

John Economaki, trained in industrial design, is a proponent of customer-centered craft. Asked by the owner of an elegant Portland restaurant to participate in a competition to create a dessert trolley, Economaki followed a list of requested elements without sacrificing his aesthetic focus: a specific height, a silverware drawer, a shelf for French pastries, easy to maneuver in close quarters, expandable, attractive and so forth. To the owner's surprise, Economaki unexpectedly added wheels that could roll over a variety of floor surfaces, making the trolley both easy and a pleasure to use. The trolley proved to be such a success that patrons requested copies, making it one of Economaki's most successful designs. Economaki took a workshop with Sam Maloof at Anderson Ranch in

1978. However, unlike Maloof who intuitively responds to the wood, Economaki created his designs on paper, more in keeping with his industrial training.

In June 1984, Economaki's work was featured in a solo exhibition at CCG. Within the year, however, he developed a severe allergic reaction to rosewood dust and contracted double pneumonia, forcing him to change careers nearly overnight. Today, Economaki is president of Bridge City Tools, a Portland-based company that creates high-end, handmade woodworking tools.

Bob Stocksdale was a pioneer in lathe-turned wood bowls and was a participant in the renaissance of wood turning in the years following World War II. Reared on a farm with many mechanically inclined relatives

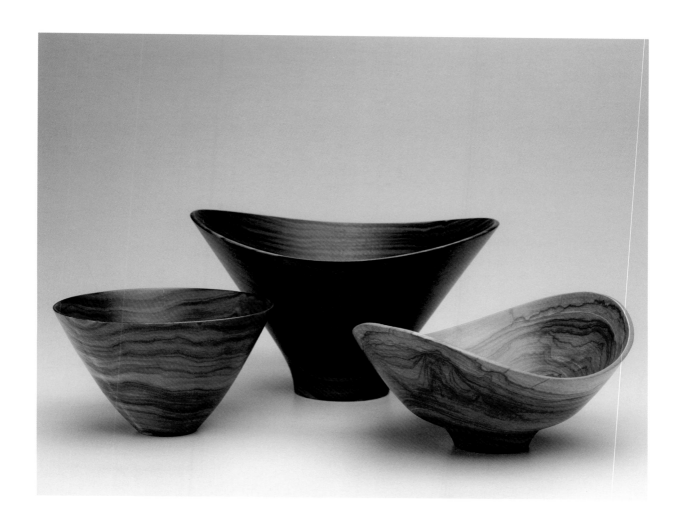

around him, Stocksdale learned to repair farm tools early in life, turn baseball bats and whittle with a pocket-knife. However, it wasn't until 1942 while interned at a conscientious objector camp in Valhalla, Michigan, that Stocksdale turned his first wood bowl. Helen Winnemore, a gallery owner from Columbus, Ohio, began selling his bowls, trays and plates during the war. Retailers Gump's and Fraser's in San Francisco and a number of galleries across the country quickly followed suit.

Stocksdale became a member of the International Wood Collector's Society, which provided him access to rare woods from around the world. Stocksdale designed his bowls from the outside, determining the exterior shape as he cut into a block of wood. Next, he concen-

trated on the interior, gently curving and carving the wood to bring out the natural beauty of the material. He created over 10,000 bowls in his lifetime, which he tracked by burning notches into the wall of his studio with a piece of red-hot wire.

FACING PAGE: John Economaki, *Vaughn Street Dessert Trolley*, 1985; walnut; 34 × 46 × 15.5 inches; Contemporary Crafts Gallery Purchase; 1998.85.02

ABOVE (L TO R): Bob Stocksdale, *Bowl*, c. 1980; Brazilian kingwood; 3 × 4.75 inches diameter; Promised gift from Carol and Seymour Haber

Ebony Bowl, 1973; lathe turned Macassar ebony bowl; 4 × 7.25 × 6.5 inches; Gift of Contemporary Crafts Gallery Women's Activities Committee; 1998.73.04

Bowl, 1985; Brazilian tulipwood; 6.75 × 5.25 × 3.5 inches; Promised gift from Carol and Seymour Haber

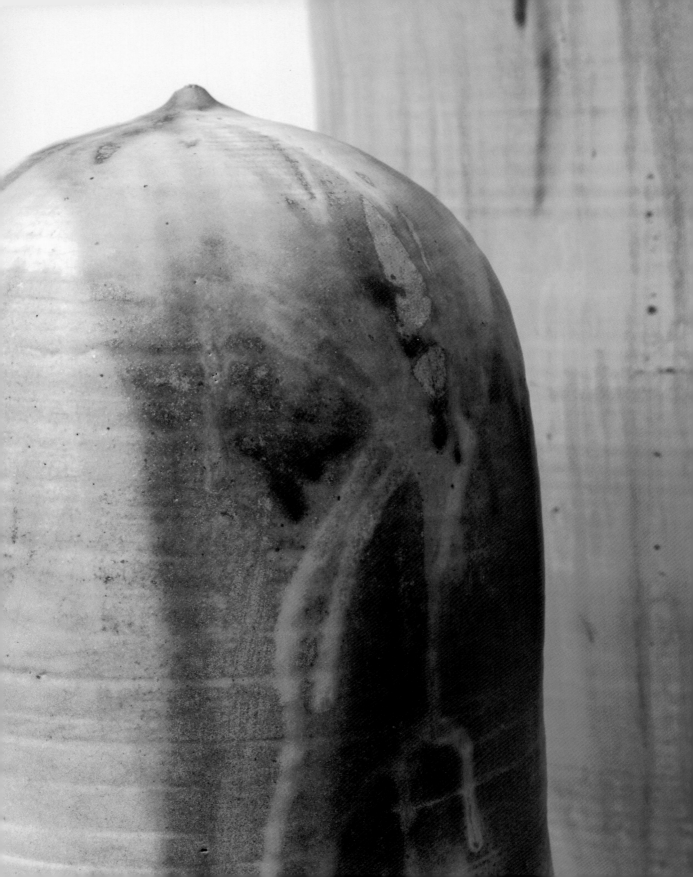

Toshiko Takaezu
EAST AND WEST

Toshiko Takaezu is widely recognized for her organic, "closed" vessels and spontaneous and painterly approach to glazes. Her forms range from a few inches to several feet tall, many adorned with small clay beads inside that make sounds when shaken. Through a combination of handbuilt and thrown techniques, her rounded shapes invite handling. Takaezu is widely considered to be the first person to close—or at least nearly close—a ceramic vessel. However, the work is not recognized for its technical mastery alone. Each Takaezu vessel is individually glazed, using a range of applications that build layers of color surrounding the form. Walking around her larger pieces is a contemplative experience similar to viewing a Helen Frankenthaler painting. Even at nearly four feet tall, the largest of Takaezu's vessels do not dominate their environment; instead, they occupy a quiet co-existence.

Takaezu earned an MFA in ceramics from Cranbrook Academy of Art in 1954, where she studied under Maija Grotell. She then traveled to Japan to study Buddhism, visit Shoji Hamada and learn traditional Japanese pottery techniques. This foundation, combining Eastern and Western approaches to ceramics, allowed Takaezu to move away from functional vessels and develop her distinctive style and technique.

Takaezu's connection to Portland began when she and Ken Shores met at the First Annual Conference of the American Craftsmen at Asilomar, California, in 1957. Despite living on opposite coasts, Shores and Takaezu have remained lifelong friends. From 1970 to 1995, Takaezu conducted annual workshops at Lewis & Clark College at Shores' invitation; open to students and the public at large, her workshops were a major summertime event. In 2007, the artist donated eighteen pieces in honor of the grand opening of the newly renamed Museum of Contemporary Craft.

FACING PAGE AND RIGHT (L TO R): Toshiko Takaezu, *Untitled*, c. 1990; stoneware; 21 × 10 inches diameter; Gift of the artist; 2007.20.08

Untitled, c. 1990; stoneware; 48 × 20 inches diameter; Gift of the artist; 2007.20.01

Untitled, c. 1980; stoneware; 26.5 × 16 inches diameter; Gift of the artist; 2007.20.03

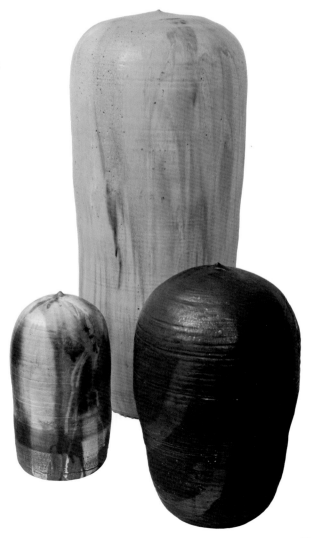

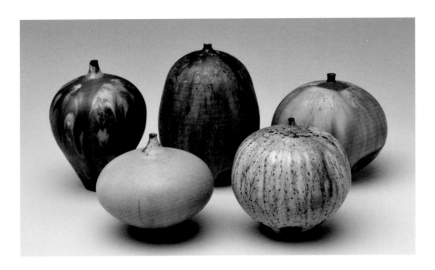

Personal Vocabularies
ROSE CABAT AND RUTH DUCKWORTH

Rose Cabat is known for her porcelain "Feelies"—small, round vessels that beg to be touched, held and examined up close. Cabat taught herself to use a potter's wheel in the fifties at the Greenwich Settlement House in New York City. She continued to experiment with shapes and scale during the next decade, eventually developing the small, hand-sized vases with narrow necks for which she is recognized worldwide. After a glaze calculation course in Hawaii, Rose and Erni, her late husband, began developing a range of jewel-toned, satin matte glazes. Merging this color palette with velvety smooth surfaces on small, intimately scaled vessels that echo abstracted fruit or vegetable forms became Cabat's signature style in the sixties. She is one of but a few studio artists who came of age in the fifties still actively creating work today.

Ruth Duckworth fled Nazi Germany in 1936 and settled in England, where she assisted Lucie Rie with her button-making business during World War II. These two small porcelain sculptures, one from the cup-and-blade series Duckworth began in the seventies, have such crisply defined edges and contours that at first glance they appear to be industrially fabricated. Close inspection, however, reveals a subtly mottled, alabasterlike surface—evidence of her prior experience with stone carving. The luminosity of the thin porcelain slices reveals her skill in working with this temperamental material.

Much like Cabat's work, Duckworth's porcelain pieces are devoid of context, inviting visual and tactile exploration. The works' delicate tonalities and planar forms recall the materiality of Cycladic sculpture, as well as the way in which body parts of such ancient figures bisect, dissect and bulge into space. These small porcelains represent one part of her oeuvre, the other being large architectural installations, including *Earth, Water and Sky* in the Geophysical Science Building at the University of Chicago (1964).

Duckworth remains a modernist sculptor who refuses to follow trends. She refines ideas to their basic elements, creating works along the lines of Constantin Brancusi and Isamu Noguchi in their organic roundness, materiality and embrace of abstracted formal elements from a range of ancient cultures. Duckworth has embraced challenges throughout her career, from the decision to work with many clay types instead of limiting herself to just one, and embracing various experimental techniques such as coiling in defiance of those who dismissed it as a "primitive" process. Regardless of scale or materials, Duckworth has chosen her own ways of working and developed her own visual vocabulary.

ABOVE (BACK ROW, L TO R): Rose Cabat, *Green & Brown Feelie*, c. 1980; porcelain; 3.75 × 2.5 inches diameter; Promised gift from Carol and Seymour Haber

Green Feelie, c. 1980; porcelain; 4 × 2.5 inches diameter; Gift of Hal Cary; 1998.91.06

Gold Feelie, c. 1980; porcelain; 3 × 3 inches diameter; Gift of Hal Cary; 1998.91.07

ABOVE (FRONT ROW, L TO R): *Light Green Feelie*, c. 1980; porcelain; 2.5 × 3 inches diameter; Promised gift from Carol and Seymour Haber

Yellow & Brown Feelie, c. 1980; porcelain; 3 × 2.75 inches diameter; Promised gift from Carol and Seymour Haber

FACING PAGE (L TO R): Ruth Duckworth, *Untitled*, 1988; porcelain; 4.25 × 4 inches diameter; Promised gift from Carol and Seymour Haber

Untitled, 1988; porcelain; 10.75 × 3.75 inches diameter; Promised gift from Carol and Seymour Haber

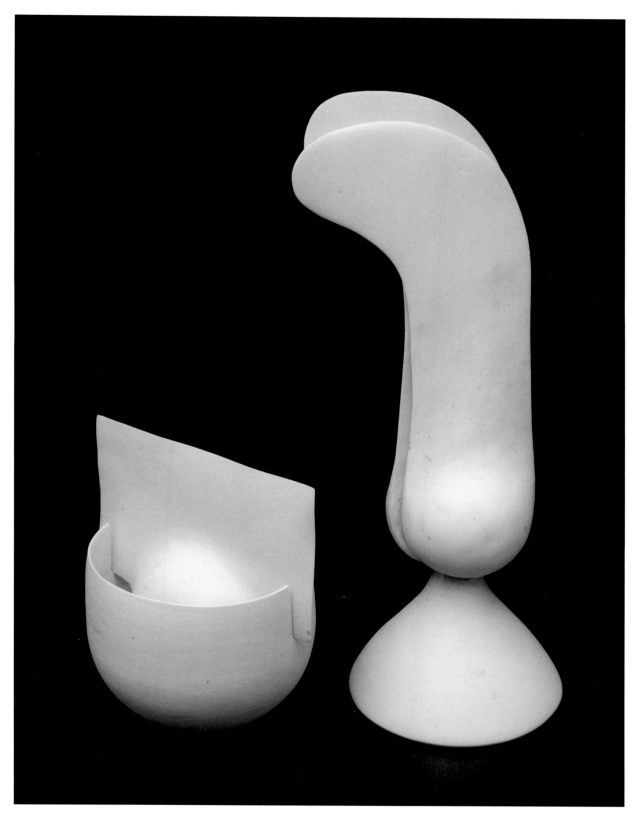

1990s
Identity
Crisis

T he 1990s tested CCG's ability to remain integral to Portland's cultural landscape. The decade was a challenging time for the institution on a number of levels, partly due to the increasing blurring of distinctions between "art" and "craft." Director Marlene Gabel enrolled the CCG in the Museum Assessment Program (MAP), founded by the American Association of Museums (AAM) to help organizations understand how they compare to standards in their field, evaluate the most pressing challenges before them and determine avenues for improvement. The MAP evaluation noted in 1990 that the organization's relationship between its profit-making sales gallery (in existence since 1937) and the overarching nonprofit organization, the Contemporary Crafts Association, was poorly defined. In addition there were management issues between CCG programming and the Artists-in-the-Schools program, which had separate funding sources. Coordinating these branches under one management structure became a priority.

As a number of commercial contemporary galleries surfaced in Portland featuring the work of craft artists, CCG's unique status and primary source of revenue diminished significantly. With the growing burdens of administrative tasks, Gabel struggled to write grants and

fundraise, almost single-handedly. The institution was clearly in transition and needed to reassess its purpose, mission and role in the community.

Despite these difficulties, CCG continued to organize significant exhibitions in the nineties, focusing on fiber, glass and thematic group exhibitions often comprised of local artists. With exceptions, such as *The Reality of Illusion* (1992) and *What Modern Was: Three Decades of Furniture '30s–'50s* (1993), both guest-curated by Ed Cauduro, and important historical retrospectives of the work of Vivika and Otto Heino (1993), Frank Boyden (1996) and Ray and Jere Grimm (1997), most exhibitions during the decade were sweeping surveys with only a single or just a few examples of any one artist's work. Textile exhibitions revealed the different ways fibers were being engaged including *Art Quilts: Message in Disguise* (1992), *New Voices in Weaving* organized by Cynthia Schira (1996), and several exhibitions showed a strong local interest in a myriad of tapestry approaches. Glass exhibitions included *Contemporary Kilnformed Glass*, guest-curated by Dan Schwoerer and Lani McGregor of Bullseye Glass (1992), and a neon exhibition curated by Gabel (1995).

The proliferation of artists working in craft media mirrored the pluralism with which the contemporary art world was struggling at the time. The primary difference between the so-called art and craft arenas, however, rested in a lack of tactical programming and educational focus, both at CCG and in the craft world at large.

Despite financial difficulties, inadequate facilities and lack of staff, Gabel led a successful fundraising campaign to add a new annex to the building on Corbett Avenue. Designed by local architect Bill Fletcher, the new gallery made it possible to safely and professionally exhibit rarely seen works from the CCG collection, many by West Coast pioneers in the American Craft Movement. Gabel saw the ongoing display of these pieces as playing a significant role in the next phase of development for the organization. Sadly, Gabel resigned and died shortly after the christening of the new gallery space, which was named in her honor.

Gabel was succeeded by Pam Siers, who quickly changed the organization's name to the Portland Center for Contemporary Craft, revamped the staff and brought important issues to the forefront. However, Siers faced significant resistance from the Board and volunteers, and resigned after eight short months. In 1999, Darcy Edgar, who at the time was under contract to catalogue the collection, became the director and spent the next few years rebuilding the institution's infrastructure, which included the hiring of professional staff to organize exhibitions and develop programs centered on the collection. Edgar returned the name to Contemporary Crafts Gallery and directed the organization until 2002.

IMAGE LEFT: Maribeth Collins and visitor at a Contemporary Crafts Gallery event celebrating the new permanent collection gallery, September 1999. Photo: Mary Tapogna.

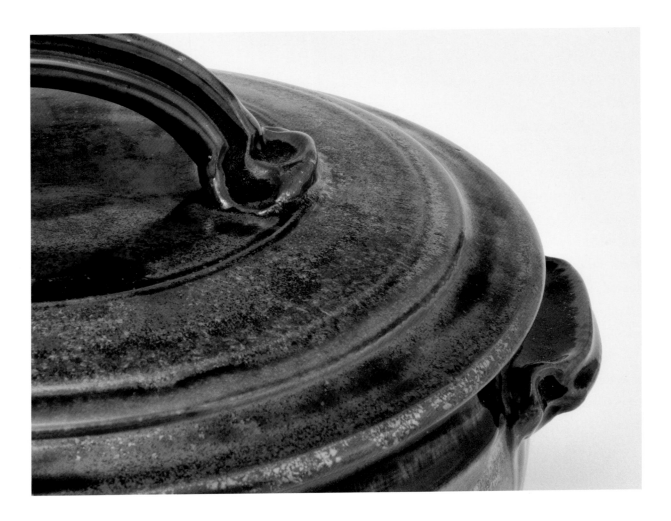

Wally Schwab
FUNCTIONAL CERAMICS

For the past several decades, Wally Schwab's distinctive style of presentational pottery has remained a popular element in Portland's craft community. Schwab's pottery often juxtaposes cosmos-like patterns against a black base, providing a visual surprise upon lifting a lid. Other pieces are covered in orderly designs that echo Moroccan tile work but in a softer palette that is further warmed by Schwab's earth-toned stoneware, versus the white backgrounds typically found in Islamic patterns. His pottery has an ideological connection to that of Frances Senska, linking the handcrafted vessel to the home environment and a history of the vernacular, as well as beautiful and functional ceramics.

Wally Schwab, *Yunnan Steamer*, c. 1990; ceramic; 6 × 11.5 inches diameter;
Gift of Diane and Roy Marvin; 2001.12.02 A,B

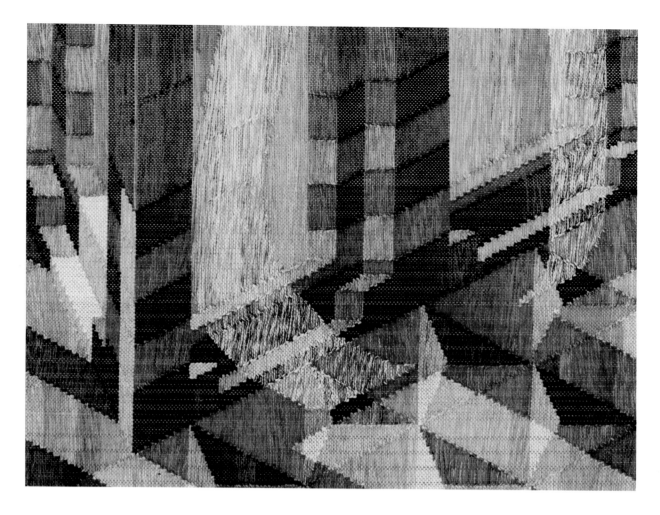

Judith Poxson Fawkes
ARCHITECTURE/TAPESTRY

Judith Poxson Fawkes based this large linen tapestry
on photographs of interiors of Italian churches. Fawkes
employs a technique exclusive to architecture called
axonometric drawing in which an interior space is trans-
lated into a drawing using only vertical and horizontal
lines and forty-five-degree angles—an abstracted image
of the space that retains the illusion of depth. The con-
fines of this type of drawing are particularly suited to the
logic and constraints of tapestry, leaving plenty of room
for Fawkes to employ her own palette to accentuate the
resulting patterns. Switching from painting to weaving
while earning her MFA from Cranbrook Academy of Art,
Fawkes redefined the ancient craft by introducing a new
pictorial structure borrowed from architecture but leav-
ing enough room for the artist to explore a new applica-
tion of technique, processes and materials.

ABOVE: Judith Poxson Fawkes, *Dyer's Passage*, 1998; linen; 54 × 73 inches;
Gift of the artist; 2000.10.01

Linda Hutchins
PUSHING BOUNDARIES

Linda Hutchins' *DO NOT CROSS THIS LINE* is a humorous challenge to the processes, procedure and constraints of tapestry. Responding to a call for entries that stipulated a specific square footage for a woven and wall-mounted piece, Hutchins instead created an absurdly long woven strip that matched the square footage in linear form, installed between stanchions as a freestanding piece. The work raises questions about where meaning is found in tapestry. Does it reside in the tedious, repetitive process of moving threads or in the execution of a predetermined pictorial representation? Hutchins' tapestry addresses both questions simultaneously through the creation of a piece executed in a counted stitch process and the representation of common, easy-to-replicate letters used in signage. Pushing questions about tedium, meditative processes and banality to the forefront, Hutchins challenges the viewer to consider where the line lies, and why it must be crossed—both physically and conceptually.

FACING PAGE: Linda Hutchins, *DO NOT CROSS THIS LINE*, 1994; cotton, steel, wood; 2 × 18 × 2 feet when fully extended; Gift of the artist; 2007.14.01

ABOVE AND RIGHT: Sharon Marcus, *Reconstructing Time*, 1994; cotton, wool, linen, goathair, horsehair; 36 × 59.5 inches; Gift of the artist; 2000.11.01

Sharon Marcus
ARCHAEOLOGY/TAPESTRY

Sharon Marcus draws a metaphorical relationship between the grid structure of an archaeological site and tapestry as a means for communicating narratives, some more visible than others, and some perhaps never fully realized. Whereas excavation involves the uncovering of layers of time from top to bottom, working through a process in which nature has obscured meaning and relationships, tapestry is a building process in which meaning is constructed from the bottom up. Trained as an archaeologist and longtime head of the Fibers Program at Oregon College of Art and Craft, Marcus used a photo from ruins in Costa Rica as the source for this abstracted tapestry. While the grid provides some structure, Marcus' weaving reveals how the device is an inherently inadequate means of understanding a full picture of a cultural site.

Lou Cabeen
HANDICRAFTS IN ART

Lou Cabeen defines herself as part of a "witness generation," women who watched older generations create an extraordinary amount of domestic handicrafts during a time when there was no external outlet for the exhibition—or appreciation of—their skills. Stitched together at the top, *Ambition* is composed of six dresser scarves embroidered by several generations of women in Cabeen's family. Cabeen's own simply rendered, ghostly white stitches recall the sayings on samplers used to showcase a young woman's skills at executing domestic handicrafts. By adding the phrase "If These You See, Will You Remember Me," and exhibiting the work in a gallery or museum, Cabeen resurrects and brings renewed life to a domestic past and pastime within the context of the art world's "white cube." When hanging in a museum, the work raises questions about cultural expectations surrounding the many women who created the piece, and the contexts in which creative endeavors are pursued. *Ambition* exposes handicraft traditions as a site of feminine creativity, propelling Cabeen's project into a feminist critique of a women's place in and outside the home, and the role of domestic practices in the contemporary art arena.

Lou Cabeen, *Ambition*, 1995; embroidery on found family textiles; 17 × 48 inches; Gift of the artist; 2007.11.01

Donna D'Aquino
DIMENSIONAL DRAWING

Constructed from steel bending wire—typically a disposable material used in making art jewelry—Donna D'Aquino's bracelet is a study in the architectural form of a three-dimensional drawing. When not in use, the bracelet hangs from a nail on the wall. Lit from above, its shadows highlight linear qualities within the broader architectural context of a room. On the body, the work is large—even cumbersome—requiring the wearer to be continuously aware of its physical presence. This bracelet is characteristic of D'Aquino's ongoing exploration of the relationship between line and space, corporeality and architecture.

FACING PAGE, TOP: Donna D'Aquino, *Wire Bracelet #13*, 1999; steel; 6 × 7 × 3 inches; Contemporary Crafts Gallery Purchase; 2000.02.01

FACING PAGE, BOTTOM: Lino Tagliapietra, *Purple Bowl*, 1999; glass; 28.5 × 4.5 inches diameter; Gift of the Larsen Estate; 2004.08.02

BELOW, RIGHT: Patrick Horsley, *Purple Teapot*, 1998; stoneware; 20 × 16 × 4 inches; Oregon Potters Association Award 1998; 2001.08.22

Patrick Horsley
OREGON POTTERS ASSOCIATION

Along with the bowl, the teapot functions as a foundational structural form for exploration in the craft arena, particularly through clay and metal. The teapot serves as the form that first teaches students how to build a body, handle, spout and lid, and how to connect these pieces to one another. Patrick Horsley created this teapot on the potter's wheel and then manipulated it to push the form of the teapot into an architectural silhouette. Colored glazes, strategically applied using an airbrush, add dimensional effects and further accentuate the contours of the object.

A graduate of the Museum Art School (now Pacific Northwest College of Art), Horsley defines himself as a potter and has actively participated in the Northwest craft community since the seventies. He worked with George Cummings and Phil Eagle and shared a studio with Tom Coleman and Don Sprague. Horsley is a longtime member of the Oregon Potters Association (OPA), a local guild organized in 1979 by Tom Coleman, Ellen Currans and Bert McDowell to provide the community with technical support and assistance in obtaining materials. In 1983, the OPA started the "Ceramic Showcase," which is one of the largest shows and sales of ceramics today.

Lino Tagliapietra
SHARING SECRETS

When Lino Tagliapietra taught a workshop at Pilchuck Glass School in Washington in the summer of 1979, he injected new energy into a languishing Studio Glass Movement. Tagliapietra, who apprenticed with Muranese master Archimede Seguso at age eleven and earned the rank of maestro by twenty-one, shared the secrets of centuries-old Venetian glassmakers from the Island of Murano, making their techniques available outside of that small, closed community for the first time.

Despite criticism from the Murano glass community, Tagliapietra continues to share his techniques and experience—knowledge that significantly raised the level of craftsmanship throughout the American studio glass community. In turn, the artistic freedom in which American glass artists operated encouraged Tagliapietra to move beyond his formal training to further develop his own studio practice. Created in the nineties, this bowl reveals his skill at creating dimensional forms with complex linear patterns that enhance the architectural structure of the vessel.

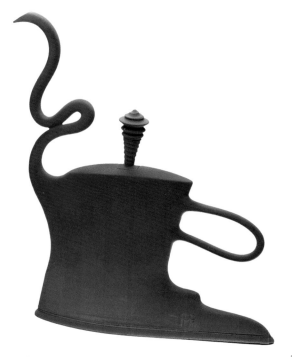

2000s
Renewal

*We stick our necks out. We are venturesome, willing
to face the consequences and take the bruises.*

—Lydia Herrick Hodge[1]

David Cohen succeeded Darcy Edgar as executive director of Contemporary Crafts Gallery in 2002. With a long history of arts administration, Cohen, much like former directors Gabel and Edgar, placed the collection at the center of the institution's focus. To reflect this, the name of the institution changed again to Contemporary Crafts Museum & Gallery in 2003. Reckoning with the fact that the building was suffering from years of deferred maintenance and that the picturesque but out-of-the-way locale hindered audience development, Cohen led the Board to the momentous decision to move the organization to a new location in Portland's art-centric Pearl District.

Taking up residence in the historic DeSoto building in downtown Portland, the newly named Museum of Contemporary Craft opened in July 2007. In an age when many institutions are removing the word "craft" from their names—most notably the American Craft Museum, renamed the Museum of Arts and Design (2002), and California College of Arts and Crafts, renamed California College of the Arts (2003), the Board and staff of the Museum continue to embrace craft as a vital part of the history of the visual arts in the Pacific Northwest. Craft is engaged as a verb and is more than a media-defined mode of artmaking, historical movement or subset of other forms of visual art practice. Redefining itself as a center for dialogue and inquiry, the Museum of Contemporary Craft continues to embrace the spirit of the institution's founder Lydia Herrick Hodge.

1. Van Cleve, Jane. *3934 Corbett: Fifty Years at Contemporary Crafts* (Portland, OR: The Contemporary Crafts Association, 1987), p1.

FACING PAGE: Yoko Inoue, North Window Project, Performance/Installation view, 2006.

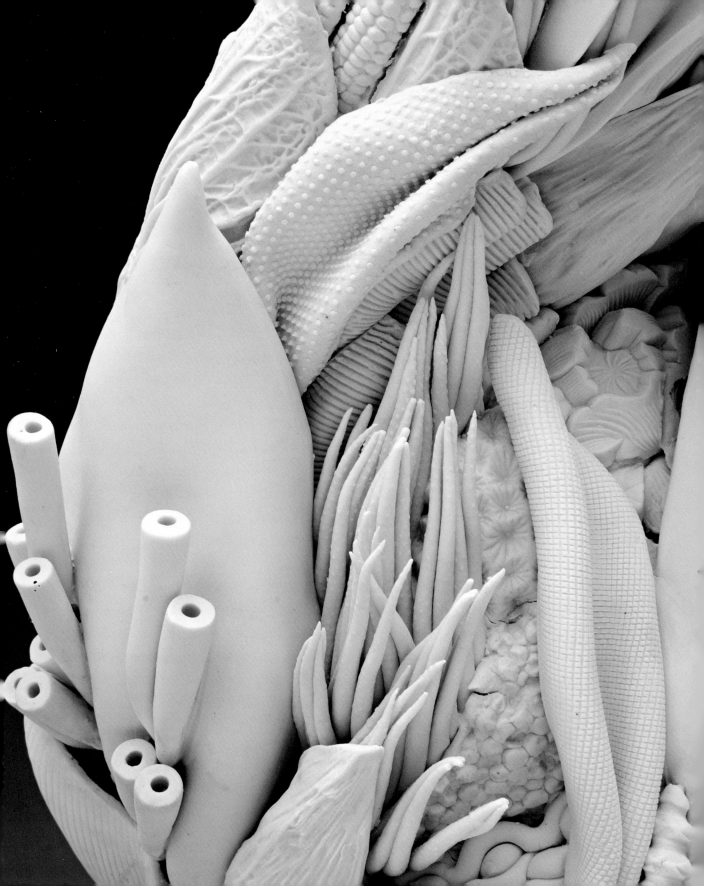

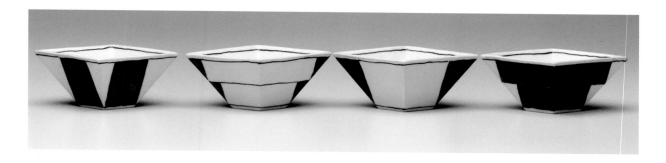

Kyoko Tokumaru
ACCUMULATED FORMS

Kyoko Tokumaru's *Germination* series, created during her Halvorsen Residency at CCG in 2001–02, focused on exquisitely detailed built forms. At first glance, the works appear to be carved stone—arrested forms pulled from a watery space, frozen but not devoid of life. Upon closer inspection, it is clear that each individual segment, frond and furl has been obsessively created and assembled. The way in which Tokumaru's porcelain forms are built creates the sensation that at any moment more fronds and forms could erupt from within, pushing the configuration to shift its shape. Tokumaru's project, in many ways, reflects a global interest in accumulation and an almost obsessive-compulsive attention to detail, which is considered by some to be a reflection of—and response to—the post-9/11 milieu.

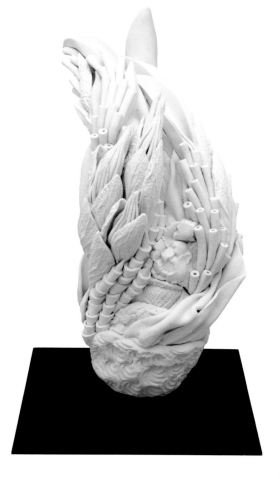

Bodil Manz
GEOMETRIC FORMS

Bodil Manz applies transfers to her crisp, white and translucent porcelain vessels to create patterns of light and shadow, often visible through not just one, but both walls of the form. Her vessels are often cylindrical and always geometric. The contrast between bold lines and surface decoration applied to paper-thin, slip-cast porcelain forms is striking and self-assured, recalling the work of Russian Suprematist Kazimir Malevich and the De Stijl paintings of Piet Mondrian.

FACING PAGE AND RIGHT: Kyoku Tokumaru, *Germination (Festive)*, 2002; porcelain; 13.75 × 7.5 × 5 inches; Gift of Carol and Seymour Haber, Purchased from Artist-in-Residence Exhibition, 2002.01.01

ABOVE: Bodil Manz, *Untitled four vessels*, date unkown; porcelain; 4 × 3 × 1.5 inches; Promised gift from Carol and Seymour Haber

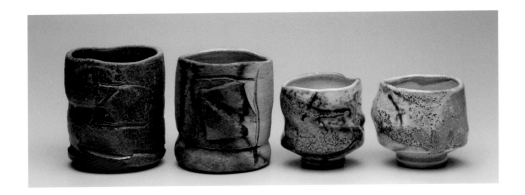

Don Reitz and Tom Coleman
THE SOUL OF A BOWL

Don Reitz and Tom Coleman created these tea bowls for
The Soul of a Bowl, a traveling exhibition organized by
CCG on view in 2004. Considered a basic ceramic form,
the Japanese-style tea bowl served as the focus of the
exhibition. Reitz, Frank Boyden, Tom and Elaine Cole-
man and Jenny Lind each created a set of eight bowls,
demonstrating how contemporary ceramists might make
an iconic form their own. Despite historical links to
traditional vessels created and used in China, Korea and
Japan, Reitz clarifies this distinction in emphatic terms:

> I'm not Japanese; I can't make a Japanese tea bowl
> as I cannot make a child drawing because I'm not a
> child. And it seems to me a great waste of my time
> to try and make a Japanese tea bowl. I make a Don
> Reitz tea bowl. [1]

Reitz is recognized for reviving a centuries old
salt-fired glazing process in studio practice in the United
States. When fired in a salt kiln, spontaneous recordings
of fumes on the clay mark the surfaces with unusual
colors, an extension of Reitz's spontaneous and expres-
sionstic approach to ceramics.

While Reitz's work is about embracing process,
chance and the sculptural aspects of functional forms,
Tom Coleman's bowls are about refined control and a
focus on the final form. Widely recognized for his vast
knowledge and willingness to share the intricacies of
his decorative and technical skills, Coleman's tea bowls
reveal his facility with ceramics.

1. Clowes, Jody. *Don Reitz: Clay, Fire, Salt, and Wood* (Madison, WI: Chazen Museum of
Art, 2005) p92.

Rick Bartow
EXPERIMENTS

At Frank Boyden's urging, Rick Bartow experimented
briefly with clay, creating a series of pieces that
expressed the emotional intensity of his approach to
materials. Quickly formed, the works incorporate frag-
ments and discarded bits from Boyden's studio, an
assemblage approach Bartow also uses in his sculptures
created from found objects and scraps of wood.

Bartow engages a diverse and complex range of
influences, merging Native American mythology from
his Wiyot heritage with a conscious decision to use art
materials that suit his years of art school training and a
life connected to—but lived outside of—a tribal situation.
His works on paper, for example, combine an intense
use of color with graphic marks and expressive, fantasti-
cal images drawn from a composite of Native American
mythological figures and Western art history. Fired by
Boyden in his wood-fired kiln, dark reds and browns
bring out the emotional intensity and physicality of
Bartow's art, regardless of the materials.

ABOVE (L TO R): Don Reitz, *Tea Bowl #8*, 2003; stoneware; 5.5 × 4.5 inches diameter; Gift
of the Collins Family; 2003.09.32

Don Reitz, *Tea Bowl #7*, 2003; stoneware; 5 × 4.5 inches diameter; Gift of the Collins
Family; 2003.09.31

Tom Coleman, *Tea Bowl #8*, 2003; porcelain; 4 × 4.5 inches diameter; Gift of the Collins
Family; 2003.09.16

Tom Coleman, *Tea Bowl #4*, 2003; porcelain; 4 × 4 inches diameter; Gift of the Collins
Family; 2003.09.12

FACING PAGE (L TO R): Rick Bartow, *Crow Figure 8*, 2002; Anagama fired ceramic,
porcelain; 3.5 × 3.25 × 7 inches; Gift of the artist and Froelick Gallery in honor of the
Museum's 2007 Grand Re-Opening; 2007.09.02

Crow Figure 9, 2002; Anagama fired ceramic; 3 × 3 × 5.75 inches; Gift of the artist and
Froelick Gallery in honor of the Museum's 2007 Grand Re-Opening; 2007.09.03

Crow Figure 2, 2002; Anagama fired ceramic; 7 × 7.5 × 7.5 inches; Gift of the artist and
Froelick Gallery in honor of the Museum's 2007 Grand Re-Opening; 2007.09.01

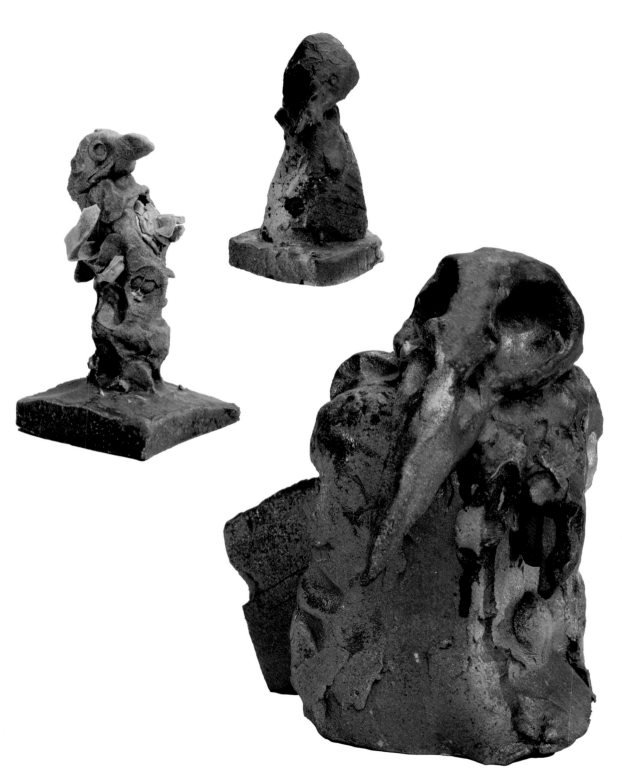

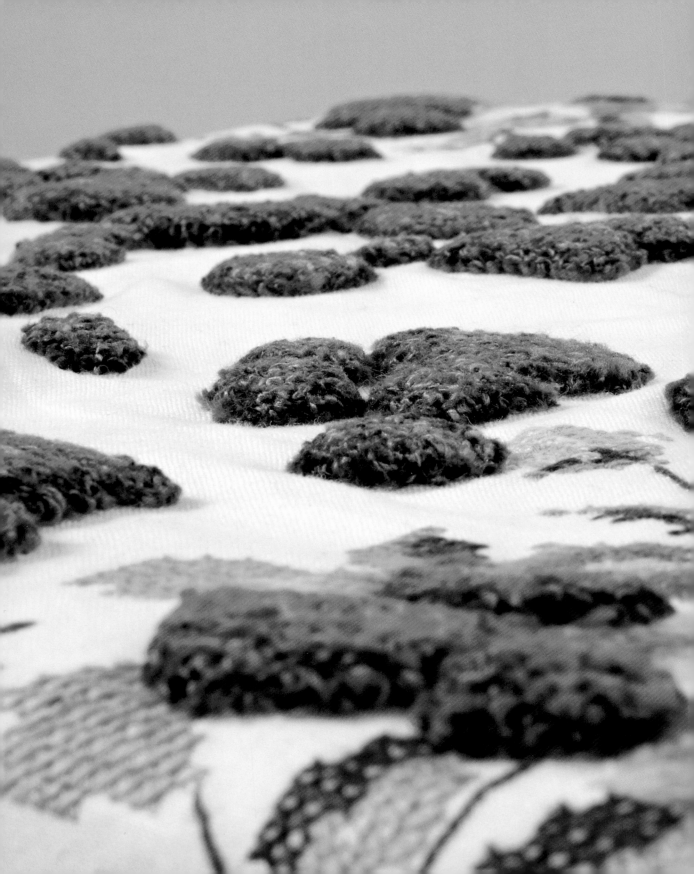

Hildur Bjarnadóttir
CRAFT AS PRACTICE

Hildur Bjarnadóttir's work takes on layers of history and cultural connections through craft practices linked to domesticity. In *Frippery*, Bjarnadóttir embroidered patches resembling velvet-pile "moss" to a hand-embroidered cotton tablecloth, similar to those created by her grandmother. Placed atop a pedestal, the piece is a humorous play on relocating the domestic outside the home. Its scale also mimics the lichen and moss-covered concrete walls that line the sidewalks in her hometown in Iceland. In addition, placing the work in the context of a gallery or museum brings both the domestic and the natural realm into an art-historical framework, simultaneously referencing the vernacular and renowned Icelandic landscape painter Johannes S. Kjarval. Labor-intensive and full of humorous double entendres, Bjarnadóttir's piece subverts and challenges ideas of what a work of art is and how it comes into being. Bjarnadóttir raises an important question through her practice: is this art, craft or both?

FACING PAGE AND RIGHT: Hildur Bjarnadóttir, *Frippery*, 2005; velvet pile embroidery on vintage tablecloth; 48 × 48 inches; Gift of MaryAnn Deffenbaugh; 2007.12.01

Artist Information

The following includes an annotated biography for each artist featured in this publication.

Note: *California College of Arts & Crafts* is now *California College of the Arts; California School of Fine Arts* is now *San Francisco Art Institute; Museum Art School* is now *Pacific Northwest College of Art; Oregon Ceramic Studio* and *Contemporary Crafts Gallery* are now *Museum of Contemporary Craft; Oregon School of Arts & Crafts* is now *Oregon College of Art and Craft; Otis Art Institute* is now *Otis College of Art and Design.*

Laura Anderson
b. 1902 San Bernardino, CA d. 1999

EDUCATION
1932 BA Valedictorian, University of California, Los Angeles
1937 MFA in Painting, Columbia University, New York, NY

PROFESSIONAL EXPERIENCE
1933–70 Ceramics teacher and Department Chair, University of California, Los Angeles

Joe Apodaca
b. 1942 Tucson, AZ

EDUCATION
1961 University of Arizona, Tucson, AZ
1964 AA, 1966 BFA, 1967 MFA Rochester Institute of Technology, NY

PROFESSIONAL EXPERIENCE
1967–1990 Teaching experiences in US, Canada and Costa Rica
1979–81, 83–85 Head of Metals Department, Oregon School of Arts & Crafts, Portland, OR
1969–present Self-employed jeweler/craftsperson

Linda Apodaca
b. 1944

EDUCATION
1964 AA, Pasadena City College, CA
1964–68 BFA, Rochester Institute of Technology, NY
1968–69 California State College, Los Angeles

PROFESSIONAL EXPERIENCE
1989–96 Steering Committee President, Creative Metal Arts Guild Show, Portland
1969–present Self-employed jeweler/craftsperson

Robert Arneson
b. 1930 Benicia, CA d. 1992

EDUCATION
1949–51 College of Marin, Kentfield, CA
1954 BA, California College of Arts & Crafts, Oakland
1958 MFA, Mills College, Oakland, CA

PROFESSIONAL EXPERIENCE
1962–91 Professor and Head of Ceramics, University of California, Davis

Rudy Autio
b. 1926 Butte, MT d. 2007

EDUCATION
1950 BS, University of Montana, Bozeman
1952 BFA, Washington State University, Pullman
Honorary DFA, Maryland Institute, Baltimore

PROFESSIONAL EXPERIENCE
1943–44 Served in US Navy
1952–57 Artist-in-Residence, Archie Bray Foundation for the Ceramic Arts, Helena, MT
1957 Assistant Curator, Montana Museum & Historical Society, Helena
1957–71 Professor and Head of Ceramics at University of Montana, Missoula
1980 Lecturer, Arabia Porcelain Factory & the Applied Arts University, Helsinki, Finland

Rick Bartow
b. 1946 Newport, OR
Tribal Affiliation: Member of the Wiyot Tribe, Northern CA

EDUCATION
1969 BA, Western Oregon State College, Monmouth

PROFESSIONAL EXPERIENCE
1969–71 Served in US Army during the Vietnam War
1978–80s Teacher, Portland Community College and Corvallis Community College, OR
1977–present Teacher, workshops, symposiums and visiting lecturer
2001 Artist-in-Residence, Crow's Shadow Institute of the Arts, Pendelton, OR
Musician

Fred Bauer
b. 1937 Memphis, TN

EDUCATION
1962 BFA, Memphis Academy of Arts (now Memphis College of Art), TN
1964 MFA, University of Washington, Seattle

PROFESSIONAL EXPERIENCE
1964 Archie Bray Foundation for the Ceramic Arts, Helena, MT
1964–65 Teacher, University of Wisconsin, Madison
1967 Teacher, Haystack Mountain School of Crafts, Deer Isle, ME
1965–68 Teacher, University of Michigan, Ann Arbor
1968–71 Teacher, University of Washington, Seattle
1972–present Farmer, CA

Hildur Bjarnadóttir
b. 1969 Reykjavík, Iceland

EDUCATION
1985–89 Commercial College of Iceland, Reykjavík
1998–92 Icelandic College of Art & Craft, Reykjavík
1997 MFA, Pratt Institute, Brooklyn, NY

PROFESSIONAL EXPERIENCE
Artist

Frank Boyden
b. 1942 Portland, OR

EDUCATION
1965 BA, Colorado College, Colorado Springs
1968 BFA, MFA, Yale University, New Haven, CT
1977 Ceramic studies in Peru and Ecuador

PROFESSIONAL EXPERIENCE
1968–71 Professor at University of New Mexico, Albuquerque
1970–present Founder and Teacher, Sitka Center for Art and Ecology, Otis, OR
1971–present Self-employed artist
1976–78 Faculty, Oregon School of Arts & Crafts, Portland
1985 Assistant Editor, *Studio Potter*
1985 Artist-in-Residence, National College of Art & Design, Oslo, Norway
1991–present Founder, Margery Davis Boyden Wilderness Writing Residency Program, OR

Rose Cabat
b. 1914 New York, NY

EDUCATION
Self-taught
1940 Greenwich House Pottery, New York, NY
1956 University of Hawaii

PROFESSIONAL EXPERIENCE
1954 Helped set up Tucson Art Center (now Tucson Museum of Art), AZ
1972 Assisted in designing and marketing handcrafts at the Tehran School of Social Work

Lou Cabeen
b. 1950

EDUCATION
1973 BA, University of Maryland, College Park
1989 MFA, School of the Art Institute of Chicago, IL

PROFESSIONAL EXPERIENCE
1993 Artist-in-Residence, Illinois Wesleyan University, Bloomington
1993–present Professor of Art and Women's Studies, University of Washington, Seattle

Elaine Coleman
b. 1945 Long Beach, CA

EDUCATION
1964–67 Museum Art School, Portland, OR

PROFESSIONAL EXPERIENCE
1967–2002 Studio potter
1973–present Various workshops and teaching
1989–92 Gallery Director, Moira James Gallery, Green Valley, NV
1994–2001 Coleman Clay Studio & Gallery, Inc., Las Vegas, NV

Tom Coleman
b. 1945 Amarillo, TX

EDUCATION
1968–69 Apprentice to Bill Creitz, Portland, OR
1968 MFA, Museum Art School, Portland, OR

PROFESSIONAL EXPERIENCE
Served in US Army
1969 Teacher, Oregon School of Arts & Crafts, Portland
1969–73 Ceramics Instructor, Portland State University and Museum Art School, OR
1989–92 Ceramics Instructor, University of Nevada, Las Vegas
1994–2001 Coleman Clay Studio & Gallery, Inc., Las Vegas, NV

Peter Collingwood
b. 1922 London, United Kingdom

EDUCATION
Epsom College, Surrey, United Kingdom
1946 Qualified in Medicine, St. Mary's Medical School, London, United Kingdom
Late 1940s Farnham Art School, Surrey, United Kingdom

PROFESSIONAL EXPERIENCE
Early 1940s–present Musician
1946–50 Surgeon, Royal Army Medical Corps, British Army
1949–50 Doctor, Red Cross, Amman, Jordan
1950–present Weaver
Teacher, Hammersmith College of Arts & Crafts, United Kingdom
1962, 64, 68 Visiting teacher, US

Anna Belle Crocker
b. 1867 Milwaukee, WI d. 1961

Florence Crocker
b. unavailable d. unavailable

EDUCATION (ANNA BELLE)
1904, 08 The Art Students League of New York, NY

EDUCATION (FLORENCE)
unavailable

PROFESSIONAL EXPERIENCE (ANNA BELLE)
1909 Bank secretary, Portland, OR
1940s Designer, weaving team with sister Florence Crocker
1909–36 Curator, Portland Art Museum and Head of Museum Art School, OR

PROFESSIONAL EXPERIENCE (FLORENCE)
1940s Weaver, weaving team with sister Anna Belle Crocker

George Cummings
b. 1936 Edmonton, Alberta, Canada

EDUCATION
1959 BA in Philosophy, University of British Columbia, Canada
1960–62 Museum Art School, Portland, OR
1962 Apprentice, Pacific Stoneware Co.
1964–65 Studios in United Kingdom and Switzerland

PROFESSIONAL EXPERIENCE
1959–63 Biophysics Research Assistant, University of Oregon Medical School (now Oregon Heath & Science University), Portland
1966–72 Instructor, Oregon School of Arts & Crafts, Portland
1966–69, 74–80 Instructor, Museum Art School, Portland, OR

Donna D'Aquino
b. 1965 Newburgh, NY

EDUCATION
1989 BS in Design, State University of New York, Buffalo
2000 MFA in Jewelry and Metalsmithing, Kent State University, OH

PROFESSIONAL EXPERIENCE
1996–99 Graduate Teaching Assistant, Kent State University, OH
1999 Teacher, Kent State University, OH
1999–2001 Professor, University of Akron, OH
2001–03 Professor, University of Toledo, OH
2005 Visiting artist, Arrowmont Craft School (now Arrowmont School of Arts and Crafts), Gatlinburg, TN
2005–present Self-employed artist

Ruth Duckworth
b. 1919 Hamburg, Germany

EDUCATION
Liverpool School of Art, United Kingdom

PROFESSIONAL EXPERIENCE
1964–77 Professor of Sculpture, University of Chicago, IL

John Economaki
b. 1952, IA

EDUCATION
1973 BS in Industrial Arts, Iowa State University, Iowa City
1974–75 Graduate work, Oregon State University, Corvallis, OR
1978 Furniture-making workshop with Sam Maloof, Anderson Ranch, Aspen, CO

PROFESSIONAL EXPERIENCE
1973–78 Woodworking Instructor, Lincoln High School, Portland, OR
1975–83 Independent furniture maker and designer
1980–83 Board Member, Contemporary Crafts Gallery, Portland, OR
1983–present Founder and Owner, Bridge City Tool Works, Portland, OR

Judith Poxson Fawkes
b. 1941

EDUCATION
1963 BFA and Teaching Certificate, Michigan State University, East Lansing
1965 MFA, Cranbrook Academy of Art, Bloomfield Hills, MI

PROFESSIONAL EXPERIENCE
Tapestry weaver
1965–66 Teacher, Southern Oregon State College (now Southern Oregon University), Ashland
1966–68 Teacher, Wisconsin State University, Oshkosh
1969–72 Teacher, Maude Kerns Art Center, Eugene, OR
1972–74 Teacher, Mt. Hood Community College, Gresham, OR
1975–77 Teacher, Marylhurst College (now Marylhurst University), Portland, OR
1974–84 Teacher, Lewis & Clark College and Portland Community College, OR

Ken Ferguson
b. 1928 Elwood, IN d. 2004

EDUCATION
1952 BFA, 1955 Public School Teaching Certificate, Carnegie Institute of Technology, Pittsburgh, PA
1958 MFA, New York State College of Ceramics at Alfred University

PROFESSIONAL EXPERIENCE
1952–54 Corporal, US Army in Japan
1954–56 Drawing and Ceramics Instructor, Carnegie Institute of Technology, Pittsburgh, PA
1956–58 Teaching Fellow and Graduate Assistant, New York State College of Ceramics at Alfred University
1958–64 Resident Potter and Manager, Archie Bray Foundation for the Ceramic Arts, Helena, MT
1964–96 Head of Ceramics, Kansas City Art Institute, MO
1996–2004 Studio potter

Betty Feves
b. 1918 Lacrosse, WA d. 1985

EDUCATION
1939 BFA, Washington State College, Pullman
1939–1940 St. Paul School of Art, MN
1941 MA in Arts Education, Teachers College, Columbia University, New York, NY
1943 Studied with Ossip Zadkine, The Art Students League of New York, NY

PROFESSIONAL EXPERIENCE
Artist, Violin teacher, President of Oregon Board of Higher Education

Ray Grimm
b. 1924 St. Louis, MO

EDUCATION
1953 BFA, Washington University, St. Louis, MO
1956 MS, Southern Illinois University, St. Louis, MO

PROFESSIONAL EXPERIENCE
Served in US Navy during World War II
1953–55 Instructor, Peoples Art Center, St. Louis, MO
1954–55 Instructor, Mary Institute, St. Louis, MO
1957 Instructor, Museum Art School, Portland, OR
1957–88 Professor of Art, Founder of Ceramics Department, Portland State University, OR
1972 Founder, Glass Shack Workshop, Portland State University, OR

Erik Gronborg
b. 1931 Copenhagen, Denmark

EDUCATION
1962 BA, 1963 MA, University of California, Berkeley

PROFESSIONAL EXPERIENCE
1960–63 Teaching Assistant, University of California, Berkeley
1964 Photographer of archeological site, Cairo, Egypt
1965–69 Professor, Reed College, Portland, OR
1969–73 Professor, University of Nevada, Las Vegas
1973–75 Professor, San Diego State University, CA
1973–2001 Professor, Mira Costa College, Oceanside, CA

Shoji Hamada
b. 1894 Tokyo, Japan d. 1978

EDUCATION
1916 Ceramics, Tokyo Advanced Technical College, Japan
1917 Kyoto Municipal Institute of Ceramics, Japan
1920 Studied with Bernard Leach in the British Museum, United Kingdom
Honorary Doctorate, Michigan State University, East Lansing
Honorary Doctorate, Kings College, London, United Kingdom

PROFESSIONAL EXPERIENCE
1920 Set up St. Ives Pottery with Bernard Leach, United Kingdom
1924 Established studio in Mashiko, Tochigi Prefecture, Japan
1955 Awarded Living National Treasure Award, Japan
1962 Director, Japan Folk Art Museum (Nihon Mingei-Kan), Tokyo, Japan

Tom Hardy
b. 1921 Redmond, OR

EDUCATION
1938–40 Oregon State College, Corvallis
1942 BS, 1952 MFA in Metal Sculpture and Lithography, University of Oregon, Eugene

PROFESSIONAL EXPERIENCE
1942–45 First Lieutenant in US Air Force during World War II
1952 Graduate Assistant, University of Oregon, Eugene
1953–56 Sculpture Teacher, Oregon State Board of Higher Education
1956–58 California School of Fine Arts, San Francisco
1959–61 Artist-in-Residence, Reed College, Portland, OR
1975 Artist-in-Residence, University of Wyoming, Laramie
Artist

Vivika Heino
b. 1909 Caledonia, NY d. 1995

Otto Heino
b. 1915 East Hampton, CT

EDUCATION (VIVIKA)
1944 MFA, New York State College of Ceramics at Alfred University
1940 California School of Fine Arts, San Francisco
1933 BA in Fine Arts, Colorado College, Colorado Springs

EDUCATION (OTTO)
1951 League of New Hampshire Arts & Crafts, Concord
1955 University of Southern California, Los Angeles
1957 Chouinard Art Institute, Los Angeles, CA

PROFESSIONAL EXPERIENCE (VIVIKA)
1940s Teacher, League of New Hampshire Arts & Crafts, Concord
1950 Established pottery studio, Los Angeles, CA
1952–55 Head of Ceramics, University of Southern California, Los Angeles
1955–63 Department Head, Chouinard Art Institute, Los Angeles, CA
1963–65 Teacher, Rhode Island School of Design, Providence
1968–70 Sheridan College of Design, Ontario, Canada
1970–73 Head of Ceramics, New England College, Henniker, NH
Full-time potter

PROFESSIONAL EXPERIENCE (OTTO)
Served in US Air Force during World War II
1950 Established pottery studio, Los Angeles, CA
1954, 55 Teacher, University of Southern California, Los Angeles
1958–63 Teacher, Chouinard Art Institute, Los Angeles, CA
Full-time potter

Laurie Herrick
b. 1908 d. 1995

EDUCATION
Self-taught weaver

PROFESSIONAL EXPERIENCE
1940s Designer and Weaver for private clients and the film industry, Hollywood, CA
1952–55 Designer and Weaver for interior designers, Beverly Hills, CA
1958–79 Weaving Instructor, Oregon School of Arts & Crafts, Portland
Artist

Wayne Higby
b. 1943 Colorado Springs, CO

EDUCATION
1966 BFA, University of Colorado, Colorado Springs
1968 MFA, University of Michigan, Ann Arbor

PROFESSIONAL EXPERIENCE
1968–70 Professor, University of Nebraska
1970–73 Professor of Ceramics, Rhode Island School of Design, Providence
1973–present, Professor of Ceramic Art, School of Art & Design at Alfred University, NY

Ron Ho
b. 1936 Honolulu, HI

EDUCATION
1958 BA in Arts Education, Pacific Lutheran University, Tacoma, WA
1968 MAT in Arts Education, University of Washington, Seattle

PROFESSIONAL EXPERIENCE
Teacher, Portland State University, OR
Jewelry teacher, Haystack School, Cannon Beach, OR
1960–present Elementary school art teacher, Bellevue School District, WA

Lydia Herrick Hodge
b. 1886 Valparaiso, IN d. 1960

EDUCATION
Early 1900s, Undergraduate, Indiana State College, Terre Haute
1916 Scholarship to New York School of Philanthropy (now Columbia University School of Social Work), NY
1920 Art Program, University of Oregon, Eugene
1930–31 Studied in Paris, France

PROFESSIONAL EXPERIENCE
1910s Volunteer at Unitarian and Universalist Settlement House, Minneapolis, MN
1919 Researcher, New York Education Association
1930s Organized University Art Alumni League, University of Oregon
1937–60 Founder and Director, Oregon Ceramic Studio, Portland

Patrick Horsley
b. 1943 Pasco, WA

EDUCATION
1964–66 Columbia Basin College, Pasco, WA
1971 Museum Art School, Portland, OR

PROFESSIONAL EXPERIENCE
1962–64 Served in US Navy
1972–74 Teacher, Oregon Arts & Crafts Society and Head of Ceramics, Marylhurst College (now Marylhurst University), Portland
1974–76 Teacher, Museum Art School, Portland, OR
1970–80s Shared studio with Don Sprague, Portland, OR
1983 Teacher, Northwest College of Art, WA
1983 Formed Clay Artists Association (now Oregon Potters Association, OPA), Portland
1984 Teacher, Portland Community College, Sylvania, OR
2004–08 Board Member, Contemporary Crafts Museum & Gallery, Portland

Linda Hutchins
1957 Pontiac, MI

EDUCATION
1978 BSE in Computer Engineering, University of Michigan, Ann Arbor, MI
1988 BFA in Drawing, Pacific Northwest College of Art, Portland, OR

PROFESSIONAL EXPERIENCE
1988–present Artist
2004–present Board of Trustees, Portland Institute of Contemporary Art, OR

Howard Kottler
b. 1930 Cleveland, OH d. 1989

EDUCATION
1952 BFA, 1956 MA in Ceramics,

Ohio State University, Columbus
1957 MFA in Ceramics, Cranbrook Academy of Art, Bloomfield Hills, MI
1964 PHD in Ceramic Art, Ohio State University, Columbus

PROFESSIONAL EXPERIENCE
1958 Fulbright Scholarship, Finland School for Industrial Crafts
1961–64 Art History Instructor, Ohio State University, Columbus
1965–late 1980s Professor and Head of Ceramics, University of Washington, Seattle

Jack Lenor Larsen
b. 1927 Seattle, WA

EDUCATION
1945 BA in Interior Design & Architecture, University of Washington, Seattle
1951 MFA, Cranbrook Academy of Art, Bloomfield Hills, MI

PROFESSIONAL EXPERIENCE
1952 Founder, Larsen Design Studio, New York, NY
1966–67 Vice President, Architectural League of New York, NY
1976–81 Chairman, Haystack Mountain School of Crafts, Deer Isle, ME
1978 Fellow, American Craftsmen Council (now American Craft Council, ACC)
1981–89 President, ACC, New York, NY
1991 Established the LongHouse Reserve, East Hampton, NY

James Lovera
b. 1920 Hayward, CA

EDUCATION
California School of Fine Arts, San Francisco
University of California, Berkeley

PROFESSIONAL EXPERIENCE
1948–86 Professor, San Jose State University, CA

Glen Lukens
b. 1887 Cowgill, MO d. 1967

EDUCATION
1921 BS Oregon State Agricultural College (now Oregon State University), Corvallis
Ceramics coursework, School of the Art Institute of Chicago, IL

PROFESSIONAL EXPERIENCE
Middle school and high school teacher, MI
Teacher, Fullerton Junior College, Fullerton, CA
Inventor, Potter's wheel using sewing machine parts
Provided therapy for World War I and II veterans through pottery courses
1933 Chairman of Ceramics Department, University of Southern California, Los Angeles
1936–45, 52–58 Professor, University of Southern California School of Architecture, Los Angeles
1945–52 Worked for UNESCO, Haiti

Sam Maloof
b. 1916 Chino, CA

EDUCATION
Self-taught
Scripps College, Claremont, CA

PROFESSIONAL EXPERIENCE
1941–45 Served in US Army
Late 1940s Commercial artist and graphic designer
Founder of Maloof Woodworking

1994 Established Sam and Alfreda Maloof Foundation for Arts and Crafts, Alta Loma, CA

Bodil Manz
b. 1943 Copenhagen, Denmark

EDUCATION
1961–65 The School of Arts & Craft, Copenhagen, Denmark
1966 Escuela de Diseno y Artesanias, Mexico
University of California, Berkeley

PROFESSIONAL EXPERIENCE
Artist

Sharon Marcus
b. 1941 Des Moines, IA

EDUCATION
California State University
MA in Anthropology, San Francisco State University, CA

PROFESSIONAL EXPERIENCE
Editor, *International Tapestry Network Newsletter*
1974 Opened own studio
1979 Founded Craftsmen's Council (an independent advocacy group), Portland, OR
1984–1988 Board Member, Contemporary Crafts Gallery, Portland, OR
1980–2003 Professor and Head of Fibers Department, Oregon College of Art and Craft, Portland
Artist/Weaver

John Mason
b. 1927 Madrid, NE

EDUCATION
1952 Ceramics, Los Angeles County Art Institute, CA
1955 Chouinard Art Institute, Los Angeles, CA
1955–57 Otis Art Institute, Los Angeles, CA

PROFESSIONAL EXPERIENCE
1955–57 Designer, Vernon Kilns, Los Angeles, CA
1957 Shared studio and built large kiln with Peter Voulkos, Los Angeles, CA
1958 Established own studio
1974–85 Faculty, Hunter College of the City University of New York, NY

Gertrud Natzler
b. 1908 Vienna, Austria d. 1971

Otto Natzler
b. 1908 Vienna, Austria d. 2007

EDUCATION (GERTRUD)
Handelsakademie Commercial School, Austria
Self-taught in ceramics

EDUCATION (OTTO)
1927 School for Textile Design, Austria
1934 Workshop of Franz Iskras in Vienna
Self-taught in ceramics

PROFESSIONAL EXPERIENCE (GERTRUD AND OTTO)
1935 Established workshop in Vienna, Austria
1939 Established workshop in Los Angeles, CA

PROFESSIONAL EXPERIENCE (OTTO)
1927–33 Textile designer for Fritz Schönwälder, Vienna, Austria

Ronna Neuenschwander
b. 1954 Hoxie, KS

EDUCATION
1976 BFA, University of Kansas, Lawrence

PROFESSIONAL EXPERIENCE
1979 Halvorsen Artist-in-Residence, Contemporary Crafts Gallery, Portland, OR
Artist

Eric Norstad
b. 1924 Valhalla, NY

EDUCATION
1957 BA in Architecture, University of Oregon, Eugene

PROFESSIONAL EXPERIENCE
1957–59 Architect, Seattle, WA
1959–63 Architect, CA
1963–on Full-time potter
Teacher, College of Marin, CA

Pam Patrie
b. 1948

EDUCATION
1966 Weaving and study with Lloyd Reynolds, Reed College, Portland, OR
1967–68 Museum Art School
Tapestry workshops, US and international

PROFESSIONAL EXPERIENCE
Bridge tender, weaver
1979–80 Weaving and watercolors teacher, Artists-in-Schools Program, Portland, OR
Teacher, Patrie Studios, Portland, OR

Antonio Prieto
b. 1912 Valencia, Spain d. 1967

EDUCATION
Early 1940s California School of Fine Arts, San Francisco
New York State College of Ceramics at Alfred University

PROFESSIONAL EXPERIENCE
Served in US Army during World War II
1946–50 Professor, California College of Arts & Crafts, Oakland
1950–66 Head of Ceramics, Mills College, Oakland, CA
1963–64 Fulbright Scholarship, Spain

Don Reitz
b. 1929

EDUCATION
1962 MFA, New York State College of Ceramics at Alfred University

PROFESSIONAL EXPERIENCE
1962–88 Professor of Art Education, University of Wisconsin, Madison
Ceramist and Workshops teacher

Lucie Rie
b. 1902 Vienna, Austria d. 1995

EDUCATION
1922–26 School of Art & Design, Vienna, Austria
1969 Honorary Doctorate, Royal College of Art, London, United Kingdom

PROFESSIONAL EXPERIENCE
1938 Founded studio for producing ceramic buttons and accessories for the couture market in United Kingdom
1940s–50s Produced domestic tableware
1960–71 Tutor, Camberwell School of Art and Crafts (now Camberwell College of Arts), United Kingdom
1968 OBE (Officer of the British Empire), 1981 CBE (Commander of the British Empire), 1991 DBE (Dame Commander of the British Empire)

Visiting lecturer at Royal College of Art, London

Hal Riegger
b. 1913 Ithaca, NY d. 2006

EDUCATION
1938 BS, New York State College of Ceramics at Alfred University
1940 MA, Ohio State University, Columbus

PROFESSIONAL EXPERIENCE
1942–46 Helped organize pottery program for interns at conscientious objector camp during World War II
1946–47 Studio Technician, Oregon Ceramic Studio, Portland
1947–51 Teacher, California School of Fine Arts, San Francisco
1950–52 Teacher, University of Oregon, Eugene, and Museum Art School, Portland
1956–60 Exhibition Chairman & Designer, Association of San Francisco Potters, CA
1955–57 Teacher, College of Arts & Crafts, Oakland, CA
1958 Teacher, Haystack Mountain School of Crafts, Deer Isle, ME
1960–79 Teacher, workshops, Mill Valley, CA

Victoria Avakian Ross
b. 1895 Harpout, Armenia d. 1975

EDUCATION
1927 BA, University of Oregon, Eugene, OR
1939 MFA, University of Southern California, Los Angeles, CA

PROFESSIONAL EXPERIENCE
1920–64 Professor and Head of Ceramics, University of Oregon School of Architecture & Allied Arts, Eugene
1937–75 Teacher and Volunteer, Oregon Ceramic Studio, Portland, OR

Wally Schwab
b. 1932 Lincoln, NE

EDUCATION
1962 BS in Elementary Education, Portland State University, OR
1968 MFA in Ceramics, New York State College of Ceramics at Alfred University

PROFESSIONAL EXPERIENCE
Served in US Army during the Korean War
Teacher and Founder of the Ceramics Department, Marylhurst University, Portland, OR
Teacher, Portland State University, Portland Community College, and Oregon School of Arts & Crafts, Portland

Frances Senska
b. 1914, Cameroon, West Africa

EDUCATION
Cranbrook Academy of Art, Bloomfield Hills, MI
1935 BA, 1939 MA, University of Iowa, Iowa City

PROFESSIONAL EXPERIENCE
1942–46 Officer, US Navy during World War II
1939–42 Teacher, Grinnell College, IA
1946–73 Teacher, Montana State University, Bozeman

Leroy Setziol
b. 1915 Bristol, PA d. 2005

EDUCATION
1938 BA, Elmhurst College, IL
1941 BD, Eden Theological Seminary, MO
Philosophy, Johns Hopkins University, Baltimore, MD

PROFESSIONAL EXPERIENCE
Reverend
Chaplain, US Army during World War II
1952–2005 Full-time sculptor

David Shaner
b. 1934 Pottstown, PA d. 2002

EDUCATION
1956 BS in Art Education, Kutztown
University, PA
1959 MFA in Ceramic Design, New York
State College of Ceramics at Alfred
University

PROFESSIONAL EXPERIENCE
1959–63 Teacher, University of Illinois,
Urbana-Champaign
1963–70 Resident Director at the Archie
Bray Foundation for the Ceramic Arts,
Helena, MT
1970–98 Full-time ceramist

Ken Shores
b. 1928 Lebanon, OR

EDUCATION
1955 BS, 1957 MFA with Honors,
University of Oregon, Eugene
1955, 56 Pond Farm workshop with
Marguerite Wildenhain, Guerneville, CA

PROFESSIONAL EXPERIENCE
1951–52 Served in US Army in Germany
1957–64 Studio Technician/Artist-in-Resi-
dence, Oregon Ceramic Studio, Portland
1965–68 Director, Contemporary Crafts
Gallery, Portland, OR
1968–95 Professor of Art, Lewis & Clark
College, Portland, OR
1980 Lifetime Trustee Emeritus to the
National Board American Craft Council, NY

Ramona Solberg
b. 1921 Watertown, SD d. 2005

EDUCATION
1951 BA, 1957 MFA in Jewelry,
University of Washington, Seattle
University of Arizona, Tucson
California College of Arts & Crafts,
Oakland

PROFESSIONAL EXPERIENCE
Served in Women's Army Corps during
World War II
1967–83 Professor, University of
Washington, Seattle

Paul Soldner
b. 1921 Summerfield, IL

EDUCATION
1946 BA in Art, Bluffton College, OH
1954 MA in Art Education, University of
Colorado, Boulder
1956 MFA in Pottery, Otis Art Institute,
Los Angeles, CA

PROFESSIONAL EXPERIENCE
Served in US Army during World War II
1967–68 Teacher, University of Iowa, Iowa
City, and University of Colorado, Boulder
1969–91 Professor, Scripps College,
Claremont, CA
1970 Founded Soldner Pottery Equipment

Robert Sperry
b. 1927 Bushnell, IL d. 1998

EDUCATION
1950 BA in Art History, University of
Saskatchewan, Canada
1953 BFA, School of the Art Institute of
Chicago, IL
1954 MFA, University of Washington,
Seattle

PROFESSIONAL EXPERIENCE
1954 Artist-in-Residence, Archie Bray
Foundation for the Ceramic Arts,
Helena, MT
1954–80 Professor at University of
Washington, Seattle
Ceramicist, photographer, filmmaker,
muralist

Bob Stocksdale
b. 1913 Warren, IN d. 2003

EDUCATION
Self-taught in woodworking

PROFESSIONAL EXPERIENCE
Early 1930s Employed in cedar chest
factory, IN
Conscientious objector during World
War II (operated wood shop at the
National Forest Headquarters)
1952–80s Led woodworking
demonstrations and seminars
1971 Instructor, San Francisco Community
College, CA
1978 Fellow, American Craft Council,
New York, NY
Self-employed woodworker, Berkeley, CA

William Stromberg
b. 1890 Finland d. circa 1960

EDUCATION
1900s Studied manual training, Finland

PROFESSIONAL EXPERIENCE
1914–16 Seaman
1916–42 High rigger, logging industry, OR
1944–late 1950s Self-employed
craftsman, Portland, OR

Lino Tagliapietra
b. 1934 Murano, Italy

EDUCATION
1945 Apprenticeship with Archimede
Seguso
1955 Maestro glassblower
Glassblower and designer at Galliano
Ferro, Venini, La Murrina, and Effetre
International

PROFESSIONAL EXPERIENCE
Professional Glassblower and Teacher:
CERVAF, Vannes-le-Châtel, France
Centre International de Recherche sur le
Verre, Marseille, France
Haystack Mountain School of Crafts,
Deer Isle, ME
Pilchuck Glass School, Stanwood, WA
Pratt Fine Arts Center, Seattle, WA
Rhode Island School of Design,
Providence
San Jose State University, CA
The Studio of the Corning Museum of
Glass, NY
Toyama Art School, Japan
University of Sydney, Australia
UrbanGlass, Brooklyn, NY

Toshiko Takaezu
b. 1929 Pepeekeo, HI

EDUCATION
1948–51 Honolulu School of Art, HI
1951–54 Cranbrook Academy of Art,
Bloomfield Hills, MI

PROFESSIONAL EXPERIENCE
1952–53 Teacher, Flint Institute of Art,
Flint, MI
1954–56 Teacher, Cranbrook Academy
of Art, Bloomfield Hills, MI
1954–55 Professor, University of
Wisconsin, Madison
1955–64 Head of Ceramic Department,
Cleveland Institute of Art, OH

1958–59 Professor, Honolulu Academy
of Arts, HI
1967–92 Professor, Princeton
University, NJ

John Takehara
b. 1929 Sowan, Korea
(Japanese parentage)

EDUCATION
1959 BA in Secondary Education,
Walla Walla College, WA
1959–60, 66 Coursework, University
of Hawaii, Honolulu
1962 MA in Design, Los Angeles State
College, CA
1963 Coursework, Los Angeles State
College, CA
1974–75 Coursework, University of Idaho

PROFESSIONAL EXPERIENCE
1959–60 Gimas Art Gallery, Honolulu, HI
1963–67 Professor, Montana State
University, Bozeman
1967–68 Assistant Director and
Professor, University of Florida Art Gallery,
Gainesville
1968–94 Professor of Art, Boise State
University, ID
1974–80 Director of University Gallery,
Boise State University, ID
1980 Visiting Professor, Utah State
University, Logan
1994–98 Idaho Commission for the Arts
1996–97 Created documentaries of artists

Kyoko Tokumaru
b. 1963 Tokyo, Japan

EDUCATION
1990 BFA in Ceramics, 1992 MFA in Ceram-
ics, Tama Art University, Tokyo, Japan

PROFESSIONAL EXPERIENCE
2001 Artist-in-Residence, Archie Bray
Foundation for the Ceramic Arts,
Helena, MT
2001 Halvorsen Artist-in-Residence,
Contemporary Crafts Gallery, Portland, OR
2005–06 Artist-in-Residence, Bemis
Center for Contemporary Arts, Omaha, NE

Peter Voulkos
b. 1924 Bozeman, MT d. 2002

EDUCATION
1951 BS in Applied Art, Montana State
University, Bozeman
1952 MFA, California College of Arts &
Crafts, Oakland

PROFESSIONAL EXPERIENCE
1952–54 Artist-in-Residence, Archie
Bray Foundation for the Ceramic Arts,
Helena, MT
1953 Teacher, Black Mountain College,
Asheville, NC
1954–59 Professor, Los Angeles County
Art Institute, CA
1959–85 Professor, University of
California, Berkeley

Patti Warashina
b. 1940 Spokane, WA

EDUCATION
1962 BFA in Ceramics, 1964 MFA in Ceram-
ics, University of Washington, Seattle

PROFESSIONAL EXPERIENCE
1970–95 Professor, University of
Washington, Seattle
Artist

Marguerite Wildenhain
b. 1896 Lyons, France d. 1985

EDUCATION
1914 School of Fine Art, Berlin, Germany
1919–26 Bauhaus School, Weimar,
Germany
1922 Apprenticeship with Gerhard Marcks

PROFESSIONAL EXPERIENCE
1919 Porcelain designer at a factory in
Thuringia, Germany
1927–33 Model-maker, Royal Berlin
Porcelain Factory, Germany
1926 Head of Ceramics, Municipal School
for Arts & Crafts, Halle–Saale, Germany
1940–42 Teacher, California College of
Fine Arts, Oakland
1940s Teacher, Black Mountain College,
Asheville, NC
1945–85 Founder and Teacher, Pond Farm
Workshop, Guerneville, CA

Betty Woodman
b. 1930 Norwalk, CT

EDUCATION
1950 MFA, New York State College of
Ceramics at Alfred University

PROFESSIONAL EXPERIENCE
1958–74 Pottery teacher and
Administrator, City of Boulder Recreation
Department, CO
1977 Professor, Scripps College,
Claremont, CA
1975 Visiting artist, New York State
College of Ceramics at Alfred University
1979–98 Professor, University of Colorado,
Boulder

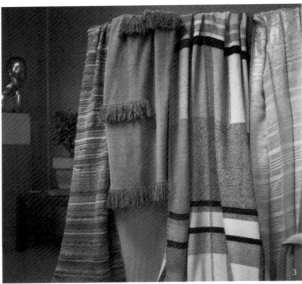

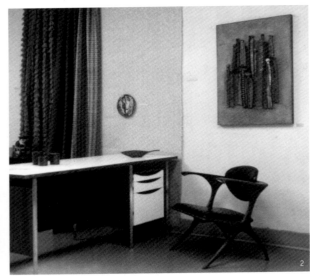

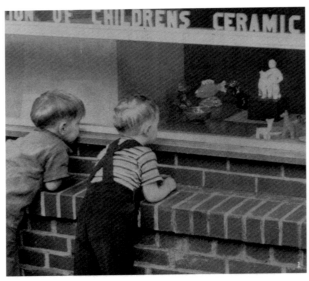

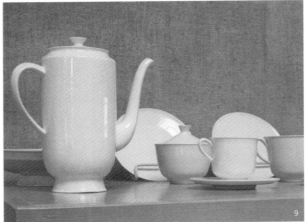

Exhibition Chronology

The following chronology documents selected exhibitions. Group and themed exhibitions appear in chronological order with all participating artists listed unless otherwise noted. Solo exhibitions are listed alphabetically following the group/themed exhibitions. Unless otherwise noted, all exhibitions were organized, coordinated and curated in-house by staff and volunteers. Partial list of artists are denoted by an asterisk ().*

1939

California Second Annual Ceramics Exhibition
Laura Andreson, Helen Gardner, Glen Lukens, Gertrud and Otto Natzler, Beatrice Wood

Hand-loomed Textiles
Anna Belle Crocker, Delight Hamilton, Victoria Avakian Ross, Cora Wilcox

Arts and Crafts Society Weavers' Show

1940

American Way
Organized by Russel Wright

South American and Philippine International Textile Show

Exhibition by Weaver's Guild of Seattle Textile

SOLO EXHIBITIONS
Anna Belle and Florence Crocker, Marianne Gold, Frederick Littman, Marguerite and Franz Wildenhain,[9] John Yeon

1941

Paul Bunyan In Clay
Lydia Herrick Hodge, Bue Kee, Katharine MacNab, Hal Riegger*

Children's Ceramics Competition

SOLO EXHIBITIONS
Mabel Griffin, Rachael Griffin, Dorothy Liebes, Ruth Penington

1942

Seattle Weavers Guild

University of Oregon Students

SOLO EXHIBITIONS
Lynn Alexander, Rosamund Stricker Day, Tom Hardy, Dorothy Liebes[3]

1943

Arts and Crafts Weavers Guild Exhibition

SOLO EXHIBITION
Marianne Strengell

1944

Students of Rosamund Stricker Day

Children's Ceramics Competition[1]

SOLO EXHIBITION
Margaret De Patta, Rachael Griffin

1945

Religious Art

Western Craftsmen
Laura Andreson, Constantin Brancusi, Margaret De Patta, Lydia Herrick Hodge, Dorothy Liebes, Glen Lukens, Getrud and Otto Natzler, Victoria Avakian Ross, Contance Spurlock, Mary Starr Sullivan, Rosamond Stricker Day, Marguerite Wildenhain

The Art of the Book

Wood Carving

1946

Milwaukee Handicraft Project

Marian Hartwell Design Workshop
Lynn Alexander, Tom Hardy, Leta Kennedy, Hal Riegger, Rosamond Stricker Day, Cliff and Frances Walker*

Modern Textiles
Circulated by Museum of Modern Art
Anni Albers, Artek-Pascoe, Inc., Louise Bourgeois, Dan Cooper, Danny Deaver, Galena Dotsenko, Marli Ehrman for Moss Rose, Donelda Fazakas, Howard and Schaffer, Inc., Pamela Humo, Dorothy Liebes for Goodall Fabrics, H.B. Lohman-Connor, Co., Virginia Nepodal, Antonin Raymond, Robert D. Sailors, Marianne Strengell, Julian Taylor, Angelo Testa, Henning Watterston

SOLO EXHIBITIONS
Lynn Alexander, Merlin Dow, Rachael Griffin, Tom Hardy, Hal Riegger

1947

International Textiles
Henrietta Atkin, Henrietta Virginia Carter, Georgia B. Chingren, Merlin Dow, Lorinda Epply, Helen Druley Eeles, Donelda Fazakas, Berta Frey, June Groff, Florence Floyd Hamann, Ilse Hamann, Louise Hardwick, May Kedney, Stella La Mond, Floyd La Vigne, Mona Marx, Dorothy Meredith, Lea Van Miller, Jill Mitchell, Patricia Patton, Noemi Raymond, Elsa Regensteiner, Ed Rossbach, Lois Russell, Robert D. Sailors, Marianne Strengell, Mary Elizabeth Sullivan, Edna Vogel, Norvella M. Weise, Rebecca Gallagher Williams

Eleventh Annual Ceramic Exhibition of Contemporary American Ceramics

SOLO EXHIBITIONS
Margaret De Patta, Lydia Herrick Hodge

1948

Eugene Weavers Guild

Oregon Ceramic Studio's Tenth Birthday Group Show

Twenty Craftsmen

Edgar Bohlman: Moroccan Costumes

1949

Young Sculptor's Show, Children's Art

SOLO EXHIBITIONS
Charles Jacobs, Rex Mason

1950

First Annual Exhibition of Northwest Ceramics
Juried by Victoria Avakian Ross, Walter Froelick and Glen Lukens
Rudy Autio, Victoria Avakian Ross, Bonnie Bartell, Jim Bartell, Aldrich Bowler, Jean Burdick, Jeffrey Case, Earle Curtis, Mary Ann Ellison, James H. Fitzgerald, Shirley Gilbert, Kenn Glenn, Margaret Murray Gordon, Gerald Halbett, Tom Hardy, Gloria Hibbitt, Hitt Milton, Charles W. F. Jacobs, Margaret Jacobs, Robert King, Betsy Moffitt, Robert Morgan, Kenneth E. Peabody, Linda Pedron, William G. Rudy, John Ryder, Frances Senska, Marclay and Joseph Sherman, Jeanne Speelman, Bob Speelman, Constance Spurlock, Dale E. Thorsted, Lee R. Tilloston, Margaret Tomkins, Richard Trojan, Bill Wilbanks, Thel Wilson, Kelly Wong

Autumn Arrangements Annual Garden Show

SOLO EXHIBITIONS
William Stromberg, Jack Lenor Larsen[8]

1951

Second Annual Exhibition of Northwest Ceramics[4]
Juried by Whitney Atchley, Lydia Herrick Hodge, Dean Sidney W. Little and Frances Senska
Victoria Avakian, Bonnie Bartell, James Bartell, Dean M. Brown, Linda Church, Bob Cox, Robert E. Grippen, Joe Daugherty, Clark Davis, Mary Ann Ellison, Francis A. Ford, Marianne Gold, Harland Goudie, Tom Hardy, Milton Hitt, Robert Hoyt, W.K. Huntington, M. Kiyokawa, Eloise McKinnell, Peter Meloy, Louis Mideke, Robert Morgan, William G. Rudy, William J. Sagar, Frances Senska, Branson G. Stevenson, Robert Swanson, Richard Trojan, Jayne Van Alstyne, Peter Voulkos, David Whitman, Bill Wilbanks, Kelly Wong

Bernard Leach: St. Ives Pottery

Joan Patterson and Oregon Flax

SOLO EXHIBITIONS
Tom Hardy, Jack Lenor Larsen, Hal Reigger

1952

Good Design
William Stromberg, Josephine Harrison, Delight Hamilton*

Third Annual Exhibition of Northwest Ceramics
Juried by Edith Kiertzner Heath, Lydia Herrick Hodge, Edgar Kaufmann, Jr. and Frederic Littman
Bonnie Bartell, James Bartell, Lilian Boschen, Linda B. Church, Silvana Cenci and Stuart H. Church, Sylvia Clise, Earle Curtis, Ruth Curtis, Louise Dennis, Mary Ann Ellison, Betty Feves, Francis A. Ford, Tom Hardy, Milton Hitt, Harry W. Holl, Manuel Izquierdo, James McKinnell, Nan McKinnell, Peter Meloy, Louis Mideke, Lucille Nutt, John Polikowsky, Rebecca Rinearson, Frances Senska, Robert Speelmon, Lorene Spencer, Ralph E. Spencer, Doris Jean Strachan, Peter Voulkos, Bennett Welsh, Bill Wilbanks, Jessie Wilber, Jack Wright

SOLO EXHIBITIONS
Tom Hardy, Peter Voulkos

1953

Fourth Annual Exhibition of Northwest Ceramics
Juried by William H. Givler, Margaret Murray Gordon, Tom Hardy and Peter Voulkos
Rudy Autio, Harold Balazs, James and Bonnie Bartell with Robert McCabe, Bernice Boone, Ivarose Bovingdon, Eugene F. Bunker, Jr., Earle Curtis, Louise L. Dennis, Mary Ann Ellison, Betty Feves, David P. Hatch, Milton Hitt, Ralph Holker, Manuel Izquierdo, Nan and James McKinnell, Peter Meloy, Lucille C. Nutt, H. and F. Piper, William Rudy, Frances Senska, Lorene Spencer, Ralph Spencer, Jayne Van Alstyne, Marie Vickers, Peter Voulkos, Bennett Welsh, Jane Sweet Wherrette, Bill Wilbanks, Jessie Wilber

Mariska Karasz: Abstraction in Needle Work

1954

Fifth Annual Exhibition of Northwest Ceramics
Juried by Thomas C. Colt, Lydia Herrick Hodge, Mary Risley, John Risley and Mark Sponenburgh
Rudy Autio, Victoria Avakian Ross, Harold Balazs, Bonnie and James Bartell, M. Barthel, Bernice Boone, Ivarose Bovingdon, Ruth Curtis, Everett DuPen, Betty Feves, Muriel Guest, Milton Hitt, Manuel Izquierdo, Constance Jarvis, A.I. Makovkin, Rex Mason, Marguerite Norrbo, Eric Norstad, Lucille Nutt, John Polikowsky, William Rudy, Frances Senska, Robert Shields, Kay Smith, Lorene Spencer, Ralph Spencer, Gordon Stewart, Henrietta Tragitt, Hugh B. Van Allen, Peter Voulkos, Margaret Whitcomb

Archie Bray Foundation Exhibition
Lilian Boschen, Eugene Bunker, Rex Mason, Peter Meloy, William Rudy, Frances Senska, Kay Smith, Branson G. Stevenson, Peter Voulkos, Jessie Wilber, Kelly Wong

SOLO EXHIBITIONS
Betty Feves, Tom Hardy, Peter Voulkos

1955

Sixth Annual Exhibition of Northwest Ceramics
Juried by Maija Grotell, Lydia Herrick Hodge, Hilda Morris and Dr. Francis J. Newton
Bernice Boone, Lilian Boschen, Ivarose Bovingdon, Gladys Crooks, Betty Feves, Muriel Guest, Milton Hitt, Manuel Izquierdo, Irvin R. Jolliver, Robert Koutek, Henry Lin, Dorothy Marcuse, James McKinnell, Nan McKinnell, Louis Mideke, Eric Norstad, Lucille Nutt, Frances Senska, Robert Shields, Ken Shores, Kay Smith, Lorene Spencer, Ralph Spencer, Robert Sperry, Constance Kletzer Spurlock, Doris Jean Strachan, Bennett Welsh, Jane Sweet Wherrette, William Willbanks, Jessie Wilber

Hand Loomed Rugs Show
Twila M. Alber, Lynn Alexander, Hollis Beasley, Bill Brewer, Lucille Clark, Deloyce Frost, Marjorie Gilleland, Delight Hamilton, Isabelle Jenning, Lea Van P. Miller, Joan Patterson, Jack Perkins, Georgia Ricketts, Richard Ricketts, Ed Rossbach

Portland Potters' Group Show

SOLO EXHIBITIONS
Leroy Setziol

1956

Seventh Annual Exhibition of Northwest Ceramics [6]
Juried by Betty Feves, Lydia Herrick Hodge, Leta M. Kennedy and Richard B. Petterson
Rudy Autio, Bernice Boone, Lilian Boschen, Ivarose Bovingdon, Gladys Crooks, Sylvia Clise Duryee, Betty Feves (by invitation), Francis A. Ford, Milton Hitt, Loren Jacobson, R. James, Rodney Kendall, Mary Elizabeth LaRue, Henry Lin, James McKinnell, Nan McKinnell, Louis Mideke, Eric Norstad, Lucille Nutt, Kay Perine, Richard Petterson (by invitation), Elaine Pirofsky, Frances Senska, Dawn Sipe, Kay Smith, Ralph Spencer, Robert Sperry, Mark Sponenburgh, Jane Staver, Branson G. Stevenson, Muriel Thwaite, Nelle Tobias, Peter Voulkos (by invitation), Bennett Welsh, Lynn Wentworth

Hand Loomed Draperies
Twila M. Alber, Evelyn Arnold, Lucille Clark, Lucia Gershkovitch, Marjorie Gilleland, Laurie Herrick, Isabelle Jenning, Bruce Johnston, Jack Lenor Larsen, Kay Larson, Lea Miller, Polly Mochel, Jack Perkins, Ed Rossbach, Hella Skowronski, Mildred Steinmetz

Meier and Frank Show
Rose Fenzl, Betty Feves, Byron Gardener, Mabel Griffin, Delight Hamilton, Tom Hardy, Milton Hitt, Dorothy Liebes, Jack Lenor Larsen, Katharine MacNab, Eric Norstad, Maurine Roberts, Mildred Steinmetz, William Stromberg

Weaving Show
Delight Hamilton, Ed Rossbach

SOLO EXHIBITIONS
J. B. Blunk, Tom Hardy, John Mason, Eric Norstad, Ken Shores

1957

Montana Group Show
Frances Afanasiev, Lois Blackenhorn, Gennie De Weese, Ione Foss, Margaret Gregg, Frances Senska, Jessie Wilber

SOLO EXHIBITIONS
Russell Day, Ray Grimm, [7] John Mason, Hella Skowronski, Ken Shores

1958

Portland Potters' Group Show
Martha Crockett, A. B. Crum, Milton Hitt, Irvin Jolliver, James Kelly, Lee Kelly, Leta Kennedy, Clarence Morgan, Marie Oberdorfer, John Reisacher, Martha Warner, Vernon Webb, Bennett Welsh, Bill Willbanks

Eighth Biennial Exhibition of Northwest Ceramics [19]
Alexander Archipenko, Rudy Autio, J.B. Blunk, Richard Brennan, Everett DuPen, Betty Feves, Betty Davenport Ford, Tom Hardy, Manuel Izquierdo, Charles Lakofsky, Frederic Littman, John Mason, William Mcvey, Adolph Odorfer, John Risley, Henry Rox, Lilian Swann Saarinen, Ken Shores, Peter Voulkos, Simeon Wilson III

1959

Creative Craftsmen of the Northwest [5]
Evelyn Arnold, Russell Day, Lucille Clark, Gloria Crouse, Ruth Curtis, Howard Duell, Martha Ebener, George Federoff, Betty Feves, Ray Grimm, Tom Hardy, Robert James, Solange Kowert, Will Martin, Robert Morton, Max Nixon, Lucille Nutt, Coralynn Pence, Ruth Penington, George Roberts, Frances Senska, Ken Shores, Hella Skowronski, Ramona Solberg, Robert Sperry, L.R. Steeves, William Stromberg, Donald Tompkins, Bennett Welsh

Northwest Designer Craftsmen [2]

SOLO EXHIBITIONS
Jere and Ray Grimm, Tom Hardy, Solange Kowert, Ken Shores, Robert Sperry

1960

Ninth Biennial Exhibition of Northwest Ceramics [14]
Juried by Victoria Avakian Ross, David Campbell, Maurine Hiatt Roberts and Peter Voulkos
Twila M. Alber, Maureen Armstrong, Lewis Aumack, Rudy Autio, Eve Benson, Maxine Blackmer, R. Bosard, Jerry Bosco, Beryl Coleman, Gloria Crouse, A. Doerner, Howard Duell, Sylvia Duryee, Martin Eggert, J. Ellsworth, Marie Feldenheimer, Rose Fenzl, Ken Ferguson, Betty Feves, Lawrence Getz, Jean Griffith, Jere Grimm, Ray Grimm, Bob James, Constance Jarvis, Irven Jolliver, Ronald Judd, Tom Hardy, Milton Hitt, Leta Kennedy, Howard King, B. Kundahl, Mrs. A. T. Larsen, Ray Levra, Del McBride, Anne McCosh, Ruby Montgomery, W.J Montgomery, Eunice Moran, Paul E. Nelsen, Janetta Nelson, George Nightingale, Ruth Penington, Elaine Pirofsky, Gertrude Richmond, Mahlon Reed, Henry Rollins, John Ryan, Lalla Savara, Ric Schneider, Frances Senska, Ken Shores, Jim Shull, Lillian Skaggs, Lorene Spencer, Ralph Spencer, Robert Sperry, David Stannard, Constance Stanton, Polly Stehman, Florence Tanzer, Carmen Taysom, Wayne Taysom, Jose Torres, Margarita Torres, Richard Trojan, Martha Warner, Virginia Weisel, Bennett Welsh, Fred Wollschlager

Ceramics and Weaving
Ken Shores, Henry Takemoto, Ray Grimm

1961

Northwest Potters & Sculptors in the XXI Ceramic National
Ivarose Bovingdon, Barbara S. Brotman, Marilyn A. Diehl, Jean Griffith, Jere Grimm, John and Gretchen Fassbinder, Ken Ferguson, Betty Feves, Constance Jarvis, Harold Myers Jr., Jannetta L. Nelson, Paul Nelson, Henry Rollins, Lisel Salzer, Frances Senska, David Shaner, Ken Shores, Robert Speelman, Lorene Spencer, Ralph Spencer, Robert Sperry, Toshiko Takaezu, Virigina Weisel, Bennett Welsh, Jane Wherrette, Fred Wollschlager

Recent Works
Betty Feves and Hal Riegger

University of Oregon Student Exhibition

1962

Tenth Biennial Exhibition of

Northwest Ceramics
Juried by Walter Gordon, Manuel Izquierdo, Maurine Hiatt Roberts and Paul Soldner
Rudy Autio, John Booker, Bonnie and Craig Cheshire, Bill Childers, Philip Eagle, Jean Ellsworth, John Fassbinder, Ken Ferguson, Betty Feves, Jean Griffith, Ray Grimm, Robert Gronendyke, Ngaire Hixson, Manuel Izquierdo (by invitation), Robert James, Ann Johnson, Jonnie Johnson, Ronald Judd, Leta Kennedy, William Montgomery, Marian Pringle, Robert Purser, Gertrude Richmond, Jay Rummel, Kenneth Schuldt, Jack Sears, Frances Senska, Ken Shores, Paul Soldner (by invitation), Robert Sperry, Constance Kletzer Spurlock, Karl Steinert, Patti Warashina, Walter Wegner, Bennett Welsh, Ted Wiprud, Fred Wollschlager, Virigina Weisel, Carol Youngberg

SOLO EXHIBITIONS
Tom Hardy, Rex Mason, Ken Shores, Jan Zach

1963

House and Garden Show
Gloria Crouse, Phil Eagle, Martha Ebener, Albert Goldsby, Ray Grimm, Tom Hardy, Laurie Herrick, George Johanson, Solange Kowert, Lewis Mayhew, Leroy Setziol, Ken Shores, Milton Wilson*

Northwest Invitational

Designer Craftsmen Create for House and Garden

Contemporary West African Cloth and Basketry

Art and Craft Society Instructors' Presentation of Metal, Pottery and Weaving
Haarlan R. Bakken, Ruth Clark, Phillip Eagle, Laurie Herrick

University of Oregon Allied Arts Students

SOLO EXHIBITIONS
Albert Goldsby, Ray Grimm, Phillip Eagle, Win Ng, Eric Norstad, Ken Shores

1964

Association of San Francisco Potters
Robert Arneson, Esther L. Beasley, Bert Borch, Vera Borzy, Barbara Brooks, Bernice M. Brown, Aldura Browning, Frieda Burkhart, Edwin A. Cadogan, Bernadette Cole, Luis Cervantes, Carly Moon Corey, Edward R. Cromey, John Dempsey, Kenneth J. Dierck, Viola Frey, Elizabeth Irwin, Ann L. Jack, Sandra Johnstone, Stella Kaufman, Virginia L. Linde, Mary Lindheim, James Lovera, Charles McKee, Hazel M. Marsh, Dorothy A. Martin, Rex Mason, Jacomena Maybeck, Alan R. Meisel, James Melchert, Caroline Smith Mitchell, Minoru Jojima, Teri Oikawa, Catherine Olson, Helen Peeke, Gwynne Peticolas, Elizabeth Prest, Joseph A. Pugliese, Noni E. Treadwell, Peter Voulkos, Roy Walker, Almada Washburn, Billie Wilson, Helen Woodlaw, Rebecca B. Worden, George Yokoi

Eleventh Biennial Exhibition of Northwest Ceramics
Juried by Rachael Griffin, Ken Shores, Robert Sperry and Jan Zach

Don Anawalt, Fred Bauer, Paulette Beall, Marilyn Berg, Richard Bosard, Ivarose Bovington, Robert Colescott, David Cornell, Larry E. Elsner, Richard Fairbanks, Ken Ferguson, Betty Feves, Evelyn Georges, Jerry Glenn, Margaret Gordon, Sigrid P. Gould, Jean Griffith, Ray Grimm, Ngaire Hixson, Constance Jarvis, Brother Bruno LaVerdiere, Richard Lolcama, Michael Madden, John H. Nickerson, Kay Perine, Eleanor Rycraft, David Shaner, Ken Shores (by invitation), Lorene and Ralph Spencer, Robert Sperry (by invitation), Constance Kletzer Spurlock, Leonard Stach, Daniel Stevens, Patricia Warashina, Sid Warne, W.F. Wegner, Bruce Wild, Jan Zach (by invitation)

1965

Colorado Craftsman
Alice Adams, Harman Casagranca, Peg Mayo, Eugene Norman, Ed Oshier, Mary Jane Oshier, Frida Tuinsma, Mark Zamantakis

San Jose College Instructor's Exhibition:
Robert Fritz, James Lovera, Herbert Sanders

Jack Lenor Larsen Africa 2 Collection

House and Garden Invitational [13]
Ray Grimm, Hilda Morris, Leroy Setziol, Bruce West*

Yule Bowl

SOLO EXHIBITIONS
Lorene and Ralph Spencer, Ken Shores, Robert Sperry, Jan Zach

1966

Northwest Regional Exhibition of Craftsmen USA '66
Juried by Toshiko Takaezu
M.V. Bonneville, Bill H. Boysen, Gerald C. Conaway, William Creitz, W. Ron Crosier, William K. Crosier, Jr., Betty Feves, Florence Finnegan, Jerry Glenn, Jean Griffith, Ray Grimm, Erik Gronborg, Virginia Harvey, Laurie Herrick, Mar Hudson, Jean Knutson, Solange Kowert, Brother Bruno LaVerdiere, Hope Munn, Mary Stephens Nelson, Richard Norland, Coralynn Pence, Ruth Penington, Macky Roberts, Bill Sage, Leroy Setziol, David Shaner, Ken Shores, Kay Smith, Cloyde Snook, Robert Sperry

Bookbinding

Macramé [10]

SOLO EXHIBITIONS
Lydia Herrick Hodge, Marvin Lipofsky, [18] Finn Lynggard, Eric Norstad, Leroy Setziol, Ken Shores

1967

Contemporary American Ceramics: the R. Joseph Monsen Jr. Collection

Association of San Francisco Potters

Jack Lenor Larsen: Andean Collection

Interiors/Exteriors
Twila Alber, Ron Crosier, Phil Eagle, Betty Feves, Albert Goldsby, Ray Grimm, Tom Hardy, Laurie Herrick, Lydia Herrick Hodge, Howard Kottler, Solange Kowert,

Finn Lynggard, Nan and James McKinnell, Eric Norstad, Monica Setziol, David Shaner, Ken Shores, Robert Sperry, Dean Trimble, Peter Voulkos, Virginia Weisel*

SOLO EXHIBITIONS
Erik and Irina Gronborg, Howard Kottler

ARTIST-IN-RESIDENCE
Richard Lolcama

1968

The Sun

The Collections of Ken Shores and Richard Davis

Salute to Scandinavia

SOLO EXHIBITIONS
Russell Day, Hal Riegger, Edward Livingston, Marina Schut, Leroy Setziol, Matsuo Yanagihara

ARTIST-IN-RESIDENCE
Judy Teufel

1969

Historical Oregon Ceramic Exhibition

Young Americans
Organized by the Museum of Contemporary Crafts, NY (now the Museum of Arts and Design)

Body Adornment
Dexter Bacon, Jerry Baumgarter, Margo Biestman, Helen Bitar, Paul Clark, Tony Clark, Bob Coghill, Anne Dick, Norman Eng, Deloyce Frost, G.M. Green, Ann Hawkins, Laurie Herrick, Esther Lewittes, Brick Mautx, John Murphy, Mary Stephens Nelson, Jan Odegard, Gillian E. Packard, Tom Pemberton, Chris Pillsbury, Joe Police, Jean Scorgie, Monica Setziol, Lauana Server, Robert Shaement, Henry Sjoblom, Polly Stehman, C. Stokes, Louise Todd, Lynda Watson, Mary Wells, Fred Woell, Ron Wigginton

Yule Bowl

SOLO EXHIBITIONS
John Areseneau, Patti and Fred Bauer, Albert Goldsby, Tom Hardy, Laurie Herrick, Robert Kasal, Richard Lolcama

HALVORSEN ARTIST-IN-RESIDENCE
Ginny Adelsheim

1970

Lawrence Hanson: Light That Works

Ken Shores: Fetishes

SOLO EXHIBITIONS
George Cummings, Betty Feves, Bob Hanson, Tom Hardy, Harold Hoy, Lee Kelly, Sara Long, Phil St. Clair, Sue Police, Monica Setziol, Leroy Setziol, Evelyn Sheehan, Judy Teufel, David Vogal, Bruce West

HALVORSEN ARTIST-IN-RESIDENCE
Gary Smith

1971

Plants and Containers

Five Ceramicists
Patti Bauer, Wayne Higby, Mick Lamont, David Shaner, David Simon

SOLO EXHIBITIONS
Ginny Adelsheim, Erik Gronborg, Kyung Sook Kim, Hal Riegger, Duane Zaloudek

HALVORSEN ARTIST-IN-RESIDENCE
Janet Lowe

1972

Robert Kasal: Soft Painting

Knotted Works
Donald Price, Smith Lowe, Jean Knutsen

SOLO EXHIBITIONS
Tom Coleman,[17] Ron Crosier, Erik Gronborg, Laurie Herrick, Wally Schwab, Ron Wigginton

HALVORSEN ARTIST-IN-RESIDENCE
Joan Chambers DeVault

1973

Portland Handweavers Guild

Box Social Sale
Ginny Adelsheim, Tom Coleman, Ron Crosier, David Frank, Albert Goldsby, Tom Hardy, Susanna Hayshi, Fred Heidel, Mark Hopkins, Patrick Horsley, Jay Jensen, Rick Johnson, Jan Lowe, Tim MacKansass, Lynn Mauser, Bonnie Meltzer, Bridget Merle, Karen Mishler, Ray and Diane Mueller, Peggy Rycraft, Robin Rycraft, Freddie Schatz, Dan Schwoerer, Monica Setziol, Ray and Evelyn Sheehan, Don Sprague, Judy Teufel, Kappy Thompson

Peter Teneau: Room 3

Craftsmen-in-the-Schools
Madeline Janovec, Lee Kelly, Pam Patrie, Freddie Schatz, Barbara Setsu Pickett, Shelly Stoffer, Jan De Vries*

R. Joseph Monsen, Jr. Collection

Pop Ceramics
Ginny Adelsheim, Judy Cornell, Connie Earnshaw, Ellie Fernald, Shelly Stoffer, Patti Warashina, Paula Winokur

Souper Supper
Ginny Adelsheim, Helen Bitar, Tom Hardy, Lee Kelly, Judy Nylin, Judy Tuefel, Bruce West

SOLO EXHIBITIONS
Tom Hardy, Pat Horsley, Elliott Miller, Wally Schwab, Monica Setziol, John Takehara, Ray Ahlgren and Dan Schwoerer, Kay Sekimachi and Bob Stockslead

HALVORSEN ARTISTS-IN-RESIDENCE
John Rogers and Joan Monteillet (formerly Kathy Rogers)

1974

Creative Gardening and Baking

Mike Walsh: Attachment Extinction Series[12]

Columbia Stitchery Guild Juried Group Exhibitions

American Craft Council Northwest Metal Exhibition

Jack Lenor Larsen: Belle Epoque Textile Collection

Colorado State University Faculty Exhibition

Containers
Susan Ackerman, Meredith Apperson, Alice Babcock, Claudia Baston, Julie Nelson Bonine, David Booth, Jeanine Browder, Corinna Campbell Cioeta, Tom Coleman, Janice Coleman, Jeanne De Weese, Jean Egle, Barbara Engel, Tom Fawkes, Linda Fitzgerald, Martha Forster, David Frank, Albert Goldsby, Jack Goldwasser, Penny Grist, Robert Grott, Julie Gurka, Doug Hamar, Fred Hamann, Tom Hardy, Jerry Harpster, Chuck Haynes, Martha Holt, Craig Holms, Patrick Horsley, Annabeth Jamieson, Ricki Johnson, Ron Judd, Nadine Kiyoko Kariya, Robert Kasal, Gudrun Klix, Jean Knutsen, Solange Kowert, Chris Kroupa, Susanna Kuo, Georgia Larson, Carolyn J. Lee, Ralph Lodewick, Patrick McCormick, Lee E. Meier, Bonnie Meltzer, Bridget Merle, Michael Miller, Caren Mishler, Gary Mueller, Walt Munhall, Alan Myers, Michael Nicolas, Anthony Parker, Doug Parmeter, Joyce Parmeter, Michael Pratt, Paul and Nancy Oltman, Claudia Purues, Anne Rathman, Roy Reynolds, Lou and Max Rubillard, John Rogers, Kathleen Rogers, Charles Rothschild, Diana Sala, Sara Sanford, Chris Shepard, Freddie Schatz, Wayne Scheck, Robert S. Shimabukuro, Bill Simon, Don Sprague, Constance Spurlock, Kristy St. Clair, Phil St. Clair, Shelley Stoffer, Judy Teufel, Philip Thompson, David Toney, Paul Wadsworth, Dan White, Roland White, Sally Whitton

SOLO EXHIBITIONS
Betty Feves, Margaret Hammond, Jay Jensen, Jean Knutsen, Charlotte Oscar, Pam Patrie, John and Kathleen Rogers, Leroy Setziol

HALVORSEN ARTIST-IN-RESIDENCE
Walter Gordinier

1975

Natzler Ceramics[15]

Claydreams

Montana Soft Show
Lela Autio, Anne Barnaby, Nancy Erickson, Susan Fritts, Sara Noel

Collectors' Exhibition and Sales

Oregon Craft Furniture

SOLO EXHIBITIONS
Leona Ambrose, Ron Adams, Helen Bitar, John Glick, Walter Gordinier, Ray Grimm, Laurie Hall, Ron Ho, Martha Holt, Gerhardt Knodel,[20] Solange Kowert, Jack Lenor Larsen, Eric Norstad, Bruce West, Helen Wilson, Betty Woodman

HALVORSEN ARTIST-IN-RESIDENCE
Dennis Cunningham

1976

Tom Hardy: Twenty-Five Year Retrospective

Useful Objects
Juried Exhibition by the American Craftsmen Council Northwest
Lillian Bell, Ferne Cone, Bill Crosier, Gloria Crouse, David Deal, Karen Van Derpool, Nancy Dobbs, Cheryl Glazer, Janet Gray, Penny Grist, Richard Horosko, Pat Horsley, Yoshiro Ikeda, Howard Kottler, Solange Kowert, Hazel Lasley, Bill Levin, Robert Markle, Kay Marshall, Wally

Schwab, Luana Sever, Richard Showalter, Barbara Skelly, Jan Sonniksen, Don Sprague, Christi St. Clair, Ken Stevens, Jon Torrey, Ronald Taylor, Peter Voulkos, Mike Walsh

Six Northwest Artists
Ellie Fernald, Larry Heald, Gertrude Pacific, Merrily Thompkins, Patti Warashina, Bruce Wild

Collectors' Exhibition and Sales

SOLO EXHIBITIONS
Dina Barzel, Bonnie Bronson, David Cotter, Donald Douglas, Liza Jones, Mick Lamont, Paul Soldner, Robert Sperry, John Takehara, Dan White, Paula Winokur

HALVORSEN ARTIST-IN-RESIDENCE
Charles Hannegan

1977

The Concept of Neighborhood by Lair Hill Neighbors

Celebration
Steve Adams, Linny Adamson, Ginny Adelsheim, Twila Alber, Geoff Alexander, Judy Alexander, Meredith Apperson, Doug Ayers, Carolyn Baldwin, Martha Forrester Banyas, Barry Berman, Joel Besnard, Nathaniel Biart, Bob Biniarz, Helen Bitar, George Blackman, Lynn Botten, Ethel Bowes, Frank Boyden, Eric Braunwart, Mary Burke, Fred Buss, Bruce Byall, Jerry Cage, Virginia Campbell, Ed Carpenter, Dale Chase, Orvill Chatt, Tony Clarke, Beryl Coleman, Tom Coleman, Barbara Covey, George Cummings, Barbara Currington, Deborah Dailey, Elizabeth Dasch, Mark Davis, Nelsie Davis, Dave Deal, Jeanne De Weese, Anne Dick, Tom Dimond, Dale Donavan, Ann Dengler, Connie Earnshaw, Don Eber, Garth Edwards, Beth Elliot, Sybil Emerson, Norman Eng, George Erickson, Judith Poxson Fawkes, Ron Fenter, Ellie Fernald, Betty Feves, Linda Fitzgerald, Don Fletcher, Alyce Flitcraft, Sam Fort, David Frank, Kathleen Frazier, Clifford Frost, Francis Furniss, Stephen Gerould, Judy Gibbs, Martha Gold, Hanna Goldrich, Albert Goldsby, Walter Gordinier, Sigrid Gould, Janet Gray, Margaret Griffey, Ray Grimm, Penny Grist, Erik Gronborg, Lenore Grubbe, George Hahn, Doug Haman, Fred Hamann, Marge Hammond, Charles Hannegan, Tom Hardy, Tim Harvey, Fred Heidel, Elizabeth Henry, Heather Herbst, Laurie Herrick, Marilyn Higginson, P.K. Hoffman, Pat Horsley, Don Hoskisson, Joan Husman, Terry Hutchinson, Ann Hyman, Gail Jacobsen, Madeline Janovec, Madeline Janovec, Janet Jeniye, Hugh Jenkins, Jay Jensen, Jim Johnston, Ron Judd, D. Kargler, Bob Kasal, Bonnie Bronson Kelly, Lucille Kelly, Ann Kendall, Diane Keppel, Selby Key, Gorel Kinnersly, Gudrun Klix, Allan Kluber, Stan Klyn, Jean Knutsen, Howard Kottler, Solange Kowert, Greg Kreibel, Susanna Kuo, Mick Lamont, Jack Lenor Larsen, Stephen Larson, Chas Laventure, Keith Lebenzon, Alice Van Leuneu, Carolyn Locke, Ralph Lodewick, Eric Lovell, Paulina Mack, Tim Mackiness, Katharine MacNab, Elizabeth Macy, Virginia Mahaffay, Nasiff Maloof, Linda McCarter, Alan McCoy, Bonnie Meltzer, Michael Miller, Reta Miller, Caren Mishler, Kevin Moore, D.L. Morgan, Steven Morse, Mike Mowery, Alan Myers, Nancy Myers, Jean Nakadate, Otto Natzler, Linda Neufer, Penny Niemi, Eric Norstad, Lorelei

Norvell, Judy Nylin, Shirley Oakley, Susan Olsen, Paul and Nancy Oltman, Kathleen O'Rourke-Mayer, Jack Osier, Joan Peck, Pam Patrie, Nancy Piccioni, Barbara Setsu Pickett, Mart Poldmets, Jerry Pollari, Michael Pratt, Don Price, Jeff Proctor, Charles Rasmussen, Lloyd Reynolds, Max Robillard, John Rogers, Charles Rothschild, Ben Rouzie, Peggy Rycraft, Robin Rycraft, Sandy Satterfield, Freddie Schatz, Al Schmaedick, Paul Schneider, Linda Schoenbeck, Wally Schwab, Dan Schwoerer, Christina Sells, Leroy Setziol, Evelyn and Ray Sheehan, Ken Shores, Anita Shuler, Jan Sinclair, Michael Smith, Phil Smith, Robert Sperry, Don Sprague, Judith Starbuck, Phil St. Clair, Steve Stegall, Polly Stehman, Kathy Stromme, Clark Spurlock, Constance Spurlock, Daniel Stevens, Shelley Stoffer, Vincent Suez, Mark Sutton, Russell Svaren, John Takehara, Ben Thomas, Tom Tibbs, Jean Tucker, Judy Teufel, Nancy Tunberg, Kathryn Turner, Steve Turner, Sydney Vandenakker, Glenn Vanselow, Peter Voulkos, Paul Wadsworth, David Waln, Michael Webb, Ted Weinstein, Bruce West, John Whitehead, Van Woolfe, Sally Worcester

Elements between Earth and Sky
Harvest Festival

Permutation and Combinations
Susanna Kuo, Marie Lyman, Alice Van Leunen

Tom Coleman, Steve Foley, Martha Banyas Forster, Margaret Griffey, Erik Gronborg, Sam Maloof,[11] Reta Miller, Michael Pratt, Don Sprague, Ron Taylor, Peter Voulkos

Chris Kroupa

1978

Fiber: New Directions
Organized by the Cheney Cowles Museum
Ruth Beal, Joanne Segal Brandford, Lia Cook, Kiyomi Iwata, Gyongy Laky, Helene Pancoast, Ed Rossbach, Dick Sauer, Katherine Westphal

Northwest Designer Craftsmen
Ron Adams, Bonnie Arndt, Dina Barzel, Joellen Benjamin-Fay, Ivarose Bovington, Frances Bringloe, Orville Chatt, Ron Crosier, Gloria Crouse, William Crosier, Jr., Tom Deady, Steve Dennis, Kathryn Frogbird Eyler, Judith Poxson Fawkes, Ellie Fernald, Cleo Francisco, Jean Griffith, Betty Hagen, Laurie Hall, Anne Hawkins, Anne Hirondelle, Ngaire Hixon, Trina Hoof, Nadine Kariya, Karen Kaufman, John Killmaster, Jean Knutsen, Paul Lewing, Agnes Mclin, Larry Metcalf, Hope Munn, Mary Stephens Nelson, Jill Nordfors, Lucille Nutt, Sande Percival, Regnor Reinholdtsen, Bill Sage, Margaret Ahrens Sahlstrand, Mike Saito, Nell Scott, Luana Sever, Barbara Skelly, Paula Simmons, Luella Simpson, Ramona Solberg, Polly Stehman, Carol Tate, Judy Thomas, Karen Van Derpool, Ulla Winblad-Hjelmquist, Dick Wrangle

Hot Glass
Eric Lovell, Bill and Sally Worcester

Vivika and Otto Heino, Pam Patrie

Geoffrey Pagen

1979

Traveling Exhibition of Mobiles and Hangings

Retrospective Exhibition of Stoneware by George Cummings

Craftsmen-in-the-Schools
MaryJo Anderson, Michael Boge, Nancy Cushwa-Blake, Roger Dorband, Linda Fitzgerald, Chas Hannegan, Eric Heidacker, Carolyn Lee, Susan Leeb, Michael Miller, Geoffrey Pagen, Pam Patrie, Barry Pelzner, William Rietveldt, Diane Sala-Abatiello, Freddie Schatz, Mara Stahl, Shelley Stoffer, Kathleen Stromme, Katy Turner, Kent Wade

Artists-in-Residence: Ten Year Retrospective Exhibition

Ceramics Invitational
Victor Babu, Ralph Bacerra, John Natale, David Shaner, Robert Winokur

Folk and Fantasy: 41st Holiday Show

Judith Poxson Fawkes, Susanna Kuo, Alice Van Leunen

Ronna Neuenschwander

1980

Marie Lyman: Liturgical Vestments

Toshiko Takaezu: Recent Works

Deborah Butterfield: From the Private Collection of Ed Cauduro

Timberline Lodge: Then and Now, Organized by Friends of Timberline

Flux/Fusion/Fireworks, National Enamel Competition

National Ceramic Invitational

Renwick Gallery Show
Circulated by the Smithsonian Institution
Joe Apodaca, Tom Batty, Lillian Bell, Bettye Lou Bennett, Frank Boyden, Sharon Davidson, John Economaki, Cheri Epstein, Judith Poxson Fawkes, Miles Gilmer, Stephen Gerrould, Barbara Geshwind, Walt Gordinier, Elliot Grey, Susan Hamada, Joan Husman, Jay Jensen, Chris Kroupa, Susanna Kuo, Barbara Lamont, Linda Loving, Sharon Marcus, Howard Meehan, Bradley Miller, Marilyn Nelson, Faye Nakamura, Gail O'Neill, Geoffrey Pagen, Darrelle Scott, Peggy Skycraft, Anne Storrs, S.K. Tackmier, Gene Tobey, Chris Wrench, Peter Wendell

Winter Solstice

Margaret Ford, Allan Kluber, Sherri Smith

Philip Jameson

1981

Ronna Neuenschwander, The Elephant: Assorted Histories, Artist-in-Residence Exhibition

Handmade Furniture
John Economaki, Steve Foley, Richard Weangle*

Harvest Festival

Ellen Birnbaum

1982

The Collection of John Takehara

Group Show
Stanley Beppu, Peter Eulah, Lamonts Hillside, Anne Hirondelle, Mike Mowery, Barlow Potter, Michael Pratt, Jeff Procter, Donald Sprague, John Takehara, Jeanne Maria Tumpane

Cynthia Schira: The Art Fabric

Five from Seattle
Jayme Curley, Deborah Horrell, Joyce Moty, Merrily Tompkins, Patti Warashina

10 × 7
Jane Ford Aebersold, Bennett Bean, Peter Callas, Philip Cornelius, Larry Clark, Molly Cowgill, Thomas Emmerson, Bob Forman, Richard Hensley, John Glick, Don Hoskisson, Mike Jensen, Sandra Johnstone, Andrea Joseph, David Keyes, Katherine Keefer, Doug Kaigler, Bob Lanman, Jenny Lind, Mike Moran, Pat McCormick, Jim Romberg, Harvey Sadow, Nancy Selvin, Adrian Saxe, Robert Sperry, Al Tennant, Tom Turner, Patti Warashina, Kurt Weiser, Bruce Wild

Debra Norby

1983

Tip Toland: Artist-in-Residence Exhibition

National Juried Northwest Crafts Exhibition

New Directions Invitational Glass Show
Thomas Buechner, Jody Fine, Michael Glancy, W. Stephen Hodder, David Lewin, Richard Marquis, Josh Simpson, Mary Van Cline, Robert Varin, Karen Zoot

Clay by Three Artists: Contrasts in Clay
Kathy Erteman, David Shaner, Barbara Tiso

Fiber, Clay and Metals
Wally Schwab, Warren Seelig, M. Avigail Upin

Standing Target: An Installation by Christine Bourdette and Barbro Ulander

Oregon Winners of Individual NEA Grants Over the Past 10 Years
Helen Bitar, Frank Boyden, Nelsie Davis, Garth Edwards, Tim Ely, Judy Fawkes, Patrick Horsley, Pat Kinsella, Larry Kirkland, Susanna Kuo, Marie Lyman, Richard Notkin, Geoffrey Pagen, Barbara Setsu Pickett

John Takehara: Takehara/Treasures

Wood and Seattle Show
Jan Atkinson, Karen Clark, Doug Courtney, David Paul Eck, John Economaki, Curtis Erpeldine, Steven Foley, Ed Gordon, Joanne Hammer, Linda McFarland, Mary

McIntyre, William Moore, Gary Rogowski, Del Stubbs, Steven Voorheis, Ken Waliker, John Whitehead

Laura Andreson, Jan Atkinson, Tom and Elaine Coleman, Joanne Hammer, Carol Kumata, Linda McFarland, Mary McIntyre

Tip Toland

1984

Six from the Fiber Biennal
Pat Campbell, Larry Kirkland, Gerhardt Knodel, Jarmila Machova, Lynn Mauser-Bain, Rebecca Medel

ClayWorks Northwest
Michael Bliven, Larry Elsner, Marge Hammond, Robert Harrison, Roberta Lampert, Beth Lo

Debra Norby: It's a Jungle Out There

Frank Boyden, Lillian Pitt

Anne Perrigo

1985

Beginnings...Continued: 75th Anniversary Exhibition of Pacific Northwest College of Art Ceramic Alumni & Faculty
Janet Brockway, Patrick Horsley, Charles Hannegan, Vance Perry, Anne Storrs, Judy Teufel

Side by Side
Kay Sekimachi and Bob Stocksdale

Expressions!
Joe Apodaca, Linda Apodaca, Nelsie Davis, Tami Dean, Steve Dixon, Hannah Goldrich, Lee Haga, Robert Johnson, Stewart Jones*

Enamel Wall Pieces
Alison Howard-Levy and Martha Banyas

Ghana Textiles

Arne Ase, Richard Fox, Joan Livingstone,[24] Danae Mattes, Don Sprague, Kurt Weiser

Beth Sundelin

1986

Anagama
Frank Boyden, Harvey Brody, Tom Coleman, Nils Lou, Marie Lyman

Always a Kindgom: Arboreal Numens
Harlan Butt, Kay Campbell, Charles Forster

The Spirit of Place
Randall Darwall, Sharon Marcus, Sally Bowen Prange

Glass Invitational
Sonja Blomdahl, Dale Chihuly, Stephen Dale Edwards, Doug Gansen, Ann Gardner, Michael Kennedy, Walter Lieberman, Flora Mace and Joey Kirkpatrick, Richard Marquis, Nancy Mee, Benjamin Moore, William Morris, Tim O'Neill, Richard Posner, Richard Poster, John Reed, Jan Ross, Rich Royal, Ginny Ruffner, David Schwarz, Catherine Thompson, Dick Weiss

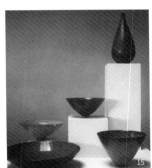

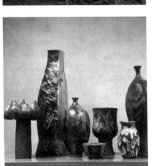

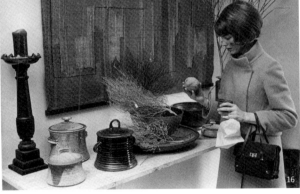

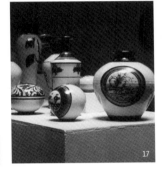

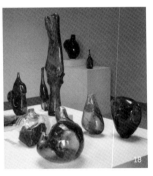

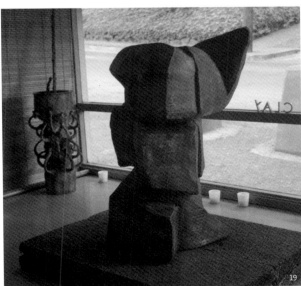

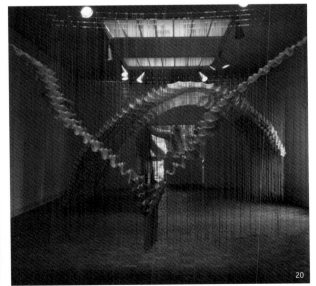

Conversations: Clay and Canvas
Catherine Arygant, Rene and Rick Baugh, Elaine Coleman, Tom Coleman, Michael Curry, Nanda D'Agostino, Robert J. Hanson, Patrick Horsley, Frank Irby, George Johanson, Roberta Kaserman, Paul Missal, Faye Nakamura, Royal Nebeker, Georgiana Nehl, Henk Pander, Lucinda Parker, Ruri, Michele Russo, Michael Zametkin

SOLO EXHIBITIONS
John Glick, Erika Kahn, Pam Patrie

HALVORSEN ARTIST-IN-RESIDENCE
Tina Dworakowski

1987
Clay
Curated by Paul Soldner
Rudy Autio, Robert Brady, Phil Cornelius, Kris Cox, David Crane, Eddie Dominquez, Jack Earl, Christine Federighi, Susan and Steven Kemeny, Richard Kugler, Brian Ransom, Steve Reynolds, Tom Rippon, Patti Warashina, Stanley Welsh, Beatrice Wood

Collectors
Co-curated by Sue Cooley and Ken Shores
Ginny Adelsheim, Laura Andreson, Rudy Autio, Ralph Bacerra, Clayton Bailey, Martha Banyas, Clair Barr, J.B. Blunk, Helen Bitar, Frank Boyden, Patricia Campbell, Elaine Coleman, Tom Coleman, Bill Creitz, Anna Belle and Florence Crocker, Ron Crosier, Nelsie Davis, Rosamond Day, Russell Day, Richard Deutsch, Phil Eagle, John Economaki, Judith Poxson Fawkes, Tom Fawkes, Betty Feves, Steve Foley, Meg Ford, David Frank, Marianne Gold, Walt Gordinier, Rachael Griffin, Jean Griffith, Ray Grimm, Erik Gronborg, Delight Hamilton, Tom Hardy, Vivika and Otto Heino, Laurie Herrick, Lydia Herrick Hodge, Kim Hoffman, P.K. Hoffman, Patrick Horsley, Bob James, Connie Jarvis, Jay Jensen, Wayne Higby, Robert Kassal, Larry Kirkland, Alan Kluber, Jean Knudsen, Solange Kowert, Coleen Kriger, Chris Kroupa, Howard Kottler, Susanna Kuo, Jack Lenor Larsen, Brother Bruno LaVerdiere, Joan Lewis, Dorothy Liebes, Marvin Lipofsky, Ed Livingston, Dick Lolcama, Glenn Lukens, Marie Lyman, Finn Lynggaard, Katharine MacNab, Sam Maloof, Sharon Marcus, John Mason, Rex Mason, Toichi Motono, Getrud and Otto Natzler, Ronna Neuenschwander, Nexus, Win Ng, Eric Norstad, Geoffrey Pagen, Pam Patrie, Antonio Prieto, Hal Riegger, Jim Romberg, Don Reitz, Victoria Avakian Ross, Herbert Sanders, Cynthia Schira, Wally Schwab, Frances Senska, Leroy Setziol, David Shaner, Ken Shores, Paul Soldner, Robert Sperry, Bob Stocksdale, Shelley Stoffer, William Stromberg, Toshiko Takaezu, Henry Takamoto, John Takehara, Judy Teufel, Alice Van Luenen, Peter Voulkos, Patti Warashina, Bennett Welsh, Bruce West, Ron Wigginton, Marguerite Wildenhain, Bill Willbanks, Paul Winneker, Paula Winokur, Robert Winokur, Fred Wollsschlager, Betty Woodman, Matsuo Yanagihara, Michael Zametkin

Contemporary Fibers
Curated by Gerhardt Knodel
Renie Breskin Adams, Marna Goldstein Brauner, Laura Brody, Susan Cannell, Deborah Frazee Carlson, Morgan Elizabeth Clifford, Barbara Eckhardt, Marla Gunderson, Ann Hiltner-Skodje,

Gerhardt Knodel, Libby Kowalski, Jane Lackey, Tom Lundberg, Fuyuko Matsubara, Laura Strand Mills, Laura Foster Nicolson, Anne McKenzie Nickolson, Nina Norris, Arturo Sandoval, Rena Thompson, Maria Tulokas, Katarina Weslien

Glass
Curated by George Saxe
Doug Anderson, Herb Babcock, Linda Benglis, William Carlson, Sydney Cash, Jose Chardict, Dale Chihuly, Jon Clark, Michael Cohn, KeKe Cribbs, Dan Dailey, Steven Devries, Michael Glancy, Henry Halem, David Huchthausen, Robert Hurlstone, Sidney Hutter, Kent Ipsen, K. William Lequier, John Lewis, Marvin Lipofsky, Harvey Littleton, John Luebtow, Flora Mace and Joey Kirkpatrick, Linda Macneil, Richard Marquis, Concetta Mason, William Morris, Hank Murta Adams, Jay Musler, Thomas Patti, Michael Pavlik, Mark Peiser, Damien Priour, Richard Ritter, Jack Schmidt, Paul Seide, Mary Shaffer, Therman Statom, Molly Stone, Michael Taylor, Karla Trinkley, Mary Van Cline, Steven Weinberg

Historical Fibers: Six Decades of American Fiber
Curated by Jack Lenor Larsen
Anni Albers, Olga de Amaral, Lia Cook, Dominic Di Mare, Helena Hernmarck, Sheila Hicks, Jack Lenor Larsen, Dorothy Liebes, John McQueen, Ed Rossbach, Jane Sauer, Cynthia Schira, Kay Sekimachi, Sherri Smith, Ethel Stein, Marianne Strengell, Lenore Tawney, Claire Zeisler

Metal
Curated by Mary Lee Hu
Martha Banyas, Jamie Bennett, Jonathon Bonner, Harlan Butt, Robert Ebendorf, Arline Fisch, Pat Flynn, Susan Ford, Donald Friedlich, Gary Griffin, Laurie Hall, Susan Hamlet, Harold Helwig, Lynne Hull, Russel Jaqua, David Jaworski, Carry Jordan, Enid Kaplan, Brent Kington, Carol Kumata, Rebekah Laskin, Leslie Leupp, Randy Long, Richard Mawdsley, Mac McCall, Bruce Metcalf, Eleanor Moty, Gary Noffke, Brigid O'Hanrahan, Hiroko and Gene Pijanowski, Elliott Pujol, Marjorie Schick, June Schwarcz, Helen Shirk, Rachelle Thiewes, Linda Threadgill, Lynda Watson-Abbott

Wood
Curated by Sam Maloof
Federico Armijo, Gary Knox Bennett, Art Carpenter, Wendell Castle, John Cederquist, John Dunningan, John Economaki, William Keyser, Tom Loeser, Kristina Madsen, Alphonse Mattia, Judy McKie, John McNaughton, Wendy Maruyama, Ed Moulthrop, Richard Newman, Jere Osgood, Mike Shuler, Rosanne Somerson, Bob Stocksdale, Bob Trotman, Howard Werner, Alan White, Rick Wrigley

Art Tech

HALVORSEN ARTIST-IN-RESIDENCE
Nan Schmitz

1988
East Meets West: National Council on Education for the Ceramic Arts (NCECA) Exhibition

Conversations in Clay: Clay and Canvas

Contemporary Glass '88
Norma Chapman, Dale Chihuly, Sheryl Cotlear, Dan Dailey, Fritz Dreisbach, Linda Ethier, Kyokei Fujita, Henry Halem, Frederick Heidel, Judy Hill, David Hopper, Jon Kuhn, Richard LaLonde, John Lewis, Marvin Lipofsky, Paul Marioni, Klaus Moje, David Schwarz, Paul Seide, Josh Simpson, Paul Stankard, Michael Taylor, Bertil Vallien, Steven Weinberg, Czeslaw Zuber, Toots Zynsky

SOLO EXHIBITIONS
Baba Wague Diakite

HALVORSEN ARTIST-IN-RESIDENCE
Yothin Amnuayphol

1989
Artists-in-Residence 1968–88

Whimsey or Why Not? Furniture Invitational
David Dochow, Ed Duin, Rhonda Cunha, Jon Dukehart, Tom Freedman, Stephen R. Grove, Stan Hain and Carol Gouthro, Elaine Hanowell, Karl Nielsen, Gerhard Pagenstecher, Gary Rogowski, Thom Ross, David Shoemaker, John and Iris Sutton, Steffan I. Wachholtz, Bruce West, Phyllis Yes, Beth Yoe

Contemporary Glass '89
Curated by Henry Hillman
John Brekke, Curtis Brock, Emily Brock, Jose Chardiet, Dale Chihuly, Peter David, Pavel Hlava, Richard LaLonde, Etienne Leperlier, Antoine Leperlier, John Lewis, Harvey Littleton, Steven McCarroll, Pavel Molnar, John Nickerson, Ginny Ruffner, David Schwarz, Susan Stinsmuehlen-Amend, Yoshihiko Takahashi, Roger Thomas, Steve Tobin, Steven Weinberg, Richard Whiteley

SOLO EXHIBITIONS
Lia Cook, Jim Koudelka

HALVORSEN ARTIST-IN-RESIDENCE
Margaret Synan Russel

1990
Bruce West: New Sculpture

The Narrative Voice, Tapestry Exhibition
Sharon Marcus, Marcel Marios, Ann Newdigate Mills, Marta Rogoyska, Ruth Scheuer

International Teaparty
Richey Bellinger, Everette Busbee, Janet Buskirk, Shelly Cutler, Lynn Dinino, Stephen Driver, Baba Wague Diakite, Jan Edwards, Ann Fleming, John Glick, Jerry Harpster, Jeanne Henry, Patrick Horsley, Terry Hutchinson, Sandra Johnstone, Leslie Lee, Berry Matthews, Dennis Meiners, Tom and Nancy Myers, Laurie O'Halloran, Gail Pendergrass, Diane Rosenmiller, Lisa Salisbury, David Shaner, Don Sprague, Kathy Triplett, Phyllis Yes, Paul Young, Mary Lou Zeek

The Garden Party
Frank Boyden, Janit Brockway, Jan Edwards, Margaret Gordon, Marge Hammond-Farness, Manuel Izquierdo, Lee Kelly and Bonnie Bronson, Michihiro Kosuge, Dennis Meiners, Faye Nakamura, Barbara Rawls, Dale Rawls, Monica Setziol, Judy Teufel, Bennett Welsh, Bruce West*

Oregon Potters Association Exhibition
Barabara Atlas, Glenn Burris, Janet Buskirk, Tom Coleman, Ellen Ann Currans, Dave and Boni Deal, Jan Edwards, Larry Evans, Rhonda Fleischman, Ann Fleming, Konky Forster, Gil Harrison, Patrick Horsley, Janice Kirkpatrick, Leslie Lee, Craig Martell, Bert McDowell, Dennis Meiners, Debra Norby, Gail Pendergrass, Kenneth Pincus, Barbara Rawls, Wally Schwab, Mike Scrivens, Victoria Shaw, Maria Simon, Craig Smith, Timothy Steeves, Daniel Stevens, Julie Stewart, Vicki Stone, Ed Thompson, Bennett Welsh*

Contemporary Glass Show
Curated by Henry Hillman
Gary Bloom and Roberta Kasserman, Ricki Bernstein, Jose Chardiet, Michael Cohn, Stephen Dee Edwards, Mark Eckstrand, Greg Englesby, David Hutchinson, Sidney Hutter, David Leppla, Steve McCarroll, Steven Rolfe Powell, David Ruth, Barry Sauter, Stephen Skiillton, Gianni Toso, Mary Van Clini, Kurt Wallstab

HALVORSEN ARTIST-IN-RESIDENCE
Betsy Wolfston

1991
Margaret Synan Russell: Artist-in-Residence Exhibition

Permanent Collection Exhibition: The Hal Cary Collection 1934–89

A.K.A: 92 Metal Works

A Gardener's Eden
Harriete Estel Berman, Frank Boyden, Jim Deardoff, Lynn DiNino, Jenny Lind, Debra Norby, Suzye Quale, Monica Setziol, Zephyr Smith, Jack Walsh, Greg Wilbur, Betsy Wolfston*

Clay & Canvas
Curated by Alyce Flitcraft
Glen Burris, Marianna Crawford, Amy Estrin, Charles Gluskoter, Anne Hirondelle, Patrick Horsley, Roberta Lampert, Craig Martell, Dennis Meiners, Michael Pratt, Dale and Barbara Rawls, Maria Simon, Anne Storrs, Judy Teufel, Margot Thompson, Sherrie Wolf, Phyllis Yes*

Contemporary Glass '91
Doug Anderson, Dale Chihuly, Peter Davis, Linda Ethier, Frederick Heisel, David Hopper, David Huchthausen, Jon Kuhn, Richard LaLonde, Marvin Lipofsky, John Lewis, Klaus Moje, Pavel Molnar, Matei Negreanu, Bretislar Novak, Tom Patti, Jack Schmidt, David Schwarz, Paul Stankard, Steven Weinberg, Mary White, Hiroshi Yamano

54th Annual Holiday Show

HALVORSEN ARTIST-IN-RESIDENCE
Benjamin Yang

1992
The Reality of Illusion
Curated by Ed Cauduro
Allan Adams, Muriel Castanis, John DeAndrea, Daniel Douke, David Furman, David Giese, Duane Hanson, Allan Kessler, Marilyn Levine, Jud Nelson, Richard Shaw, Barbara Segal, Victor Spinski, Zarko Stesancic, Keung Szeto

Don Sprague: New Work

Art Quilts: Message in Disguise

Contemporary Kilnformed Glass
*Curated by Lani McGregor and
Dan Schwoerer*
Doug Anderson, Judith Bohm-Parr, Bill
Boyson, Emily Brock, Keith Brocklehurst,
Ruth Brockman, Jaroslava Brychtova,
Frank can den Ham, Daniel Clayman,
Keith Cummings, Judi Elliott, Rudi Gritsch,
Henry Halem, Michael and Frances
Higgins, Kent Ipsen, Richard Lalonde,
Antoine Leperlier, Etienne Leperlier, Klaus
Moje, Tchai Munch, Etsuko Nishi, Yumiko
Noda, Katsuga Ogita, Warren Langley,
Stanislay Libensky, John Gilbert Luebtow,
Liz Mapelli, Glen Michaels, Willi Pistor,
Seth Randal, David Reekie, Colin Reid,
Ann Robinson, Melanie Rowe and Leslie
Rowe Israelson, Jaromir Rybak, Gizela
Sabokova, Vicki Torr, Steven Weinberg,
Toots Zynsky

1993

Forty Years in Clay [25]
Vivika and Otto Heino

What Modern Was: Three
Decades of Furniture 1930–50s [23]
Curated by Ed Cauduro
Alvar Aalto, Eero Aarnio, Joe Atkinson,
Mario Bellini, Harry Bertoia, Marcel
Breuer, Norman Cherner, Charles and
Ray Eames, Jorge Ferrari Hardoy, Arne
Jacobsen, Le Corbusier, Pierre Jeanneret,
Charlotte Perriand, Bruno Mathsson, Paul
McCobb, Ludwig Mies van der Rohe,
George Nelson, Isamu Noguchi, Verner
Panton, Charles Pollock, Eero Saarinen,
Richard Schultz, Jens Risom, Gilbert
Rohde, Hans J. Wegner

An Oregon Tribute
Steve Foley, Jere and Ray Grimm, Tom
Hardy, Bill Moore, Gary Rogowski, Leroy
Setziol, Ken Shores

Northwest Tapestry Juried
Fiber Show
Charlotte Abrams, Cecilia Blomberg, Anne
Clark, Claudia Haspedis Dixon, Barbara
Heller, Betty Hilton-Nash, Linda Hutchins,
Lori Johnson Jeffery, Alison Keenan,
Mary Lane, Sharon Marcus, Inge
Norgaard, Pam Patrie, Laura Shannock,
Mildred Sherwood, Kathe Todd-Hooker,
Kaija Tyni-Rautiainen

Connections: 7th Annual Glass
Exhibition, Bullseye Blast Glass
*Curated by Lani McGregor and Dan
Schwoerer*
Dale Chihuli, KeKe Cribbs, Linda Ethlier,
Rudi Gritsch, Brian Kerkvliet, Dante
Marioni, Klaus Moje, Narcissus Quagliata,
Lino Tagliapietra

1994

Bruce Conkle: SWM seeks TV
for viewing...

North American Juried Student
Metal Exhibition
Jan Baum, Kristin Beeler, Jim Berger,
Brian Bennett, Nisa Blackmon, Amy

Buettner, Eric W. Burris, Yong Jun Chung,
Rebecca Davies, David Echols, Eun Ju
Lee, Matthew Wayne Litteken, Jeanne L.
Paterak, Julia Turner, Sadie Wang,
Heather M. White, Jungwha Yoon*

Environmental Boxes: Containing
the Earth

Byron Temple Folk Art: Take
Another Look

A Medieval Holiday

1995

Archeologies: Structures of Time
Sharon Marcus and Diana Wood Conroy

Redefining the Book: Exploring Text,
Image and Structure in Book Arts
Curated by Liza Pastine
Tom Bannister, Victoria Benedetti, Marilyn
Burkhard, Colleen Cavin, Rona Chumbook,
Inga Dubay, Carol Erickson, Bonnie
Garlan, Debra Glanz, Patricia Grass,
Maryellen Hartman, Earle Henness, Diana
Henness, Michael Jacobs, Bonnie Meltzer,
Debby Neely, Liza Pastine, Peggy Skycraft,
T. Ellen Sollod, Lin Williams-Olson

New Tool: New Limits,
Surface Design Exhibition

Neon Glass Art Exhibit
Curated by Marlene Gabel
Lee Roy Champagne, Deborah Dohne,
Candice Gawne, Kim Koga, Vincent
Koloski, Kunio Ohashi, David Swenson,
Fred Tschida

1996

Twenty-Five Years of Clay: Frank
Boyden Retrospective Exhibition

Fertile Ground Garden Show
Curated by Tom and Elaine Coleman
Frank Boyden, Patrick Horsley, Debbie
Masuoka, Charles Morgan, Leo Pack,
James Pink, Bella Romero, Cory Roth,
Lee Sido, Mary Warner

New Voices in Weaving
Curated by Cynthia Shira
Kathleen Armstrong, Paula Stebbins
Becker, Bethanne Knudson, Christine
Laffer, Cynthia E. Lewis, Jennifer
Matsuda, Charlene H. Nemec, Susie
Taylor, Deborah Valoma

Cast Glass
Curated by Linda Ethier
Mark Abdelgaard, Gray Andolina, Irene
Frolic, Mark Furgeson, Judy Hill, John
Lewis, Paul Marioni, Anne Troutner, Bertil
Vallien, Janusz Walentynowicz, Mary
White

1997

Forty Years in the Mud: Jere and
Ray Grimm

Bauhaus Calling, Where are they
From? Influence on Contemporary
Craft Arts

Harold Balazs, Cathra-Anna Barker,
Michael Bliven, Sheri Brown, Beverly Car-
dova-Smith, Lin Cook-Harpster, Donna
Cooper, Nancy Cooper, L. Mark Cywinski,
Connie Earnshaw, Konky Forester, Joy
Ann Froding, Deborah Gall, Leslie Green,
Carol Hall, Ollie Johnson, Cheryl Kempner,
Nancy Klos, Susan Kristoferson, Martina
Maack and CaDanh, Bob McDermott,
Chistopher Morrison, Susana Nairne,
Shirley Oakley, Nancy Piccioni, Irene
Pluntky-Goedecke, Martha Reich, William
Richards, Ruri, Shelia Satow, Frances
Sersh, Frances Smersh, Kim Wasser

Good Wood: Reused/Recycled
Wood Juried Exhibition
Dorothy Gill Barnes, Beeken and Parsons,
Terry Bostwick, Chistopher Cantwell, Mark
and Suzy Coleman, Tom Crabb, David
Fobes, Margaret Forrest, Dewey Garret,
Michael and Rebecca Jesse, David Maize,
Eric Meyers, Whitney Nye, John Shipstad,
Janice C. Smith, Emily Steffian, Carrie M.
Stevens, Steve Strouse, Jesse Wells

Contemporary Beadwork
Elizabeth Bertuccio, Bobby Brown, Lani
Ching, Melinda Dahlheimer, Leroy Goertz,
Barb Grainger, Barbara Jacobs, Koe
Johnston, Jim Jones, Maya Jones, Peggy
Kendellen, Martin Kilmer, Carol Perrenoud,
Don Pierce, Alice Scherer, Teresa Sullivan

Art and Soul of the Garden,
Annual Show
Bennett Bean, Kenneth and Sandra
Callen, Patrece Canoy, Joel Cottet, Elaine
Falbo-Berg, Jeff Fetty, Erik Gronborg,
Devin Lawrence Field, Tom Hardy, Arthur
Higgins, Katy McFadden, Timothy Rose,
David Thompson, Bruce West

Traditional Asian Arts:
Greater Portland Area Artists
Anjali Bhide, Cheng Seng Cha, Subha
Chakrapani, Yang Feng, Harumi Jensen,
Deepa Kadkade, Soumontha Kanaya,
Souane Kebounnam, Pane Kinthong,
Praseuthkham Lovanh, Tung Nguyen,
Nhu-Cam Thi Nguyen, Fernando Sacdalan,
Hiroshi Ogawa, Tai Van Pham, Minh
Quang Phan, Farm On Saechao, June
Shumann, Cao Uy, Lao Mee Vang, Zhengu
Xu and Yuqin Wang, Jean Qin Ye, Jiro
Yonezawa

1998

30th Anniversary Artist-in-
Residence Show

Fabricated from Flax
Curated by Judith Poxson Fawkes
Adela Akers, Kate Anderson, Judith
Poxson Fawkes, Nancy Arthier Hoskins,
Ferne Jacobs, Jane Sauer, Kay Sekimachi

Garden of Recipes
Curated by Patrick Horsley
Joe Apodaca, Gary Bloom, Barbara Brown,
Randy Cook, Marianna Crawford, Larry
Halvorsen, Deborah Horrell, Patrick
Horsley, Roberta Kaserman, Dana Lynn
Louis, Danna Mattson, Gary Rogowski

Permanent Collection Exhibition

1999

Vivika and Otto Heino

Below 2000: Ceramics Group Show
Joe Batt, Charity Davis, Ty Davis, Ty
Dimig, Jean Nunez Donegan, Daniel
Duford, Mark Cruz Eaton, Caroline Foote,
Linda Ganstrom, Jim Grosselin, Placentia,
Carol Gouthro, Juan Granados, Deborah
Groover, Frank J. Jacques, Ho-Jeong
Jeong, Garth Johnson, Jeff Kell, James
Klueg, Melinda Maack and Ca Danh, Kicki
Masthem, Linda Hansen Mau, Paul A. Mc-
Coy, Richard Meyer, Robin Murphy, Sherry
Murray-Hansen, Thomas Orr, Elad Persov,
Scott Rench, Ben Rosenberg, Bradly
Sabin, Susan Amanda Sheedy, Porntip
Sangvanich, Lorene Senesac, Jane Spang-
ler, Rimaas VisGarda, Oliveira V'Lou

Tribute to the Oregon Potters
Association

Christian Burchard: The Art of
Turned Wood

Beadwork I: Up Close,
National Juried Bead Show

Handmade Oregon, Juried Show

Pam Patrie: Mount Angel Tapestry

2000

New Metal: Emerging Views,
National Exhibition
Juried by Bill Jean Theide
Brian Capps, Kit Casati, Donna D'Aquino,
Angela Gleason, Sarah Hood, Yevgeniya
Kaganovich, Anya Kivarkis, Leslie Mac-
Innes, Emiko Oye, Sarah Peterman, Shari
Pierce, Manya Shapiro, Jan Smith*

Over, Under: Textile Arts from the
Permanent Collection, 1940–1999

Linda Welker: Two Installations/
Labyrinth

Portland's Woven Treasures
Re-Discovered

Taking Form: Ceramic Arts in the
Northwest, 1940–60

Leroy Setziol: Growing Up with Roy

Wood Works: Northwest Style
Furniture
*Selected by Gary Rogowski and
Fred Edera*
Bobbie Biggar, Christian Burchard, Sam
Bush, Sarah and David Dochow, John
Economaki, Fred Edera, Curtis Erpeling,
Steve Foley, Steve Grove, Ed Livingston,
Dan Kvitka, Tim Mackaness, Ahoi
Mench, William Moore, Ken Moran, Doug
Parmeter, Gary Rogowski, Leroy Setziol,
Bob Shimabukuro, David Simon and Bill
Tooney, Tom Tucker, Harry Weitzer, John
Whitehead

Stone Brushes: Three Chinese
Calligraphers from Suzhou
Curated by Ian Boyden

Breaking the Mold: Selections from
the Permanent Collection

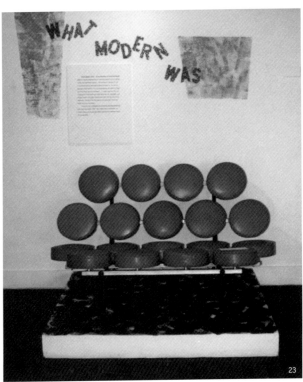

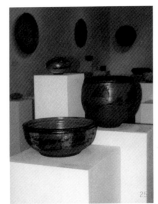

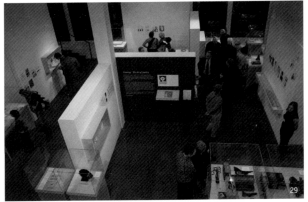

2001

Michael de Forest: Fables and Chains, MFA Furniture Project

Doma Model Living Room

Below 2002: Low Fired Ceramics
Juried by Richard Shaw
Paul and Rebecca Berger, Rebekah Bogard, Pattie Chalmers, Cameron Crawford, Joe Davis, Jeremiah Donovan, Eric Ferrari, Gerard Ferrari, John Goodheart, Ingrid Hendrix, William Hoovler, Jason Huff, Benjamin Jacket, Michelle Jurist, Denise King, Paul McCoy, Kathy Mommsen, Avra Moskowitz, Megumi Naitoh, Ben Killen Rosenberg, Johannette Rowley, Helen Otterson, Bradley Sabin

Contemporary Skeins
Hildur Bjarnadóttir, Maria Inocencio, Tamiko Kawata, Marie Watt

Dan Schmitt: New Porcelain Tableware

Recent Acquisitions to the Permanent Collection
Ann Christenson, Donna D'Aquino, Judith Poxson Fawkes, Kicki Masthem, Chris Warren, Marie Watt, Mardi Wood

100 Universes

Yul-Tensils National Competition, 65th Annual Holiday Show
Anya Kivarkis, Charles Lewton-Brain, Kicki Masthem, James Obermeier, Rebecca Scheer, Kristin Shiga*

Jere Grimm: Dreaming the Dark

2002

Representing the Functional: Selections from the Permanent Collection

Visions and Inspirations of the Oregon Potters Association
Mary Barringer, Richey Bellinger, Joanna Bloom, Barb Campbell, Mary Louise Carter, Lisa Conway, Joe Davis, Kathryn Finnerty, Viola Frey, John Glick, Heidi Preuss Grew, Richard Hotchkiss, George Kokis, Jim Koudelka, Sinisa Kukee, Eva Kwong, Warren Mackenzie, Peg Malloy, Ron Meyers, Stephen Mickey, Kim Murton, Susan Mulley, Lisa Orr, Thomas Orr, Daniel Rhodes, Thomas Rohr, Gary Schlappal, Wally Schwab, Victoria Shaw, Kathleen Stephenson, Susanne Stephenson, Natalie Warrens

150 Divided by Five
Elaine Coleman, Tom Coleman, Patrick Horsley, Wally Schwab, Don Sprague

Nancy Moore Bess: Ritual Offerings/Woven Bamboo

Marie Sivak: Lacing Atropos

Pretty as a Pitcher: Permanent Collection Exhibition

American Craft Council Awards Exhibition of Gold Medalists and Fellows

Harlan Butt, John Cedarquist, Don Reitz, Jane Sauer, Kay Sekimachi, Paula and Robert Winokur

Designed by War: War's Direct and Indirect Influence on Creativity and Craft Design
Rudy Autio, J.B. Blunk, Anna Belle and Florence Crocker, Ray Grimm, Erik Gronborg, Delight Hamilton, Charles Hannegan, Lydia Herrick Hodge, Glen Lukens, Katharine MacNab, Gertrud and Otto Natzler, Hal Riegger, Victoria Avakian Ross, Frances Senska, Jeanne Speelman, Bob Stocksdale, Spaulding Taylor, Judy Teufel, Peter Voulkos, William Wilbanks, Marguerite Wildenhain, Paula Winokur

Moving Through Light: Themed Juried Show

2003

Traditions in Cedar: Contemporary Native American Carving
Curated by Bill Mercer
Larry Ahvakana, David Boxley, Ed Archie Noisecat, Othneil Oomittuk

Adrian Arleo: Giving Refuge

Frances Senska: The Montana Collection

William Morris: Man Adorned

Eric Franklin: Embodied Cognition

Charissa Brock: Passages

Matt Proctor: New Works

Excellence in Craft Award Recipients
Galia Amsel, Giles Bettison, Eva Castellanoz, Del Harrow, Judy Hill, Sharon Marcus, Lani McGregor, Klaus Moje, Kristie Rea, Dan Schwoerer, Leroy Setziol

On the Edge, International Juried Enamel Exhibition
Ruth Altman, Ellen Becker, Lain Biggs, Vladimir Bohm, Sandra Ellen Bradshaw, Morgan Brigg, Katy Bergman Cassell, Dato Chkheidze, Mary Chuduk, Joanne S. Contant, Linda Darty, Karin Drechsler-Ruhmann, Helen Elliot, Dee Fontans, Mary Ann Forehand, Herbert Friedson, Caroline Elizabeth Gore, Jane Wells Harrison, Karen Jablonski, Bok Hee Jung, Kimberly Keyworth, John Killmaster, Mary Klein, Audrey B. Komrad, Sandra Kravitz, Sarah Krisher, Ora K. Kuller, Susanne Kustner, Felicia Liban, Barbara Lipp, James Malenda, Glenice Lesley Matthews, Imi Maufe, Edward Lane McCartney, G. McLarty, Richard McMullen, Lilian Menache, Renee Menard, Taweesak Molsawat, Hiroko Morita, Jill Parnell, Sarah Perkins, Susan Remnant, Barbara Ryman, Leslie A. Schug, Bae Chang Sook, Judy Stone, Laura S. Sutton, Hannah M. Voss, Yohko Yoshimura, Regina Zorzi

Anthems and Anthologies: Recent Tapestries and Maquettes by Shelley Socolofsky

Saluting Six Decades: Contemporary Crafts Museum & Gallery's Artists-in-Residence, Selections from the Permanent Collection

2004

The Soul of a Bowl
Frank Boyden, Elaine Coleman, Tom Coleman, Jenny Lind, Don Reitz

OPA Award Winners 1984–2004: Selections from the Permanent Collection
Glen Burris, Mariana Crawford, Boni and Dave Deal, Ellen Fager, Kathryn Finnerty, Michael Fromme, Chris Gum, Patrick Horsley, Hsin-Yi-Huang, Jim Koudelka, Carol Lebreton, Craig Martell, Dennis Meiners, Richard Rowland, Ruri, Tamae Sawano, Michael Scrivens, Maria Simon, Gary Sloane, Don Sprague, Vern Uyetake, Natalie Warrens

The Art of Bob Stocksdale: Selections from the Collection of Forrest L. Merrill

A Master Inspires Oregon: Contemporary Wood Turning
Curated by Dan Kvitka
Terry Bostwick, Christian Burchard, John Dickinson, Dan Kvitka, David MacFarlane, William Moore, Don Vanderpot

Oregon College of Art and Craft Thesis Exhibition

Purposeful Pattern: Selections from the Permanent Collection

Coefficients: A Selection of Contemporary Kiln-formed Glass
Mel George, Deborah Horrell, Jeremy Lepisto, Scott Schroeder

Outside, Looking In: New Work by Beth Cavener Stichter

Liz Frey: Elements

Shared Legacies: Contemporary Crafts and the WPA, Selections from the Permanent Collection
Curated by JulieAnne Poncet

Beyond Tradition: New Ply-Split Fiber Sculpture
Juried by Martha Stanley
Peter Collingwood, Linda Hendrickson, Katoko Kitade, Errol Pires, Dr. James Pochert, Kay Sekimachi, Akiko Shimanuki, Noemi Speiser, Pallavi Varia, Barbara Walker, Rieko Yamane

Zen Parry: Spiritual Maps; Terry Bostwick; Bruce Conkle: Flumes; Gina Carrington; Taylor Vogland Dreiling; Vicki Lynn Wilson: The Catch

2005

Portland Collects: Contemporary Ceramics
Curated by Marie Sivak
Laura Andreson, Gordon Baldwin, Frank Boyden, Edith Sonne Bruun, Jack Earl, Kathy Erdman, Viola Frey, Bendt Friberg, Erik Gronborg, Lisa Henriques, Sergei Isupov, Jun Kaneko, Connie Kiener, Beata Kuhn, Michael Lucero, Bodil Manz, Tony Marsh, Harrison McIntosh, Gunner Nylund, Teo Paulsen, Lucie Rie, Mary Rodgers,

John Rogers, Alex Salto, Ben Sams, Karl Scheid, Frances Senska, Mardi Wood

Everyday Wonders: Ceramics from the Collection of Dr. Francis J. Newton, Permanent Collection Exhibition

Layers of Meaning: The Art Quilt
Juried by Bill Mercer, Jeannette DeNicolis Meyer and Sally Sellers
B.J. Adams, Lisa Call, Judith Content, Quinn Zander Corum, Debra M. Danko, Kristin Dukay, Darcy Falk, Valerie S Goodwin, Trisha Hassler, Beth T. Kennedy, Melisse Laing, Judy Langille, Linda Levin, Stephanie Green Levy, Denise Linet, Linda McDonald, B. Michele Maynard, Eleanor McCain, Angela Moll, Dominie Nash, Jean Neblett, Emily Richardson, Dinah Sargeant, Laura Wasilowski, Nelda Warkentin, Barbara W. Watler, Jeanne Williamson, Sandra L. H. Woock

Natural Elements: Selections from the Permanent Collection

Oregon College of Art and Craft Thesis Exhibition

Looking Forward, Glancing Back: Northwest Designer Craftsmen at 50
Curated by Lloyd Herman

Woven in the Round: Contemporary Native American Cylinder Baskets from the Columbia River Basin
Guest-curated by Bill Mercer
Pat Courtney Gold, Joe Fedderson, Natalie Kirk, Joey Lavadour

Wood, Fire, Form: New Ceramics by Ruri

When It Rains, We Pour: Teapots from Portland Collections
Richard Batterham, Gale Busch, Janet Buskirk, Barbara Campbell, Donald Clark, Philip Cornelius, Tom Coleman, Baba Wague Diakete, Paul Dresang, Charles Guskoter, Shoji Hamada, Larry Halvorsen, Patrick Horsley, Louis Katz, Connie Kiener, Jim Koudelka, Kari Russell Pool and Marc Petrovic, Leslie Lee, Warren Mackenzie, Dennis Meiners, Ron Meyers, Ronna Neuenschwander, Richard Rowland, Richard Notkin, Peter Shire, Don Sprague, Chris Staley, Timothy Steeves, Mara Superior, John Takehara, Akio Takemori, Susan Thayer, Patti Warashina, Betty Woodman*

Good Bird, Bad Bird
Juried by Marcia MacDonald, Namita Gupta Wiggers and Mary Lou Zeek

Andi Kovel and Justin Parker, Ted Vogel

Bonnie Meltzer: Memory Quilts; Manya Shapiro; Lisa Medlen; Micki Skudlarczyk; Guruhans Kroesen

2006

Chronicles in Clay: Ceramics from the Permanent Collection
Curated by Peter Held
Laura Andreson, Rudy Autio, Fred Bauer, Frank Boyden, Elaine Coleman, Tom Coleman, Baba Wague Diakite, Ken Ferguson,

Betty Feves, Kathryn Finnerty, Timothy Foss, Michael Fromme, Ray Grimm, Erik Gronborg, Lydia Herrick Hodge, Patrick Horsley, Howard Kottler, Jim Koudelka, William Krietz, James Lovera, Glen Lukens, James McKinnell, Gertrud and Otto Natzler, Ronna Neuenschwander, Antonio Prieto, Hal Riegger, Victoria Avakian Ross, Wally Schwab, Frances Senska, David Shaner, Ken Shores, Paul Soldner, Robert Sperry, Don Sprague, Susan Thayer, Kyoko Tokumaru, Peter Voulkos, Patti Warashina, Marguerite Wildenhain

Patti Warashina: Real Politique and Drunken Power Series [26]

Antonio Prieto: A Family Collection

Defining the Bamboo Aesthetic
Guest-curated by Nancy Moore Bess
Dona Anderson, Charissa Brock, Kathy Chamberlin, Michael Cohen, Alonzo Davis, Polly Jacobs Giacchina, Glenn Grishkoff, Calvin Hashimoto, Kazue Honma, June Kerseg-Hinson, Ananda Khalsa, Jae Young Kim, Maria C. Moya, Shakti Carola Navran, Hisako Sekijima, Troy Susan, Takako Ueki, Jiro Yonezawa

An Artist Collects: Artist-made Books from the Collection of Barbara Tetenbaum

Oregon College of Art and Craft Thesis Exhibition

David Schwarz: A Mid-Career Retrospective
Guest-curated by Margo Jacobsen Greeve

Contradictions: Hybrid Ceramics by Rain Harris

New Embroidery: Not Your Grandma's Doily
Co-curated by Annin Barrett, Manya Shapiro and Namita Gupta Wiggers
B.J. Adams, Hildur Bjarnadóttir, Louise Bourgeois, Susie Brandt, Lou Cabeen, Orly Cogan, Celia Eberle, Dana Fenwick, Jenny Hart, Maggy Rozycki Hiltner, Wendy Huhn, Masah Kalugin, Emily Katz, Roberta Lavadour, China Marks, Darrel Morris, Karen Reimer, Shanon Schollian, Andrea Vander Kooij, David Willburn, Anne Wilson

The Game Show
Juried by Elizabeth Shypertt, Namita Gupta Wiggers and Bill Will

Generations: Grimm, Hardy, Setziol, Shores

NORTH WINDOW PROJECTS
Yoko Inoue; Charissa Brock; Tom Beardman: Icarus Rises; David Schwarz; Suzy Root; Stitch-o-Rama; The Game Room: Adam Blankinship, Augustin Scott de Martinville, Ken Little, Anthea Zeltzman

HALVORSEN ARTIST-IN-RESIDENCE
Eliza Au

2007

Zen Parry, Engagement: White Light

Eliza Au, Artist-in-Residence: Hymn to Calamity

Hilary Pfeifer: 's Warm

NORTH WINDOW PROJECT
Megan Heeres

MARCH 11, 2007
Contemporary Crafts Museum & Gallery closes at 3934 sw Corbett Avenue

JULY 22, 2007
Museum of Contemporary Craft re-opens at 724 NW Davis Street

Craft in America: Expanding Traditions [27]
Curated by Jo Lauria

Form Animated
Guest-curated by Rose Bond
Karen Aqua and Jeanee Redmond, Jim Blashfield and Christine Bourdette, Rose Bond, Paul Bush, Norman McLaren, Joanna Priestly

The Living Room [21]
Laura Anderson, Joe Apodaca, Linda Apodaca, Robert Arneson, Fred Bauer, Harry Bertoia, Tord Björklund, J.B. Blunk, Rose Cabat, Lou Cabeen, Chilewich, William Creitz, George Cummings, Løvig (Dansk Designs), Charles and Ray Eames, Betty Feves, Ray Grimm, Joacim Gustavsson, Shoji Hamada, Tom Hardy, Edith Heath, Laurie Herrick, Lydia Herrick Hodge, Howard Kottler, Jack Lenor Larsen, Bernard Leach, Glen Lukens, Sam Maloof, John Mason, Gertrud and Otto Natzler, Eric Norstad, Eric Pfeiffer, Antonio Prieto, Lucie Rie, Victoria Avakian Ross, Eero Saarinen, Frances Senska, Leroy Setziol, David Shaner, Ken Shores, Robert Sperry, Bob Stocksdale, William Stromberg, Kyoko Tokumaru, Peter Voulkos, Patti Warashina, Marguerite Wildenhain

Eden Revisited: The Ceramic Art of Kurt Weiser
Curated by Peter Held

2008

Touching Warms the Art
Juried by Rebecca Scheer, Rachelle Thiewes and Namita Gupta Wiggers
Maru Almeida, Laura Aragon, Eliana Arenas, Adam Arnold, Anastasia Azure, Julia Barello, Roberta Bernabei, Diego Bisso, Iris Bodemer, Allyson Bone, Jenny Campbell, Ana Cardim, Sungho Cho, Jennifer Crupi, Brigit Daamen, Christine Dhein, Cristina Dias, Teresa Faris, Yael Friedman, Alison Gates, Heidi Gerstacker, Andrea Giaier, Jennifer Hall, Catarina Hällzon, Karrie Harbart, Mindy Herrin, Megan Hildebrandt, Tomoyo Hiraiwa, Peter Hoogeboom, Lindsay Huff, Masumi Kataoka, Susan Kingsley, Steven & William Ladd, Julie Lake, Dongchun Lee, Moira Lime, Kenneth MacBain, Susanne Matsché, Tomomi Matsunaga, Mayumi Matsuyama, Carrie McDowell, Lisa Medlen, Maria Ochoa, Masako Onodera, Emiko Oye, Michelle Pajak-Reynolds, Seth Papac, Sarah Peterman, Natalya Pinchuk, Laura Prieto-Velasco

Framing · The Art of Jewelry [29]
Curated by Ellen Lupton
Harriete Estel Berman, Melanie Bilenker, Alexander Blank, Kristine Bolhuis, Helen Britton, Sigurd Bronger, Angela Bubash, Betty Cooke, Marilyn da Silva, Donna D'Aquino, Iris Eichenberg, Diane Falkenhagen, Angela Gleason, Linda Kaye-Moses, Susan Kingsley, Steven & William Ladd, Victoria Lansford, Seung-Hea Lee, Keith Lo Bue, Louise McClure, Bruce Metcalf, Maria Nuutinen, Ruudt Peters, Karen Pontoppidan, Sharon Portelance, Todd Reed, Lauren Schlossberg, Deganit Stern

Schocken, Nicola Scholz, Constanze Schreiber, Jill Schwartz, Sam Shaw, Sondra Sherman, Kiff Slemmons, Barb Smith, Bettina Speckner, Johan Van Aswegen, Lisa Walker, Lynda Watson, Roberta and David Williamson, Liaung Chung Yen

Generations: Ken Shores [22]
Victoria Avakian Ross, Ken Ferguson, Betty Feves, Erik Gronborg, Shoji Hamada, Lydia Herrick Hodge, Howard Kottler, Glen Lukens, Ted Sawyer, Steve Schrepferman, Ken Shores, Gary Smith, Robert Sperry, Toshiko Takaezu, Henry Takemoto, Skeffington Thomas, Peter Voulkos, Marguerite Wildenhain

Glass: Melissa Dyne [28]

The Ceramics of Gertrud and Otto Natzler
Jeremy Briddell, Gertrud and Otto Natzler, Adam Silverman

Manuf®actured: The Conspicuous Transformation of Everyday Objects
Guest-curated by Mara Holt Skov and Steven Skov Holt
Hrafnhildur Arnardottir, Boris Bally, Harriete Estel Berman, Jerry Bleem, Constantin and Laurene Boym, Cat Chow, Sonya Clark, Mitra Fabian, Livia Marin, Régis Mayot, Jason Rogenes, Devorah Sperber, Laura Splan, Marcel Wanders, Dominic Wilcox

IMAGE CREDITS

1. Young visitors outside the Oregon Ceramic Studio. *Children's Ceramics Competition*, 1944.

2. Chair by Evert Sodergren, wall piece by Betty Feves. Installation view, *Northwest Designer Craftsmen*, 1959.

3. Foreground: Weavings by Dorothy Liebes. Background: Constantin Brancusi, *A Muse*, 1918, donated by Sally Lewis to the Portland Art Museum. Installation view, *Dorothy Liebes Weavings*, 1942.

4. Installation view, *Second Annual Exhibition of Northwest Ceramics*, 1951.

5. Works by Ruth Penington. Installation view, *Creative Craftsmen of the Northwest*, 1959.

6. Installation view, *Seventh Annual Exhibition of Northwest Ceramics*, 1956.

7. Work by Ray Grimm, *Featured Artist Exhibition*, 1957.

8. Works by Imogen Bailey, Lin Lawson and Jack Lenor Larsen. Installation view, *Featured Artist Exhibition*, 1950.

9. Tea set by Marguerite and Franz Wildenhain. Installation view, *Featured Artist Exhibition*, 1940.

10. Installation view, *Macramé*, 1966.

11. Work by Sam Maloof. Installation view, *Featured Artist Exhibition*, 1977.

12. Installation view, *Mike Walsh: Attachment Extinction Series*, 1974.

13. Work by Hilda Morris. Installation view, *House and Garden Invitational*, 1965.

14. Exhibition catalog cover, *Ninth Biennial Exhibition of Northwest Ceramics*, 1960. Photo by Margaret Murray Gordon.

15. Installation view, *Natzler Ceramics*, 1975.

16. Contemporary Crafts Gallery visitor, c. 1965.

17. Works by Tom Coleman. Installation view, *Featured Artist Exhibition*, 1972.

18. Works by Marvin Lipofsky. Installation view, *Featured Artist Exhibition*, 1966.

19. Foreground: Work by Peter Voulkos. Front window installation view, *Eighth Biennial Exhibition of Northwest Ceramics*, 1958.

20. Work by Gerhardt Knodel. Installation view, *Featured Artist Exhibition*, 1975.

21. Installation view, *The Living Room*, 2007. Photo by Mark Stein.

22. Member Preview, *Generations: Ken Shores*, 2008. Photo by Brian Foulkes.

23. Couch by George Nelson for Herman Miller, Inc. Installation view, *What Modern Was: Three Decades of Furniture 1930s–50s*, 1993.

24. Works by Joan Livingstone. Installation view, *Featured Artist Exhibition*, 1985.

25. Installation view, *Forty Years in Clay: Vivika and Otto Heino*, 1993.

26. Installation view, *Patti Warashina: Real Politique*, 2006.

27. Museum visitor viewing John Economaki's *Vaughn Street Dessert Trolley*, 1985. Installation view, *Craft in America: Expanding Traditions*, 2007.

28. Member Preview, *Glass: Melissa Dyne*, 2008. Photo by Brian Foulkes.

29. Member Preview, *Framing · The Art of Jewelry*, 2008. Photo by Madeleine Wilhite.

Selected
Bibliography

Adamson, Glenn. "Handy-Crafts: A Doctrine." In *What Makes a Great Exhibition?* edited by Paula Marincola. Philadelphia: Philadelphia Exhibitions Initiative, Philadelphia Center for Arts and Heritage; London: Reaktion Books; Chicago: University of Chicago Press, 2006.

American Craftsmen's Council. *Asilomar: First Annual Conference of American Craftsmen sponsored by the American Craftsmen's Council*, June 1957.

Appadurai, Arjun, ed. *The Social Life of Things: Commodities in Cultural Perspective*. Cambridge: Cambridge University Press, 1986.

Bell, Robert and the National Gallery of Australia. *Transformations: The Language of Craft*. Canberra, ACT; London and Seattle: University of Washington Press, 2005.

Benjamin, Walter. *Illuminations*. New York: Harcourt, Brace & World, 1968.

Birks, Tony and Jo Lauria. *Ruth Duckworth: Modernist Sculptor*. Aldershot, UK: Lund Humphries; Los Angeles: Arts Options Foundation, 2005.

Boise State University and Gallery of Art. *Northwest Ceramics Today*. Boise, ID: Idaho Commission on the Arts, 1987.

Burgard, Timothy Anglin. *The Art of Craft: Contemporary Works from the Saxe Collection*. San Francisco: Fine Arts Museums of San Francisco; Boston: Bulfinch Press, 1999.

Clark, Garth. *Ceramic Art: Comment and Review 1882–1977: An Anthology of Writings on Modern Ceramic Art*. New York: E.P. Dutton, 1978.

———. *A Century of Ceramics in the United States, 1878–1978: A Study of its Development*. New York: E.P. Dutton, 1979.

———. *Shards: Garth Clark on Ceramic Art*. New York: Distributed Art Publications, 2003.

Clark, Garth, et al. *A Century of Ceramics in the United States, 1878–1978: Checklist of Exhibition with Marks and Supplementary Information*. Syracuse, NY: Everson Museum of Art, 1979.

Clowes, Jody, Elvehjem Museum of Art, Mint Museum of Craft + Design, et al. *Don Reitz: Clay, Fire, Salt, and Wood*. Madison, WI: Elvehjem Museum of Art, Unviersity of Wisconsin-Madison, 2004.

Dietz, Ulysses Grant. *Great Pots: Contemporary Ceramics from Function to Fantasy*. Newark, NJ: Newark Museum, Guild Publishing, 2003.

Dormer, Peter, ed. *The Culture of Craft: Status and Future*. Manchester, UK: Manchester University Press; New York: St. Martin's Press, 1997.

Failing, Patricia. *Howard Kottler: Face to Face*. Seattle: University of Washington Press, 1995.

Ferguson, Ken, et al. *Ken Ferguson: Talking With the Wheel*. Arlington, TX: Silver Gate, 2007.

Gelburd, Gail and Geri DePaoli. *The Transparent Thread: Asian Philosophy in Recent American Art*. University of Pennsylvania Press: Philadelphia, 1990.

Greenhalgh, Paul, ed. *The Persistence of Craft: The Applied Arts Today*. New Brunswick, NJ: Rutgers University Press, 2003.

Greenhalgh, Peter. "Worrying About the Modern World." *American Craft* (67.5): 121–128.

Griffin, Rachael. *A History of the Oregon Ceramic Studio*. Portland: Oregon Ceramic Studio, 1943.

Gustafson, Paula, ed. *Craft: Perception and Practice: A Canadian Discourse.* 2 vols. Vancouver: Ronsdale Press, 2002.

Halper, Vicki and Bank of America (Seattle) Gallery. *Findings: The Jewelry of Ramona Solberg*. Seattle: Bank of America Gallery and University of Washington Press, 2001.

Halper, Vicki, Howard Kottler and Tacoma Art Museum. *Look Alikes: the Decal Plates of Howard Kottler*. Tacoma: Tacoma Art Museum, 2004.

Halper, Vicki and Museum of Glass: International Center for Contemporary Art. *Contrasts: A Glass Primer*. Tacoma, WA: Museum of Glass; Seattle: University of Washington Press, 2007.

Harrington, Lamar. *Ceramics in the Pacific Northwest: A History*. Seattle: University of Washington Press, 1979.

Held, Peter, ed. *Following the Rhythms of Life: The Ceramic Art of David Shaner*. Tempe, AZ: Arizona State University Art Museum, 2007.

Held, Peter, Rick Newby, Holter Museum of Art, et al. *A Ceramic Continuum: Fifty Years of the Archie Bray Influence*. Helena, MT: Holter Museum of Art; Seattle: University of Washington Press, 2001.

Heino, Vivika, Otto Heino, Kevin Wallace, Ventura County Museum of History & Art, Craft & Folk Art Museum, et al. *The Art of Vivika and Otto Heino*. Ventura, CA: Ventura County Museum of History & Art, 2005.

Herman, Lloyd E., Northwest Designer Craftsmen, Whatcom Museum of History and Art. *Looking Forward, Glancing Back: Northwest Designer Craftsmen at 50*. Bellingham, WA: Whatcom Museum of History and Art; Seattle: University of Washington Press, 2004.

Ho, Ron and Bellevue Arts Museum. *Dim Sum at the On-On Tearoom: the Jewelry of Ron Ho*. Bellevue, WA: Bellevue Arts Museum, 2006.

Hung, Shu and Joseph Magliaro, eds. *By Hand: The Use of Craft in Contemporary Art*. New York: Princeton Architectural Press, 2007.

Johnson, Jean. *Exploring Contemporary Craft: History, Theory & Critical Writing*. Toronto: Coach House Books with the Craft Studio at Harbourfront Centre, 2002.

Kangas, Matthew, "Robert Sperry: PLANETARY CLAY," *American Craft* 41.6 (Dec 1981/Jan 1982): 22–25.

Klausner, Amos, et al. *Heath Ceramics: the Complexity of Simplicity*. San Francisco: Chronicle Books, 2006.

Larsen, Jack L. *A Weaver's Memoir*. New York: H.N. Abrams, 1998.

Larsen, Jack L., Museum of Arts and Design, et al. *Jack Lenor Larsen: Creator and Collector*. London and New York: Merrell Publishers, 2004.

Lauria, Jo, Los Angeles County Museum of Art, et al. *Color and Fire: Defining Moments in Studio Ceramics 1950–2000*. Los Angeles: Los Angeles County Museum of Art; New York: Rizzoli, 2000.

Lauria, Jo and Steve Fenton. *Craft in America: Celebrating Two Centuries of Artists and Objects*. New York: Clarkson Potter, 2007.

Longenecker, Martha and Mingei International Museum of World Folk Art. *Laura Andreson: A Retrospective in Clay*. La Jolla, CA: Mingei International Museum of World Folk Art, 1982.

MacNaughton, Mary D., Lang Arts Gallery, Scripps College, et al. *Paul Soldner: A Retrospective*. Claremont, CA: Lang Arts Gallery, Scripps College; Seattle: University of Washington Press, 1991.

Marincola, Paula, ed. *What Makes a Great Exhibition?* Philadelphia: Philadelphia Exhibitions Initiative, Philadelphia Center for Arts and Heritage; London: Reaktion Books; Chicago: University of Chicago Press, 2006.

McFadden, David R., American Craft Museum, et al. *Defining Craft 1: Collecting for the New Millennium*. New York: American Craft Museum, 2000.

McFadden, David R., Museum of Arts and Design, Chazen Museum of Art, et al. *Dual Vision: The Chazen Collection*. New York: Museum of Arts and Design, 2005.

Molesworth, Helen A. and Wexner Center for the Arts. *Part Object, Part Sculpture*. Columbus, OH: Wexner Center for the Arts, Ohio State University; University Park, PA: Pennsylvania State University Press, 2005.

Museum of Contemporary Craft Archives, 1937–2008.

The Museum of Modern Art. *MoMA Highlights: 325 Works from the Museum of Modern Art*. New York: The Museum of Modern Art, Inc., 1999.

Nordness, Lee. *Objects: USA*. New York: Viking, 1970.

Owen, Paula and M. Anna Fariello, eds. *Objects and Meaning: New Perspectives on Art and Craft*. Lanham, MD: Scarecrow Press, Inc., 2004.

Pearce, Susan M. *Interpreting Objects and Collections*. London, New York: Routledge, 1994.

Peterson, Susan. *Shoji Hamada: a Potter's Way & Work*. Tokyo, New York: Kodansha International; New York: Harper and Row, 1974.

Ramljak, Suzanne. *Crafting a Legacy: Contemporary American Crafts in the Philadelphia Museum of Art*. New Brunswick, NJ: Philadelphia Museum of Art in association with Rutgers University Press, 2002.

Sandler, Irving. *American Art of the 1960s*. New York: Harper & Row, 1988.

Sarpellon, Giovanni and Lino Tagliapietra. *Lino Tagliapietra: Vetri, Glass, Verres, Glas*. Venice: Arsenale Editrice, 1994.

Shores, Ken. Interview by Lamar Harrington, January 29, 1976, for Harrington, Lamar, *Ceramics in the Pacific Northwest: A History*. Seattle: University of Washington Press, 1979.

Slivka, Rose. "The New Ceramic Presence." *Craft Horizons* (July–August 1961): 30–37.

Solberg, Ramona. *Inventive Jewelry-Making*. New York: Van Nostrand Reinhold, 1972.

Stewart, Susan. *On Longing: Narratives of the Miniature, the Gigantic, the Souvenir, the Collection*. Baltimore: John Hopkins University Press, 1984.

Strauss, Cindi. *Crafting a Collection: Contemporary Craft in the Museum of Fine Arts, Houston*. Houston, TX: The Museum of Fine Arts, Houston, 2006.

Trapp, Kenneth R. and Smithsonian American Art Museum. *Masters of their Craft: Highlights from the Smithsonian American Art Museum*. Washington, DC: Smithsonian American Art Museum, 2003.

Trapp, Kenneth R. and Howard Risatti. *Skilled Work: American Craft in the Renwick Gallery*. Washington, DC: The Smithsonian Institution Press, 1998.

University of Minnesota: University Art Museum and American Federation of Arts. *American Studio Ceramics, 1920–1950: An Exhibition*. Minneapolis: University Art Museum, University of Minnesota, Minneapolis, 1988.

Van Cleve, Jane. *3934 Corbett: Fifty Years at Contemporary Crafts*. Portland, OR: The Contemporary Crafts Association, 1987.

Wildenhain, Marguerite. *The Invisible Core: A Potter's Life and Thoughts*. Palo Alto, CA: Pacific Books, 1973.

Yake, J. Stanley. *Toshiko Takaezu: The Earth in Bloom*. Albany, NY: MEAM, 2005.

Acknowledgements

A project of this scope requires a great deal of conversation, time and assistance, and Katherine Bovee and Namita Gupta Wiggers would like to give special thanks to some of the many people who assisted us with various aspects of this process. For help in the initial planning and/or letting us raid their bookshelves, we thank John Calvelli, Jim Carmin, Ron Laster, Whitney Lowe, Stephanie Snyder and Barbara Tetenbaum. For help with content and questions about the collection, we are indebted to Kathy Abraham, Annin Barrett, Karl Burkheimer, Peter Held, Pat Horsley, Roberta Lampert, Sharon Marcus, Gerri Ondrizek, Thomas Orr, Manya Shapiro, Sue Taylor, Ted Vogel and Greg Wilbur. We thank photographer Dan Kvitka for his infinite patience, good humor and keen eye. If not for Margaret Gordon's photographs, Darcy Edgar and Lisa Conte's focus on collection record keeping and the many, many volunteers who invested time in constructing scrapbooks and creating records, this book would not have happened. For their careful, thoughtful writing, we thank Glenn Adamson and Janet Koplos. Special thanks to Tyler Ashcraft at Dynagraphics for his attention to the printing of this book. For editorial attention beyond the call of duty, we thank Anjali Gupta and John Ewing. And we cannot thank Kat Perez enough for her unflappable attitude, willingness to take on any aspect of this project thrown her way, for her countless hours of scanning and filing slides, hunting down dates and the relentless stream of details she handled with great care and humor. Namita would like to thank Scott, Leila and Calder for their tremendous support and patience during this project. Thanks to David Cohen for his vision and support throughout the process. To the many collectors and donors who continue to build the Museum's collection, and to all those who value craft as a vital part of visual culture, our very heartfelt thanks. To the anonymous donor who believed in and supported this project from the beginning, this publication is dedicated to you and your support of the artists and craftspeople whose work we all value deeply and without whom, we should add, we would all lead very boring lives indeed.

Museum of Contemporary Craft